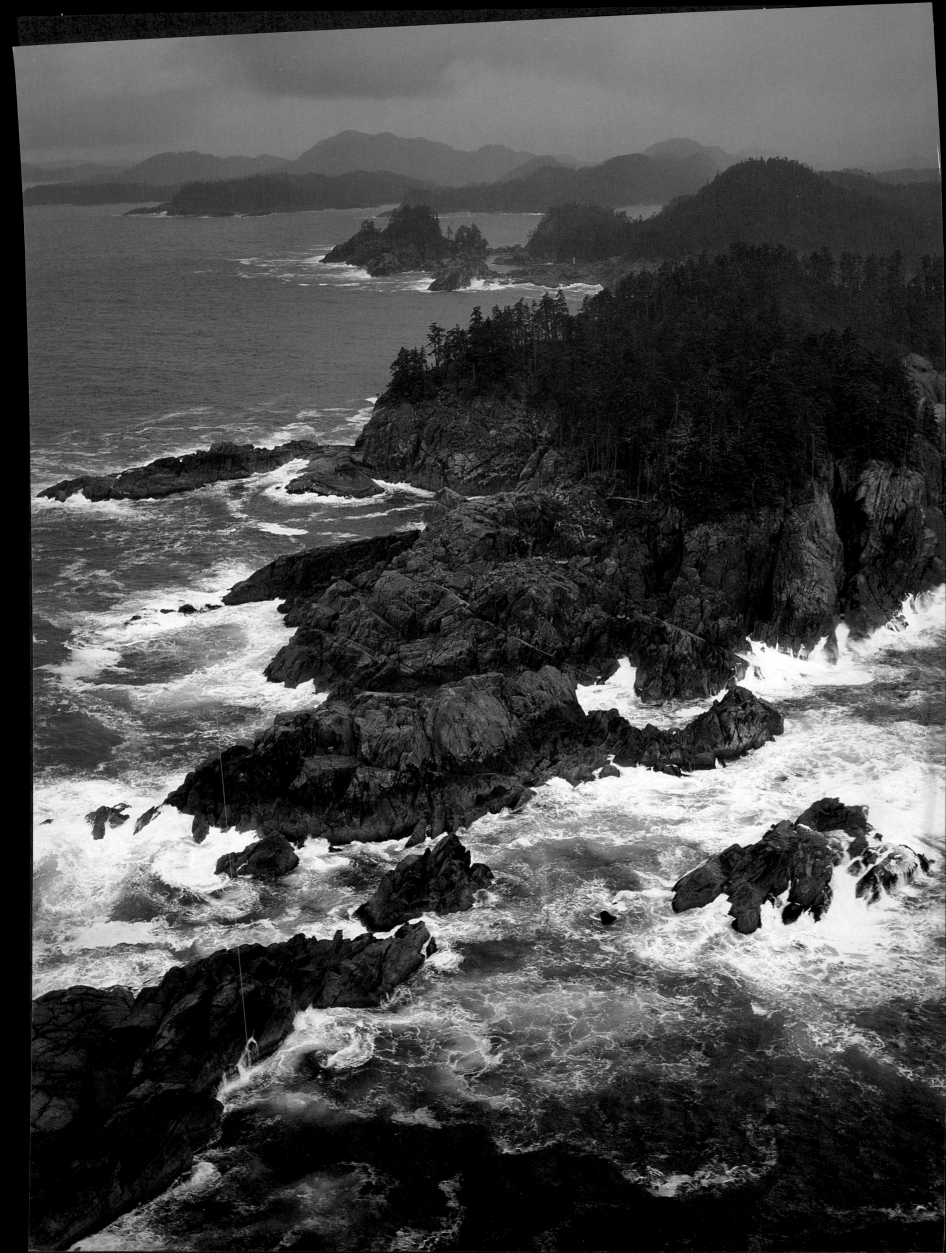

ALASKA
FROM THE AIR

FRED HIRSCHMANN

Best Wishes,
Fred Hirschmann

GRAPHIC ARTS CENTER PUBLISHING®

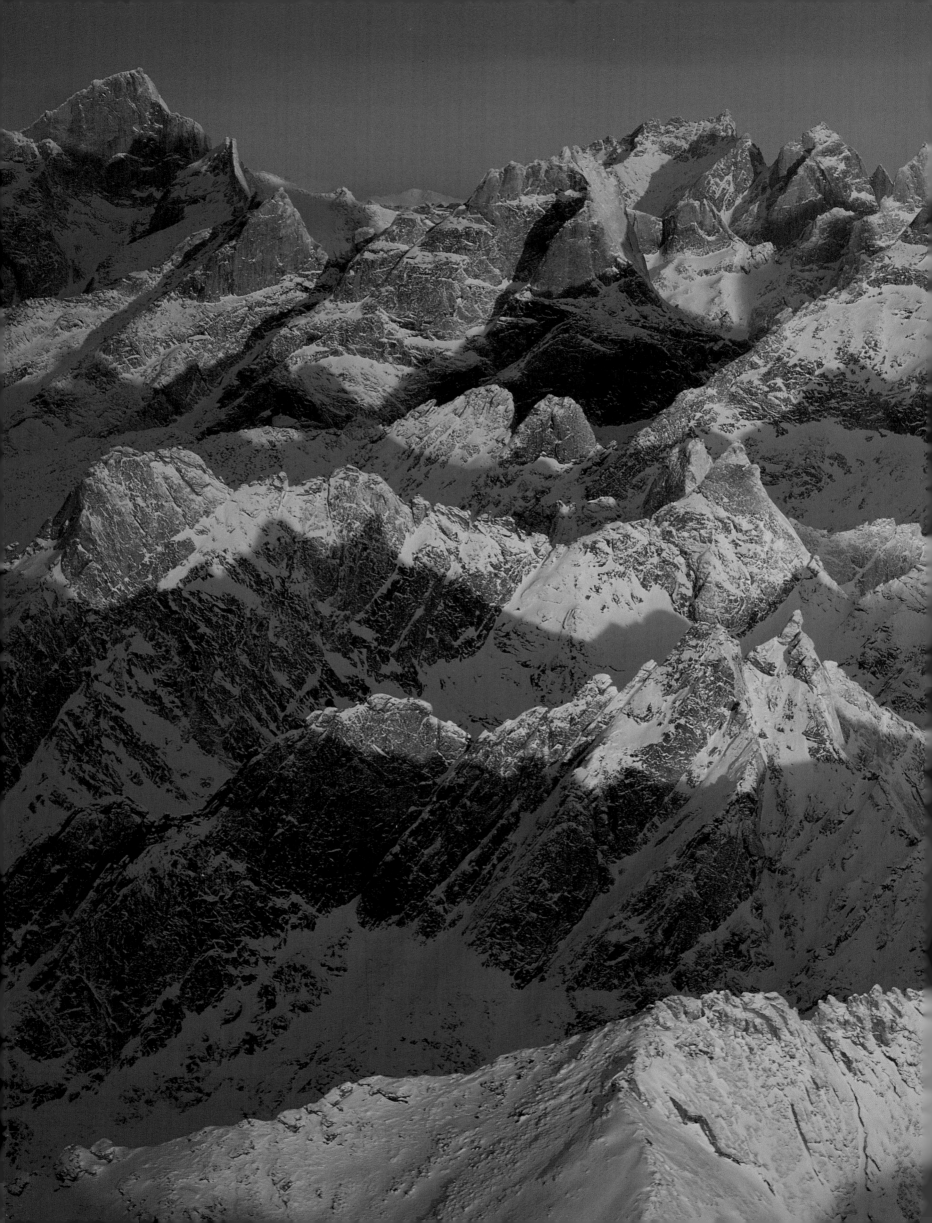

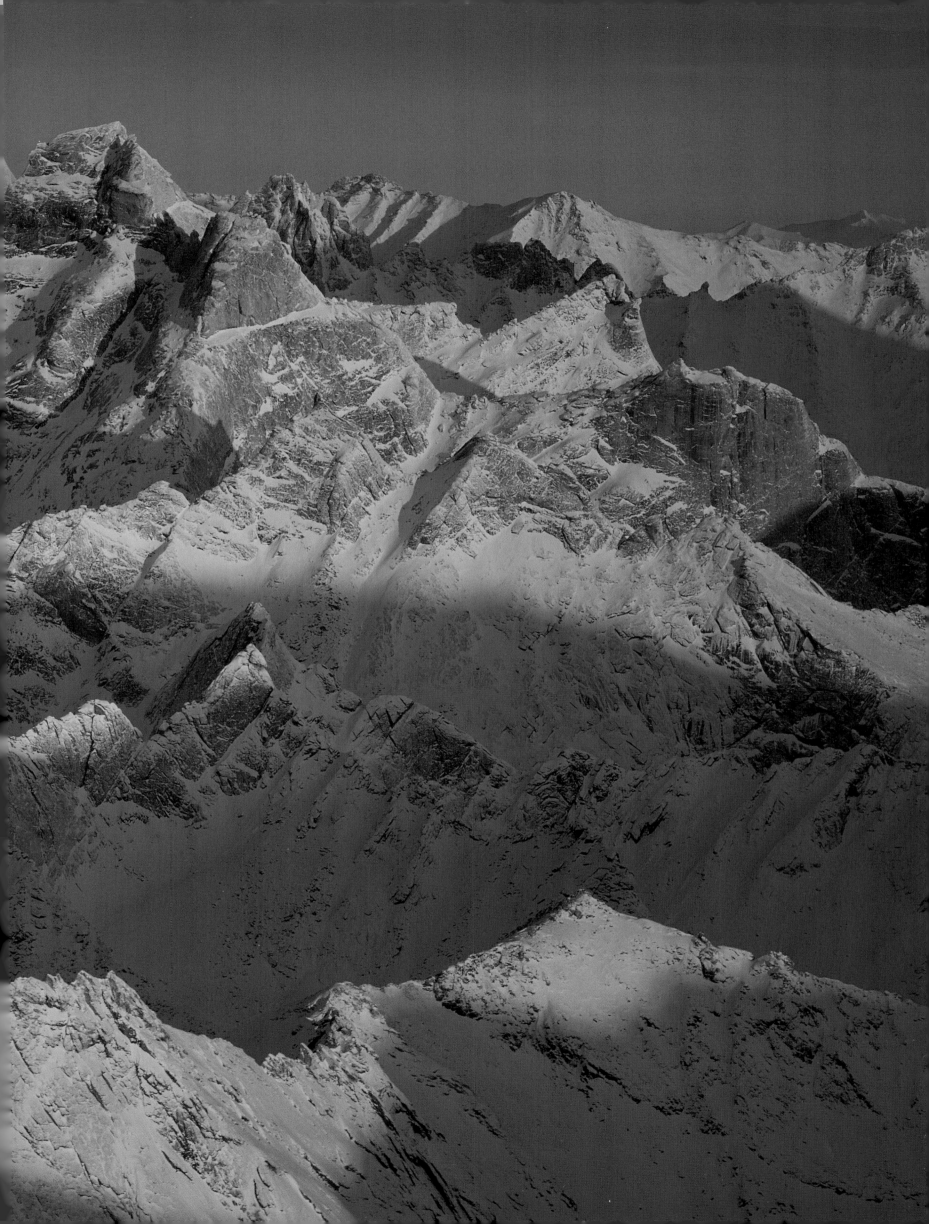

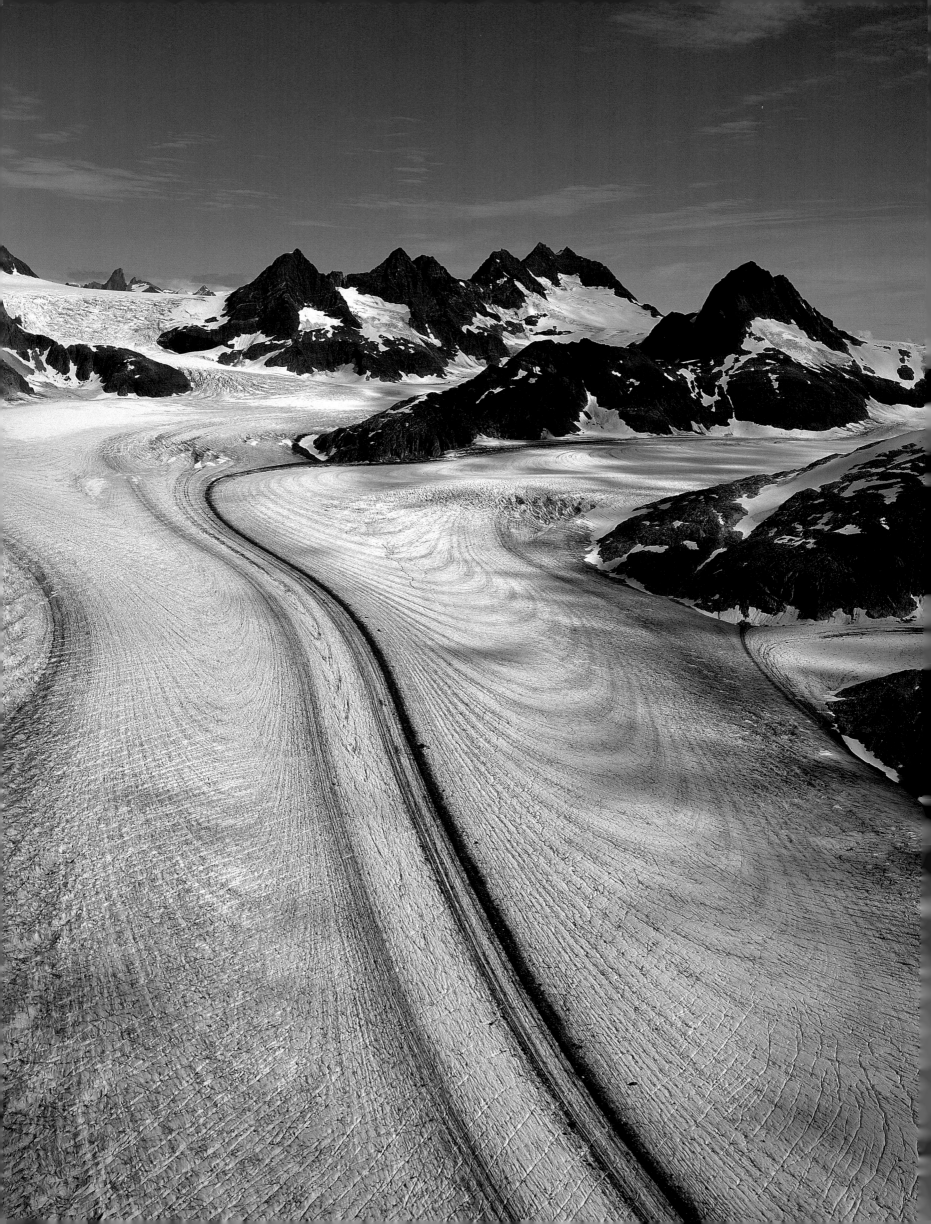

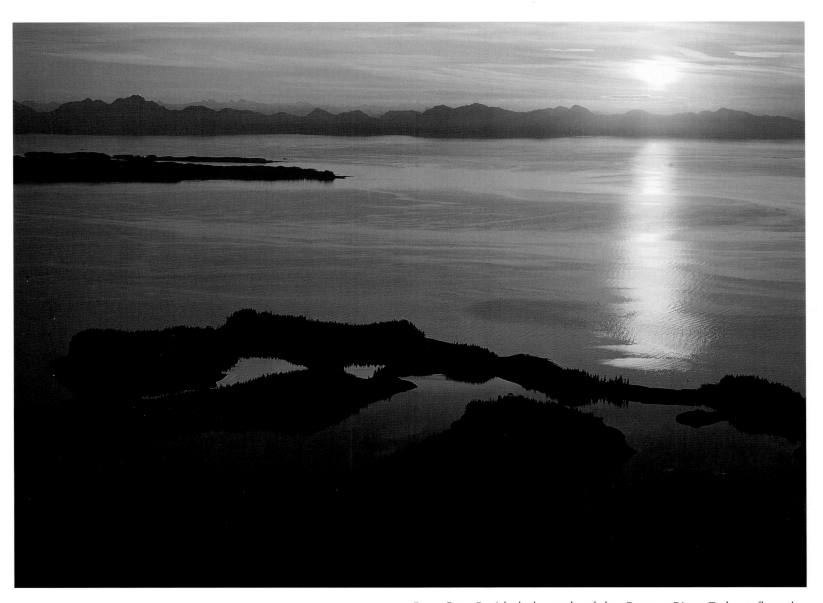

■ *Page One:* Braided channels of the Copper River Delta reflect the silver light of an afternoon sun. ■ *Frontispiece:* Waves from the open Pacific crash against islets off the stormy western coast of Baranof Island in Tongass National Forest. ◄◄ Sunrise in late winter illuminates the granite faces of the Arrigetch Peaks in Gates of the Arctic National Park. ◄ Dark stripes of glacial debris called medial moraines and ice waves called ogives mark the Herbert Glacier as it spills from the Juneau Icefield in Tongass National Forest. ▲ Shown here from above Montague Island in the Chugach National Forest, Prince William Sound encompasses more than ten thousand square miles.

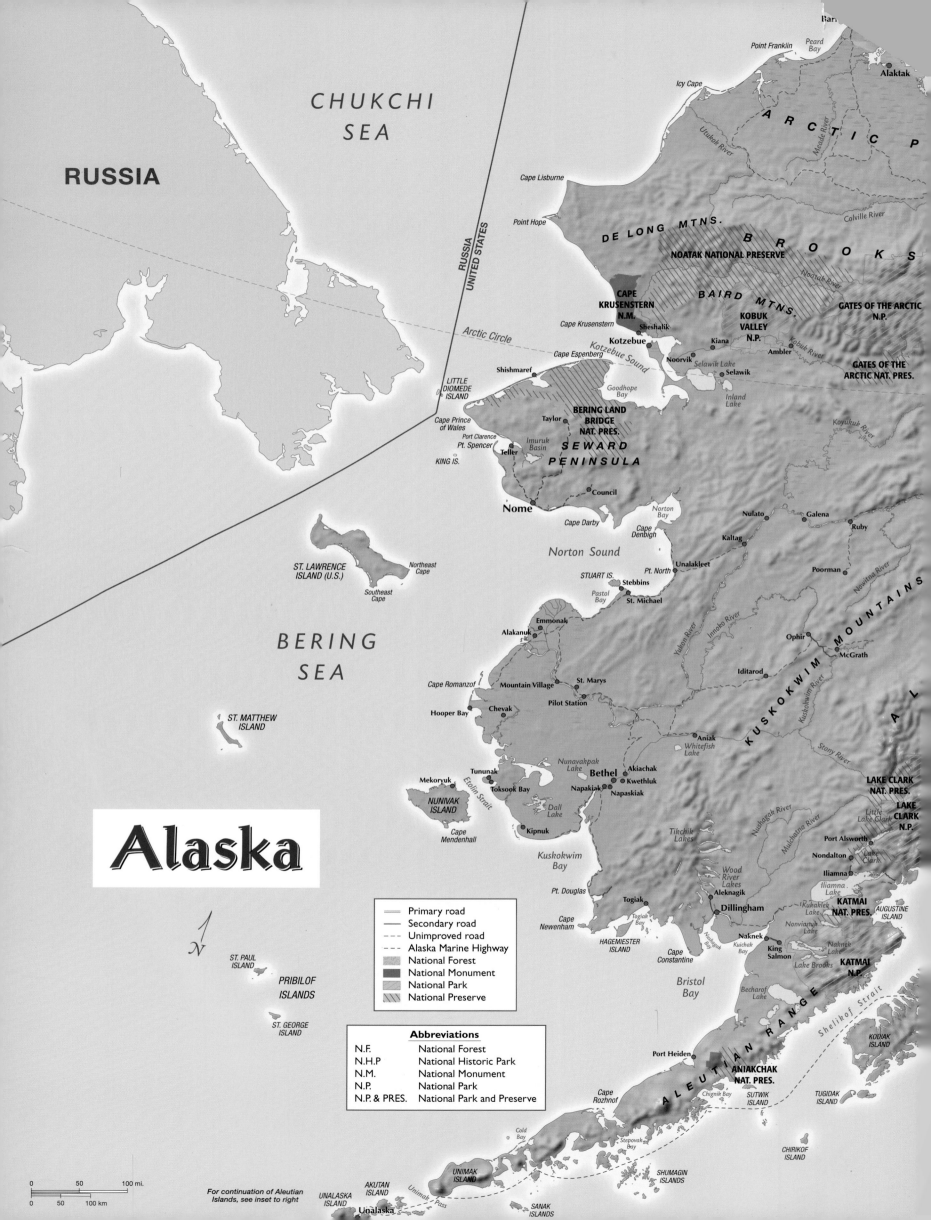

CHUKCHI
SEA

RUSSIA

Cape Lisburne

Point Hope

DE LONG MTNS.

NOATAK NATIONAL PRESERVE

Icy Cape

Point Franklin

Peard Bay

Alaktak

A R C T I C P

B R O O K S

Utukok River

Meade River

Colville River

CAPE
KRUSENSTERN
N.M.

BAIRD MTNS.

Noatak River

GATES OF THE ARCTIC
N.P.

Arctic Circle

Cape Krusenstern

Sheshalik

Kotzebue

Kiana

KOBUK
VALLEY
N.P.

Kobuk River

Ambler

GATES OF THE
ARCTIC NAT. PRES.

Cape Espenberg

Kotzebue Sound

Noorvik

Selawik Lake

Selawik

Shishmaref

LITTLE
DIOMEDE
ISLAND

*Goodhope
Bay*

BERING LAND
BRIDGE
NAT. PRES.

*Inland
Lake*

Koyukuk River

*Cape Prince
of Wales*

Taylor

*Imuruk
Basin*

SEWARD
PENINSULA

Port Clarence

Pt. Spencer

Teller

KING IS.

Council

Nome

Cape Darby

*Norton
Bay*

*Cape
Denbigh*

Nulato

Galena

Ruby

Kaltag

Poorman

Nowitna River

ST. LAWRENCE
ISLAND (U.S.)

*Northeast
Cape*

*Southeast
Cape*

Norton Sound

STUART IS.

Pt. North

Unalakleet

Stebbins

*Pastol
Bay*

St. Michael

Ophir

Innoko River

Yukon River

BERING

SEA

Emmonak

Alakanuk

Iditarod

McGrath

A L

KUSKOKWIM MOUNTAINS

ST. MATTHEW
ISLAND

Cape Romanzof

Mountain Village

St. Marys

Pilot Station

Hooper Bay

Chevak

Aniak

*Whitefish
Lake*

Stony River

Kuskokwim River

Tununak

*Nunavakpak
Lake*

Bethel

Akiachak

Kwethluk

LAKE CLARK
NAT. PRES.

Mekoryuk

Etolin Strait

Toksook Bay

Napakiak

Napaskiak

LAKE
CLARK
N.P.

NUNIVAK
ISLAND

*Dall
Lake*

*Tikchik
Lakes*

Little Lake Clark

Port Alsworth

*Lake
Clark*

*Cape
Mendenhall*

Kipnuk

Nushagak River

Mulchatna River

Nondalton

Iliamna

*Iliamna
Lake*

*Kuskokwim
Bay*

*Wood
River
Lakes*

KATMAI
NAT. PRES.

AUGUSTINE
ISLAND

Alaska

Pt. Douglas

Togiak

Aleknagik

*Kukaklek
Lake*

*Nonvianuk
Lake*

ST. PAUL
ISLAND

PRIBILOF
ISLANDS

*Togiak
Bay*

Dillingham

Naknek

*King
Salmon*

*Kuichak
Bay*

*Naknek
Lake*

Lake Brooks

KATMAI
N.P.

*Cape
Newenham*

HAGEMEISTER
ISLAND

*Cape
Constantine*

*Nushagak
Bay*

Bristol
Bay

*Becharof
Lake*

Shelikof Strait

KODIAK
ISLAND

N

| Primary road |
| Secondary road |
| Unimproved road |
| Alaska Marine Highway |
| National Forest |
| National Monument |
| National Park |
| National Preserve |

ST. GEORGE
ISLAND

*Cape
Rozhnof*

Port Heiden

ANIAKCHAK
NAT. PRES.

Chignik Bay

SUTWIK
ISLAND

TUGIDAK
ISLAND

Abbreviations

N.F.	National Forest
N.H.P	National Historic Park
N.M.	National Monument
N.P.	National Park
N.P. & PRES.	National Park and Preserve

ALEUTIAN RANGE

*Cold
Bay*

*Cape
Stepovak
Bay*

SHUMAGIN
ISLANDS

CHIRIKOF
ISLAND

0 50 100 mi.

0 50 100 km

*For continuation of Aleutian
Islands, see inset to right*

UNIMAK ISLAND

*Unimak
Pass*

AKUTAN
ISLAND

UNALASKA
ISLAND

Unalaska

SANAK
ISLANDS

ARCTIC OCEAN

BEAUFORT SEA

Photographs and Text © MCMXCIX by Fred Hirschmann
Book compilation © MCMXCIX by Graphic Arts Center Publishing®
An imprint of Graphic Arts Center Publishing Company
P.O. Box 10306, Portland, Oregon 97296-0306
503-226-2402

Library of Congress Cataloging-in-Publication Data
Hirschmann, Fred.
Alaska from the air / photography and essay by Fred Hirschmann.
 p. cm.
ISBN 1-55868-466-2
1. Alaska—Aerial photographs. 2. Alaska—Description
 and travel.
I. Title.
F905.H65 1999
917.98'0022'2—dc21 99-12329
 CIP

President • Charles M. Hopkins
Editorial Staff • Douglas A. Pfeiffer, Ellen Harkins Wheat,
Timothy W. Frew, Diana S. Eilers, Jean Andrews,
Alicia I. Paulson, Deborah J. Loop, Joanna M. Goebel
Production Staff • Richard L. Owsiany, Lauren Taylor
Designer • Robert Reynolds
Cartographer • Ortelius Design
Book Manufacturing • Lincoln & Allen Company
Printed and bound in the United States of America

CANADA

GULF OF ALASKA

ALEUTIAN ISLANDS

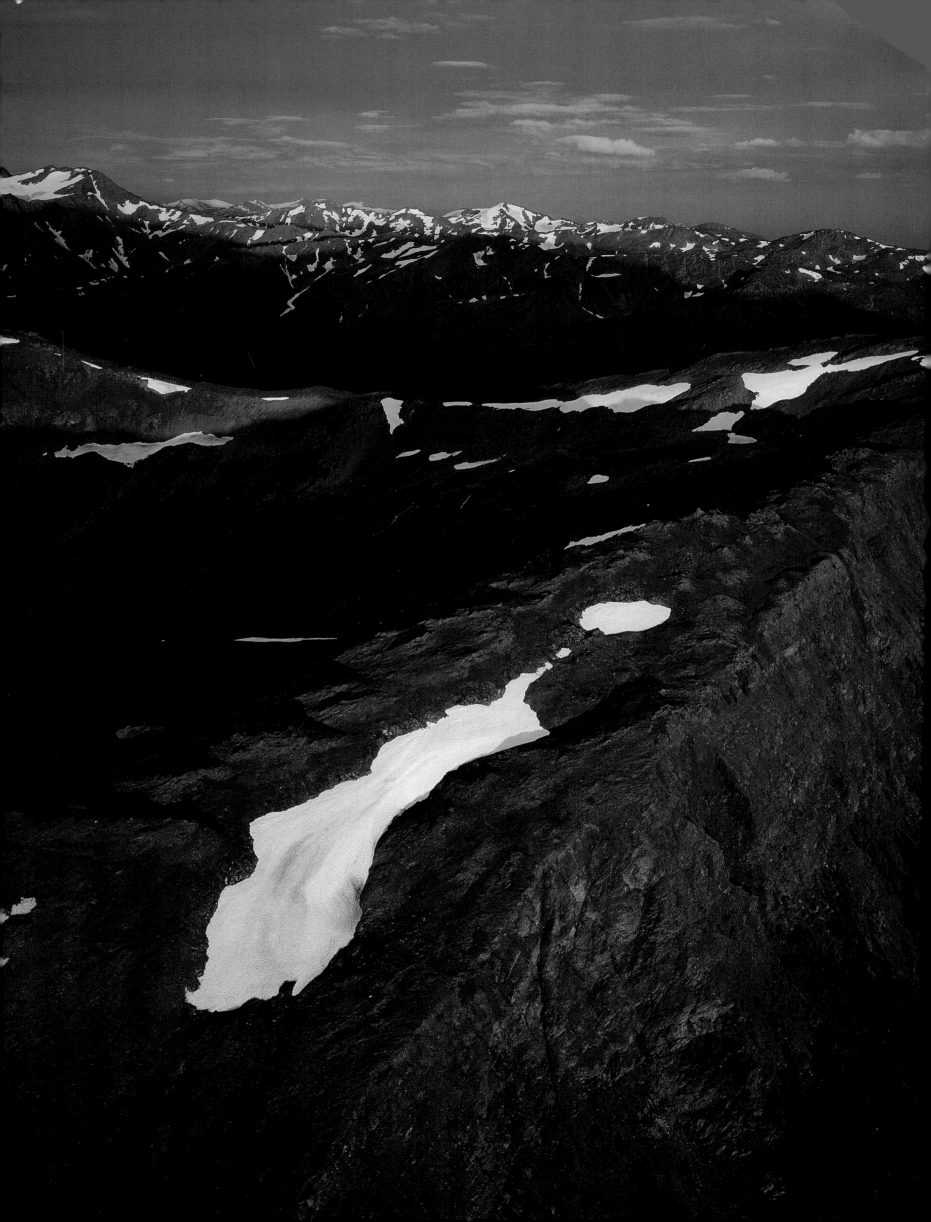

Every time I jump into a plane, cinch the seat belt, listen to the engine roar, and glide into the clean Alaskan air, I experience a deep feeling of exhilaration and excitement. You would think after hundreds of flights, flying over the Great Land would become mundane, sort of an Alaskan version of commuting to work. But exactly the opposite is true. Every flight offers me the opportunity to break free of earthly shackles and aerially explore the wild north country.

From the raven's-eye perspective provided by an airplane, Alaska appears incredibly vast. The state is huge, with a landmass equaling one-fifth the size of the Lower 48 states. Alaska has an estimated 47,300 miles of tidal shoreline, seventeen of the twenty tallest mountains in the United States, and tens of thousands of glaciers. As I fly along, a never-ending parade of designs and landforms piques my curiosity about what the country would be like to explore on foot. I think back to the three times I hiked across the Alaska Range. Memories of campsites perched below towering granite peaks, alpine meadows strewn with wildflowers, and pristine glacial lakes mingle with thoughts of bashing through seemingly impenetrable thickets of alders, finding steaming bear droppings in those same alders, fording icy glacial rivers, and searching for routes across crevasse-strewn glaciers. In twenty minutes of mountain flying, I can effortlessly soar above the country that took ten grueling days to traverse by foot. I wouldn't trade either perspective for the other—each is compellingly beautiful. Yet for people who don't have a lifetime to explore Alaska by foot, aircraft provide quick access to see some of Alaska's 365 million acres of spectacular mountains, glaciers, forests, lakes, and tundra.

The best way I've found to share the beauty of Alaska from the air—short of convincing people to hop on board a plane—is through photographic images. Time and time again, pilots have said to me, "I wish I had a camera along to capture the incredible scenery. I've never seen such perfect light." The low sun angles and crystalline clear air found in northern latitudes work wonders in painting the Alaskan landscape with spectacular light.

Even with such an astounding subject as Alaska, the key to obtaining this book's collection of aerial images was to be airborne as often as possible. And for that I have depended upon the cooperation of a legion of pilots who have helped me arrive at the right place exactly when Alaska's light worked its magic on the landscape below. All told, I spent more than five hundred hours airborne and flew with nearly one hundred aviators during the two years I spent taking the photographs for this book. I worked with many of the same fine folks I had flown with ten years earlier while photographing for *Bush Pilots of Alaska*. On that project and for this book, Alaska's aviation community soared with boundless enthusiasm, sharing with me their love of flying and great respect for the land passing beneath their wings.

In my twenty years as a photographer—working on fourteen books and countless other projects—I have never had an assignment where plans changed so often. In rural Alaska, people take in stride delays caused by aircraft mechanical problems, diversion of planes for medical emergencies, and a host of other reasons that change and delay bush travel. A couple of times I was bumped for loads of freshly caught salmon needing express delivery to canneries. Once, I forlornly watched a case of badly needed disposable

◄ *Beneath storm clouds, Thunder Mountain and Heintzleman Ridge are bathed in the warm reddish light of the setting sun. Located between the Mendenhall Valley and Lemon Creek, this portion of the Tongass National Forest is a favorite area for hikers from the capital city of Juneau.*

diapers fill my window seat on a Cessna 206 heading to Prince William Sound.

But, by far, the biggest factor impeding work on the book was Alaskan weather. Fine photography, like fine flying, requires decent weather. In my first summer on the project, Alaska was so dry and hot that it seemed the entire state was on fire. A walk across normally spongy wet tundra sounded like the crackling of crispy potato chips. Well over one million acres burned, creating grayish brown smoke that lingered for months. On a seven-hundred-mile flight from Kodiak to the Russian border, the only time we broke free from smoke was over the Diomede Islands in the Bering Strait. The entire state was under a big high pressure system, and even though flight stations reported VFR (visual flight rules) conditions, visibility was rarely more than a few miles in smoke. One of the most amazing fires we saw was burning while we flew up the Ruth Glacier below Mount McKinley. Lightning strikes from dry thunderstorms ignited spruce and willow scrub growing on till covering the glacial ice. It was the first time I had ever heard of a glacier burning!

As if summer smoke were not trouble enough, once winter came, a strong El Niño kept Alaska cloudy for weeks on end, adding to my difficulty in getting good aerial images. One pleasurable benefit of El Niño, however, was that when I opened airplane windows to take photographs, the outside winter air temperature was often ten degrees Fahrenheit above zero rather than the twenty-five degrees Fahrenheit below zero that typifies winter flying in Alaska. Most pilots don't like me opening the window when temperatures are so frigid.

My second summer on the project was also hampered by weather as El Niño conditions continued to prevail, cloaking most of Alaska in continual clouds and rain. I waited days and days on the ground for the weather to break. During one stretch, I spent twenty days at the Bettles Lodge north of the Arctic Circle while wind, rain, and fog obscured the nearby Brooks Range. Every morning I awoke, looked out the window, and shook my head at the foulness of the weather. With little else to do, I became quite adept at bussing tables, washing dishes, and fixing Bettles Lodge hoagies for a handful of hunters and pilots who were also stranded by poor weather. The reward for waiting out these storms, however, was that when they finally broke, the clarity of the air and quality of the light were often spectacular. Prolonged rains clear the air of impurities.

Another side benefit of being weather-bound was that it gave me the opportunity to do plenty of "hangar flying," sitting in the lodge and listening to amazing tales of Alaska aviation as told by the seasoned pilots who have flown these skies for years. Bettles is a crossroads of aviation in Alaska's Arctic. In the middle of a seemingly endless expanse of spruce forests, tundra, and mountains, the village is an aviator's refuge, a port in the storm, with plenty of fuel, food, hot coffee, good company, and cozy beds. A helicopter pilot flying emergency repair parts to Prudhoe Bay may share a dining room table with a park ranger who has just flown wolf surveys in Gates of the Arctic National Park. The camaraderie of these rugged individuals becomes apparent during evenings when beer is flowing and stories get rolling. While we all patiently waited for better flying weather, the pilots shared with me tales of the rising of square moons, Saint Elmo's fire dancing on propeller tips, arctic mirages causing village lights to appear to shimmer high above the horizon, and other stories of Alaskan aviation phenomena.

▲ Summer lightning storms ignite many wildfires, including this blaze near Timber Creek in western Alaska.
▶ The 10,197-foot Redoubt Volcano rises above the Chigmit Mountains and Crescent Lake in Lake Clark National Park. Redoubt's last explosive activity occurred during 1989 and 1990.

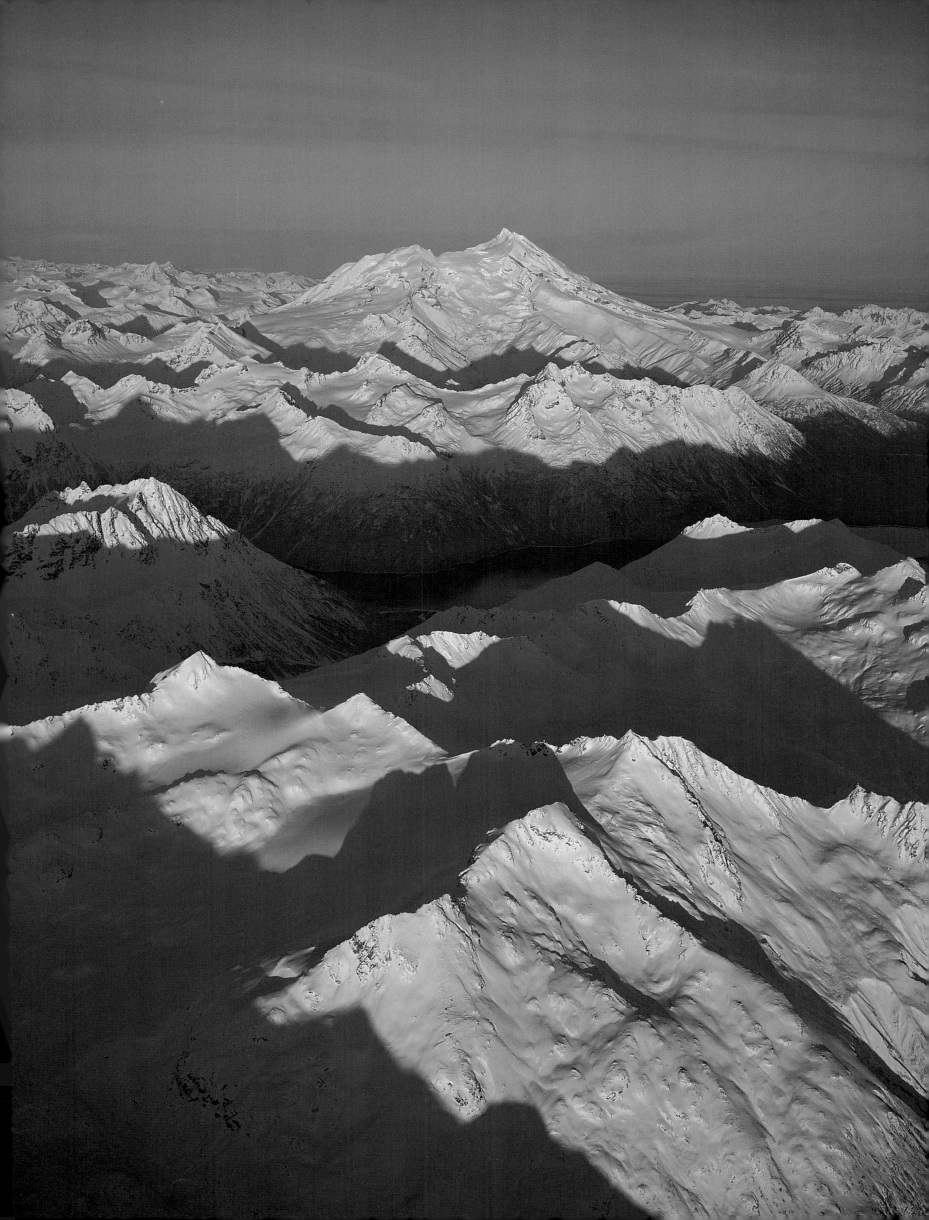

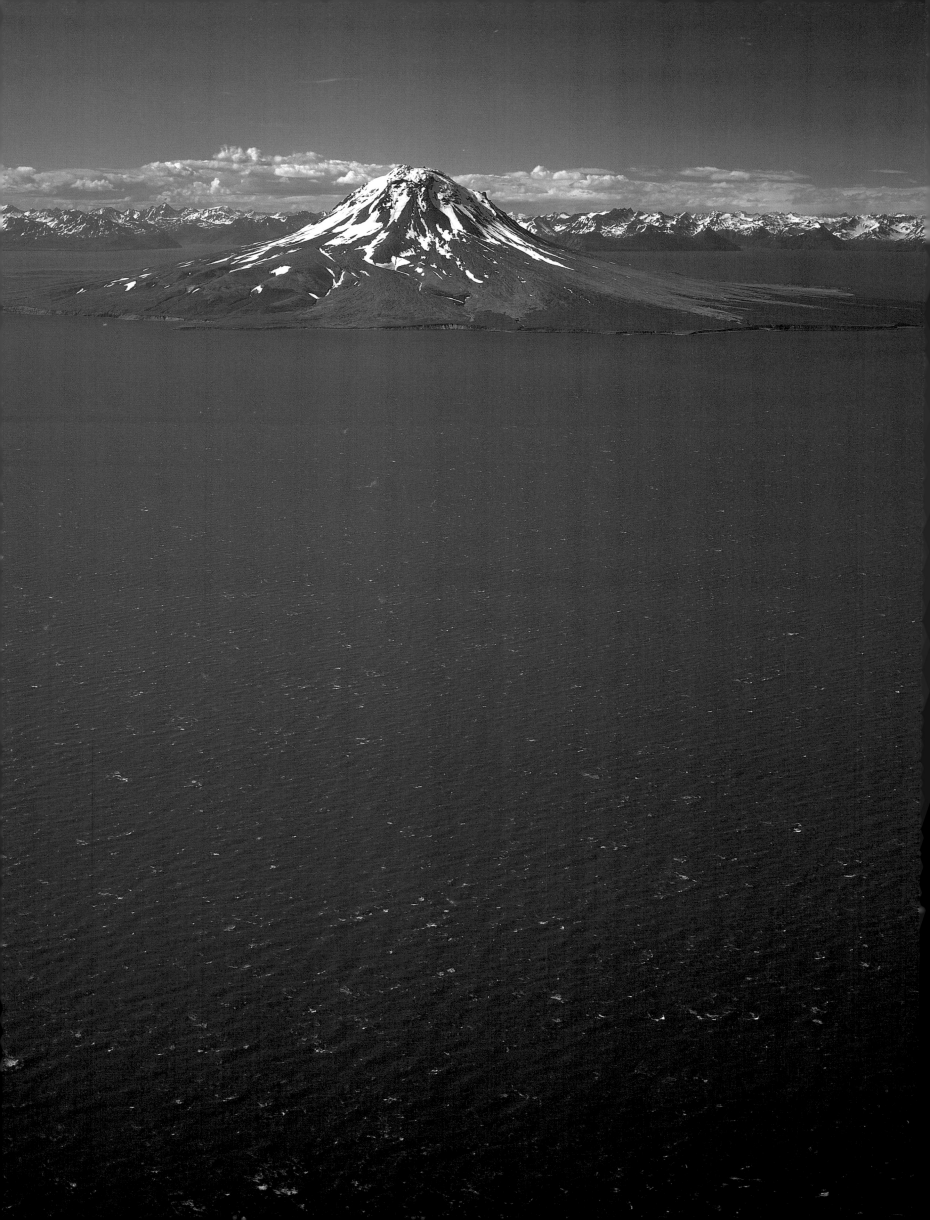

These pilots and their colleagues across the state represent the oral historians of a modern-day bush Alaska. Their lives are embedded in the very fabric of human existence throughout the Far North. They are folk heroes who unite remote villages by safely delivering loved ones, mail, and needed supplies to a country where roads are few and far between. They are my friends who helped make this book happen.

* * *

As the saying goes, "Where the road ends, the real Alaska begins." Alaska's immense size, rugged landscape, remote setting, and small population result in the state having very few roads—just eleven numbered highways to be exact. So when Alaskans need to travel around the Great Land, simply out of necessity, they fly. For 70 percent of the state's villages the only easy access is by air. Children growing up in rural Alaska are likely to understand the workings of airplanes long before they have had much experience with automobiles. A youngster will regularly jump into a plane to head to a basketball game halfway across the state, fly to the family's summer fish camp on a nearby lake, or go to an urban dentist for a checkup. For many kids, an airplane's yoke and rudder pedals are more familiar than a car's steering wheel.

It is not uncommon for Alaskan youngsters whose folks are pilots to learn how to fly before they are teenagers. In the mountains surrounding Lake Clark on the Alaska Peninsula, pioneering bush pilot Babe Alsworth taught his four boys the workings of ailerons and elevators at the same time they were learning the four R's—reading, 'riting, 'rithmetic, and religion. All the boys began taking flying lessons when they were twelve years old. Babe's youngest son, Glen, who now runs Lake Clark Air Service, explains: "What was most striking to me was that people were surprised that we were flying as kids. To all of us youngsters, it was just like learning to drive the family pick-up truck or tractor. We spent a lot of time in airplanes because that was how we lived. In the old days, our Taylorcraft [a single-engine, tail-dragging plane] was the ATV of that era. It was a fast, efficient way to get somewhere that you needed to go. Plus it was a lot of fun to fly!"

By the time he was well into his eighties, Babe had taught another generation of Alsworth children to become one with an airplane. According to Glen, Babe used to say, "I'll teach you to take off and land safely, and all the skills in between I want you to develop on your own." Babe believed that to be a truly accomplished pilot, you had to learn to interpret the workings of an airplane for yourself. As a result, each of the Alsworth boys has developed his own flying style. Bee, for instance, is very adept with his hands and thoroughly enjoys repairing airplanes. When flying, he has an inner view of how every part in the airplane works. Glen, on the other hand, says he is not really mechanical, but likes thinking about numbers and performance figures. His analytical mind allows him to easily adapt to an instrument-flying environment. Babe's flying lessons seem to have paid off: the family now has seven licensed pilots in its ranks, including grandsons who fly commercially for Alaska Airlines, PenAir, and the National Park Service.

Not only does Alaska have generations of flyers who have learned how to fly simply out of necessity, but the state is a magnet for aviators from the Lower 48 states who wish to experience Alaska's unpolluted air and vast expanse of wild country. Controlled air space is minimal above this great Far North land. Pilots have their choice of more than three million lakes on which

◄ *Situated in Kamishak Bay, Augustine Volcano, at 4,025 feet, is the youngest but most active of the Cook Inlet volcanoes. Augustine has erupted in ash, lava, and pyroclastic flows seven times since Captain James Cook discovered it in 1778. Subduction of the Pacific Plate beneath the North American Plate helps fuel Augustine's fires.*

to land a floatplane. For tail-dragging airplanes equipped with large, balloon-like tundra tires, countless gravel bars, beaches, and tundra-covered hills make suitable landing locations. There is such a paucity of navigational aids and landmarks across the state that many bush pilots jokingly refer to "IFR," not as "instrument flight rules," but as "I follow rivers."

The freedom of flying in Alaska coupled with the necessity of using aircraft to reach so much of Alaska's otherwise inaccessible country has made Alaska the most flying-oriented state in the union. Alaska has 9,488 licensed pilots—one out of every fifty-eight state residents—which, per capita, is six times the number of pilots found in the rest of the United States. There are also 9,749 aircraft registered within Alaska, which is fourteen times the average number of aircraft found per capita in the remaining forty-nine states.

In Alaska's urban areas, it is not unusual for people living in subdivisions to have access to private airstrips and floatplane-size lakes. For the luxury homes surrounding Anchorage's Campbell Lake, two cars in the garage and a Cessna 185 and Super Cub tied to the dock is often the norm. A couple of miles to the north, Lake Hood is the world's most active seaplane base, with more than eight hundred takeoffs and landings daily during busy summer weekends.

Alaskans just love to fly. Inupiat Eskimo pilot Ellen Paneok waxes poetic when she says, "I'm helplessly romantic about flying." Ellen learned to fly when she was sixteen—two years before she earned a driver's license. Since then, she has flown twelve thousand hours working for a half-dozen air taxi companies based in Bethel, St. Marys, Kotzebue, Barrow, Anchorage, and Kenai. Now an inspector with the Federal Aviation Administration, she uses her years of bush flying experience to promote aviation safety.

Ellen recently flew through Telaquana Pass, a narrow defile through the rugged Alaska Range in the northern part of Lake Clark National Park and Preserve. "Flying through Telaquana Pass is like being in a virtual-reality video game," she explains. "All around you are towering mountains and beautiful glaciers, and as you go through the pass, things start to happen really fast. No sooner after turning left, you are turning right. As you go around each corner, a brand-new landscape appears, completely different from the one you just left. It's just fantastic flying!"

Alaska flying enthusiasts come from all walks of life. Medical doctor George L. Stewart was introduced to flying as a six-year-old in Massachusetts when a barnstorming pilot—complete with leather jacket and aviator's goggles—took him up in an open-cockpit biplane. That exciting flight planted a seed that germinated decades later when George was in his fifties with an Alaskan medical practice. He had enjoyed flying with bush pilots during the 1960s while working for the Public Health Service in Bethel. Eventually the opportunity presented itself for him to earn his private pilot's license. He became active with the civil air patrol, became a flight instructor, and bought a 1948 Stinson 108-3.

Today, George is totally enamored with flying and takes great pleasure in sharing his love of exploring Alaska by air with children and adults. "Everyplace you fly in Alaska has a different kind of beauty, a different personality. I must have flown up the Ruth Glacier toward Denali thirty or forty times, yet I still get shivers up my spine every time I go," says George.

Recently, George took a visiting colleague from San Diego on a plane ride from Anchorage, down the Kenai Peninsula to Seward, and then back to Anchorage. "It was one of those incredibly clear days that allow you to see forever," says George. "At the end of the

▶ *A veneer of alpine tundra greens the Chugach Mountains between the Matanuska and Nelchina Glaciers. By late summer, most snow patches have melted from the lower mountains.*

16

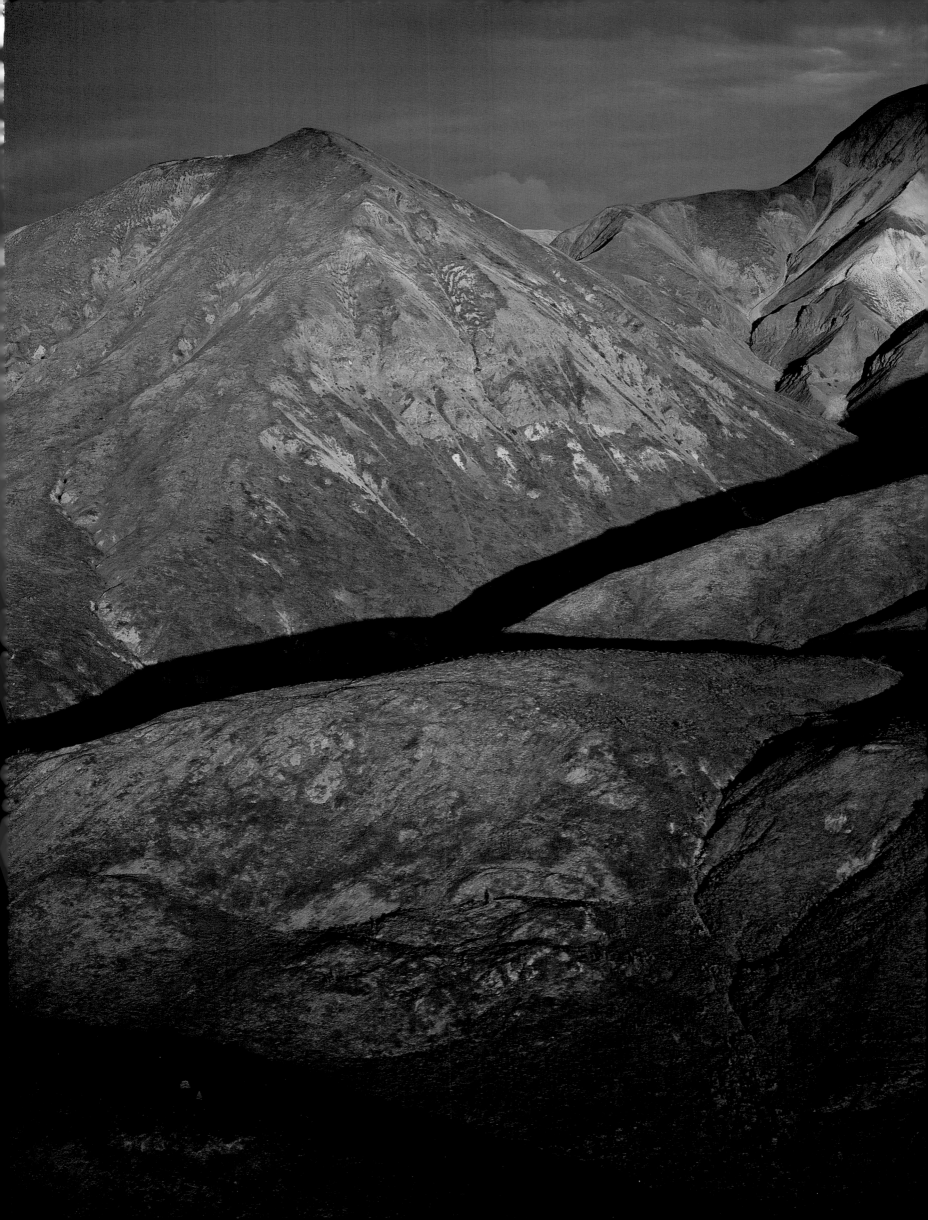

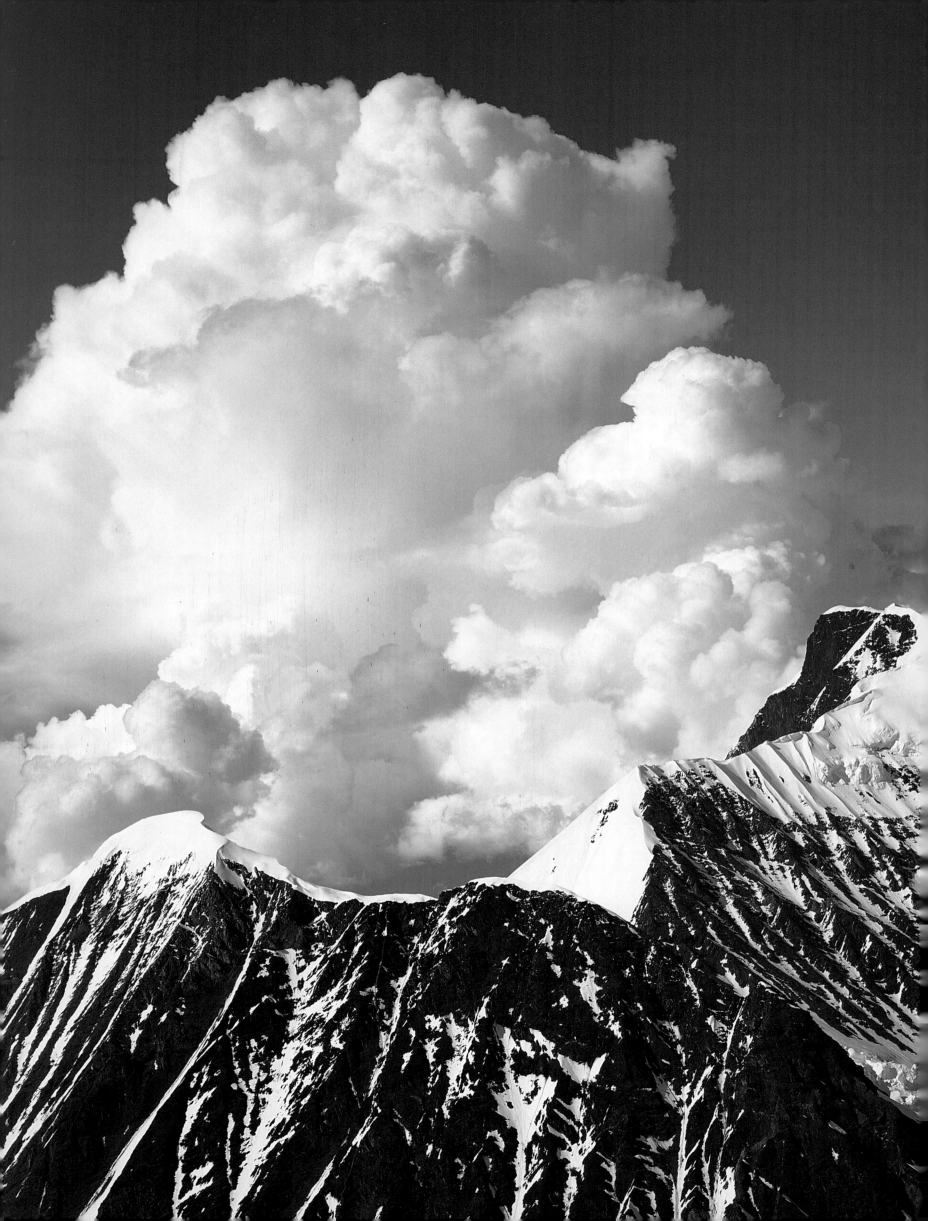

day, we were heading toward the Kenai Mountains, and everything was lit up a glorious gold by the setting sun. My friend turned to me and said, 'The only thing Alaska is guilty of is sensory overload.' It was nearly impossible for the senses to absorb so much magnificence."

Bill Dorman, another professional who loves the freedom of the skies, spends most of his piloting hours in the cockpit of an American Airlines Boeing 767 heading from Chicago to Europe or South America. "When I'm on a zillion-hour flight from Europe back to the States, I can't wait to get my airline flight done so I can head home to Alaska, hop in my Cessna 185, and rid myself of the superinsulated, overregulated world of corporate America," says Bill. He likes to share the beauty of Alaska with visitors by taking them on personalized aerial tours of the Great Land. Bill's passion is landing his floatplane on some remote pond. "Every time I fly, I see something different," says Bill. "The way the wind, sunlight, clouds, and the change of the seasons interact provides a feast for the senses. It's really fantastic seeing how people react to the experience of flying across Alaska in a small plane. My airline job pays good dollars, but it's not soul-gratifying, like flying in the bush."

Lori Egge, Bill's Alaskan boss for the flightseeing tours, once spent countless hours behind the controls of her Cessna 185 tightly circling spawning herring. Fish spotting was her former profession, a dangerous line of work in which a pilot and a spotter jockey with scores of other planes as they try to lead their fishing boats to set nets on the largest herring schools. Flying to fishing grounds off Togiak, Sitka, or a dozen other points gave Lori time to marvel at Alaskan landscapes and dream about starting a business where she could share the splendors of Alaska with others. So in 1992 she created Sky Trekking Alaska, a flying service specializing in providing custom aerial tours of the bush. Now she transports visitors in her 1943 twin-engine amphibious Grumman Super Widgeon.

"The joy I have with an airplane is the freedom to go wherever I want," says Lori. "Flying provides access to those intimate places where the beauty of wildlife and nature just reaches out and touches your soul. The country is so enormous and so diverse that I could spend a lifetime flying here, and every time I go I'll find something new."

This past summer, one of Lori's sky treks included a crossing of Prince William Sound. "The Sound was more beautiful than words can describe," Lori remembers. "Tidewater glaciers, a rocky shoreline, and deep-water inlets filled with seabirds, whales, sea otters, and porpoises: the landscape and scenery were truly intoxicating.

"After crossing the Sound, we headed to a glacial tarn nestled high in the Chugach Mountains. Up a deep, narrow valley we flew to a lake with surreal turquoise waters. A bowl of towering three-thousand-foot granite cliffs surrounded the lake. At one end of the lake was a white sand beach with scores of boulders left by the ancient glacier that had carved this wonderful place. The other end of the lake had a breathtaking two-thousand-foot waterfall. The guys I had on board had never seen anything like it. We were in an unworldly place. One fellow, a photography and geology professor from Texas, had been to Alaska twenty times and had never seen a comparable landscape."

The fact that so many Alaskan visitors thoroughly enjoy viewing the state from the air is borne by statistics showing that more than one hundred thousand people a year buckle up in light aircraft and go on Alaskan flightseeing tours. Surveys conducted by the Alaskan Division of Tourism consistently show that flightseeing

◄ *An afternoon convection of warm, moist air rising over peaks of the Alaska Range creates a cumulonimbus cloud above Denali National Park. Thunderstorms are common during summer in the Interior of Alaska.*
▲ *Lori Egge flies over the Talkeetna Mountains in Sky Trekking Alaska's 1943 Grumman Super Widgeon.*

is the top-rated activity for overall visitor enjoyment. Watch any group of passengers debarking from a flightseeing trip, and you are bound to see ear-to-ear grins and hear enthusiastic chatter extolling the fantastic scenery. Who wouldn't be enthralled by views of peaks that seem to go on forever, vast rivers of ice snaking through those mountains, and the incredible grandeur of Mount McKinley? Alaska is blessed with tens of thousands of glaciers, nineteen peaks over fourteen thousand feet, and more than eighty volcanoes, with forty being historically active. Flightseeing is a great way to experience the magnificence.

In the visitors' log for commercial flightseeing operator Denali Air, guests are encouraged to write comments about their flights to the 20,320-foot face of Mount McKinley. The compilers of *Roget's Thesaurus* could use the logbook to research their newest edition. Words such as "magical," "fabulous," "phenomenal," "sensational," "stupendous," and even "orgasmic" are often repeated to describe the flights, along with more creative responses, such as "Brilliant—yehaa!!!" "Way awesome," "Stairway to heaven," and "Gorgeous beyond words." The superlatives go on and on. In fact, the only negative comment appearing in more than a hundred pages of positive affirmations came from one fellow grousing about some turbulence causing him to toss his lunch. (His cheeseburger had cost him $8.95 at Alaskan prices!)

After a full day of flying "the Mountain," Denali Air's pilots engage in a bit of hangar flying. "It's amazing the emotions flying brings up in people," says pilot Paul Proulx. "It's not at all unusual to have passengers crying." "And those aren't tears of fear, but tears of joy," chimes in chief pilot Jim Morgan. Pilot Ron Purdum, who left behind twenty-three years as a homicide detective in New York City to become a mountain flyer in Alaska, agrees: "We have a lot of people who are absolutely scared to death of flying in a small plane next to the huge mountain. A husband and wife may start a flight clutching each other's hands. But by the time they get back, they say the flight was the best thing they've done in their entire lives. Being up close to that mountain, people are just awestruck. If God exists, this is where I think he lives."

Across Alaska at the northern end of the Panhandle, Paul Swanstrum, a pilot for Mountain Flying Service, delights in providing aerial tours of Glacier Bay National Park. In a ski-equipped Cessna 185, he departs Haines and seeks out gently sloping glaciers and snow-packed ridges on which to land guests. "Ninety-five percent of the people we carry say that the flight over and into Glacier Bay National Park was the highlight of their trip to Alaska," says Paul. "Some say it's the highlight of their life. I had a fellow from Spain who told me after an hour-and-a-half flight, 'I can die now.' A couple from East Berlin arrived in our office, and the woman told me that all her life she'd wanted to see America's national parks, but she'd been locked behind the Iron Curtain. She was only able to speak broken English, but she conveyed to me that now that the Berlin Wall had come down, this was her first opportunity to leave Eastern Europe. In her sixties, she felt too old to see America's backcountry by hiking, so flightseeing was her way to experience the land. When she returned from the flight, her eyes were filled with tears, and I had a sense of how important seeing Glacier Bay from the air had been for her."

The beauty of Glacier Bay moves many people to tears. One fall afternoon, Sam Wright, a Wings of Alaska pilot, was flying a thirty-year-old mother of two over Glacier Bay as the low sun illuminated the bottom of a rainsquall. "There was a double rainbow that was

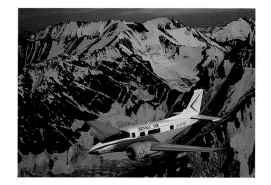

▲ *Denali Air's Beech 18 provides a flightseeing tour of Denali National Park.*
▶ *West of McCarty Fjord in Kenai Fjords National Park, a ridgeline pokes through the glacial ice and snow of the Harding Icefield. Such peaks, with all but their very tops encased by glaciers, are called nunataks. The Harding Icefield covers nearly three hundred square miles, with ice up to a mile thick.*

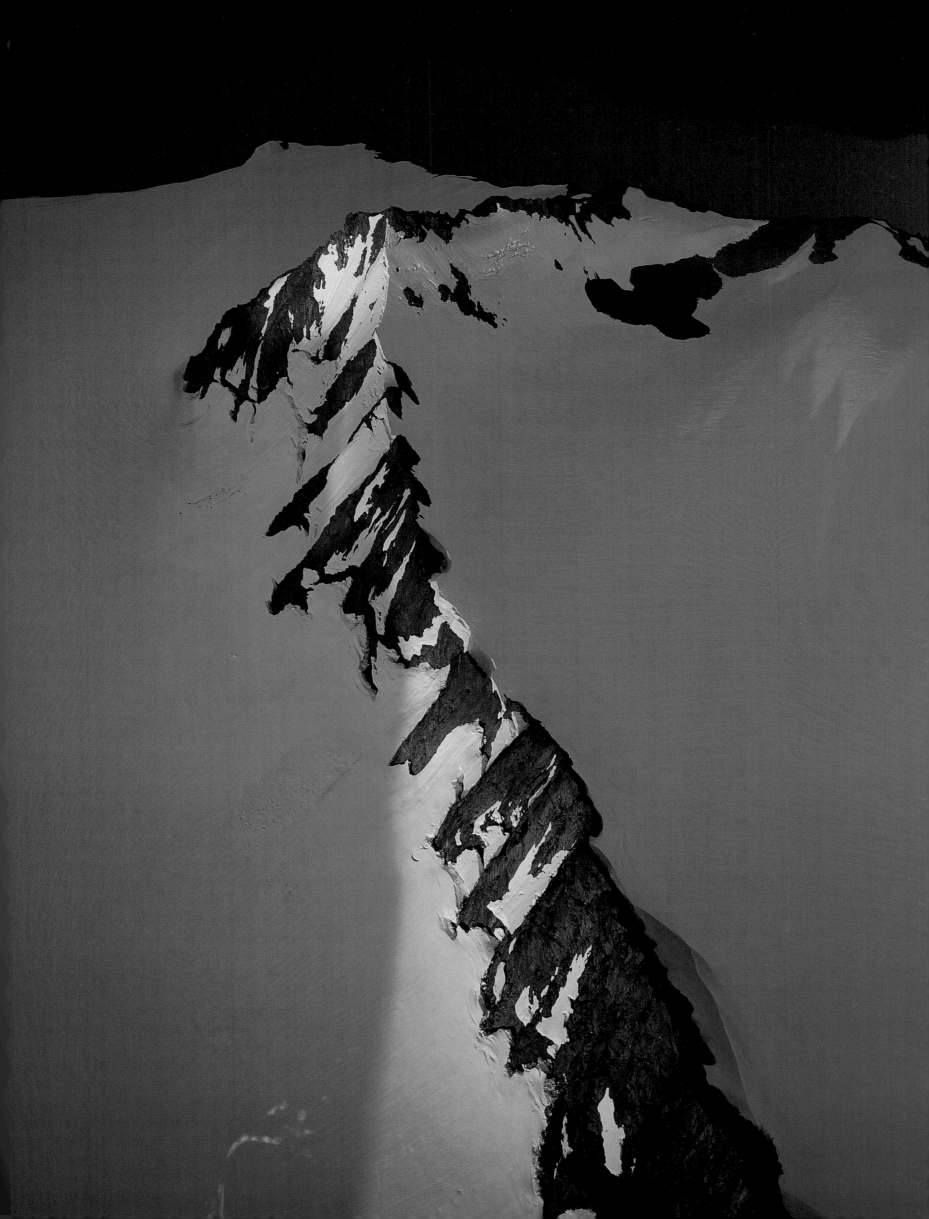

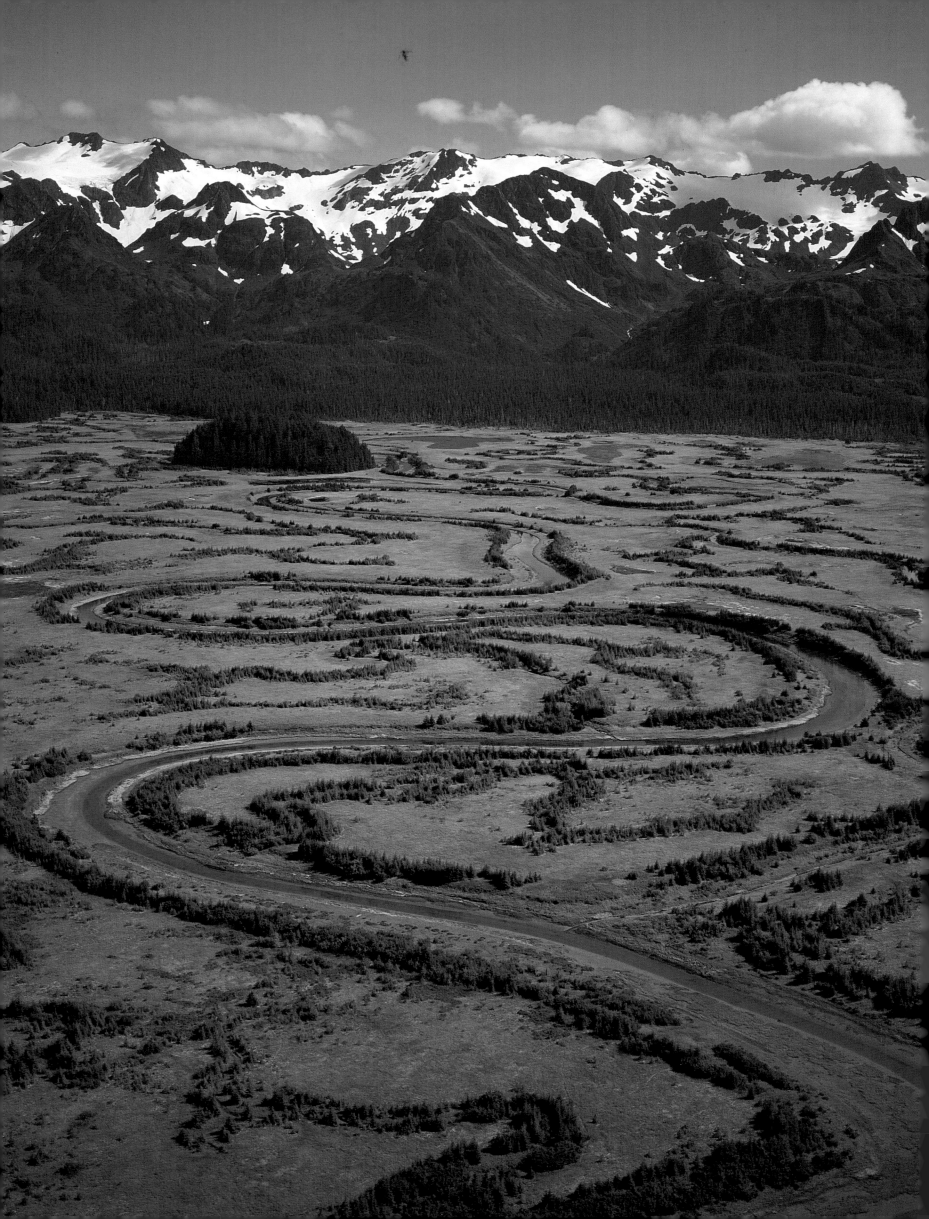

so beautiful and brilliant it looked like a neon sign," says Sam. "My passenger quietly started crying. After the flight, I asked her why she was in tears, and she said she was just moved by the 'beauty of the rainbows.'"

* * *

Alaskan pilots log well over a million hours of flight time each year. That represents a lot of time looking out airplane windows. Alaska Coastal Airways pilot Todd Hayes spent twenty years behind the stick of helicopters and another six years at the yoke and rudder pedals of fixed-wing aircraft. He says, "Alaska's an awfully pretty place to be flying. I like the sensation of always sailing over the ground. From an aircraft's vantage point, it's like watching a moving picture show. I fly along and let the world go by. Then boom, there's something interesting to see."

With so many hours spent in Alaskan skies, it is inevitable that pilots and passengers alike witness many unusual things, including amazing atmospheric and light phenomena. Without exception, pilots who talk about winter flying in Alaska tell wonderful stories about watching the northern lights. Alaska is an aurora-lover's dream because of the frequency of displays. In the upper latitudes of the state, especially those from Fairbanks north, auroras, or northern lights, are present during most dark nights. The degree of auroral activity depends upon how much solar wind (eruptions of ionized particles emitted by the sun) is funneled by the earth's magnetic field into the uppermost atmosphere. In the highly rarefied air, these particles strike single atoms of oxygen and molecules of nitrogen, producing brilliant displays of green, red, and lavender light. The bottoms of auroral curtains come within about sixty miles of the earth's surface. Although the bands of northern lights often appear to pilots to extend down to the horizon, the shimmering lights are always much higher than where planes are flying.

Observers of the sun have long recognized eleven-year cycles of increased sunspot activity, with the year 2000 being a peak activity year. Sunspots (darker, cooler areas on the surface of the sun) often trigger solar flares that produce huge streams of ionized particles. If such a flare points toward earth, it is likely that one to two days later the earth will experience greatly increased auroral activity. During these disturbances, called magnetic storms, northern light displays intensify, shift south across Alaska, and are often seen in the Lower 48 states. The night sky dances with lights, pulsating veils that captivate observers.

An ideal spot from which to view such performances is the cockpit of an airplane. For years, Bill Post flew out of the North Slope village of Kaktovik. He has since traded the "20/20" weather (twenty degrees below and a twenty-knot wind) of Alaska's Arctic for the rainforests of Southeast Alaska, where he now flies for Taquan Air. "The northern lights were most incredible up there," Bill says of his time in the Arctic. "They were so vivid, constantly changing in shape and intensity. There's so much darkness in winter. Northern lights really helped to break up monotonous flights."

On the arctic coastal plain, the land is predominately flat, with only pingos (mounds of ice covered with tundra) and low bluffs breaking the level ground. "Pilots don't need to worry about maintaining terrain clearance," comments Bill. "All the big obstacles are far away, so pilots can keep to a specific altitude and simply fly a heading to their next destination. That's when you can dim the cockpit lights to watch the aurora. You're up there all alone,

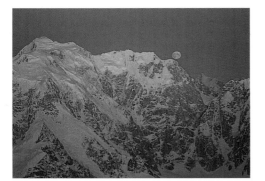

◄ *Outlined by Sitka spruce, Martin River Slough meanders through flats created by sediment deposited in the Copper River Delta. This entire area was uplifted by the 1964 earthquake.*
▲ *Its appearance slightly distorted by a temperature inversion, a full moon rises beyond the flanks of Mount Hunter in Denali National Park.*

center stage, and the only one in the auditorium enjoying your own private light show. If you were outside on the ground, the cold and wind would be so distracting that you could watch the lights for only a few minutes. But in the warm cockpit, you can watch the lights for hours."

Every Beech 1900 pilot of the now defunct MarkAir that I interviewed had at least one poetic story of climbing above twenty thousand feet on a winter night, dimming the cockpit lights, sitting back, and absorbing a great northern lights show. "One night I was flying from Kodiak to Anchorage at about twenty-two thousand feet," remembers Larry Zuccaro, who now flies for Kenai Fjords Outfitters. "It was one of those crystal clear nights when you can see the lights of town about a hundred miles out. A small cloud above Anchorage reflected the orange city lights like a Halloween pumpkin. Much farther out, but right in line with Anchorage, was the most vivid, concentrated band of northern lights I had ever seen. It looked like the aurora was being emitted from right above Anchorage."

Ellen Paneok, who also used to fly for MarkAir, reaches deep into her Inupiat heritage to discuss the northern lights and flying. For years she flew to the North Slope villages from Barrow. "Sometimes I'd be flying along, and the northern lights just went bananas. The sky became totally alive," says Ellen. "To me it was like sitting front row center for some of the most amazing sights I've seen in my life. There were shows where the northern lights were like curtains going from one side of the sky to the other. And other shows where they blinked on and off or pulsated. During exceptional light shows, I've seen the sky filled with dazzling greens, yellows, pinks, reds, and lavenders. On very rare occasions, the night sky was blood red. Those displays were really eerie, but also really beautiful. Looking at such an incredible phenomenon, I can't fathom the immensity of the universe or what huge powers must be out there that are so much bigger than me. Here I am, just a speck of blinking red and green lights flying along in the inky darkness of the high Arctic.

"Sometimes when I'm flying alone watching the northern lights, I think back to what my great-grandfather from Barrow told me. 'You're not supposed to go out and keep watching the northern lights,' he said. 'You can glance up at them every so often, but if you stare at them too long, the northern lights spirits will take your head and play ball with it.'"

Ellen explained that there was a good reason for the Inupiat not to keep staring at the northern lights. If a person were out driving a dog team across the snow, he could become mesmerized by the lights, get dizzy, and fall off the sled, or he might become disoriented and lose his sense of direction. "When flying in the dark, pilots often see a single band of northern lights rising at a low angle to the horizon, and they unconsciously turn their airplane to follow the false horizon created by the band, putting the plane into a skid. You don't think you are turning, but you actually are," she notes. "When the northern lights really start going wild, I remember what my great-grandfather said and make sure not to become mesmerized by them. Some people might think that's laughable, but I think it's good advice."

Ellen continues: "My great-grandfather also talked about how, in the old days, guys might get 'kayak fever.' They would be out paddling their skin boats. The sea could be glassy calm, and under the right conditions, the ocean would appear to merge right into the sky. A guy could just lose it by getting vertigo; he would feel

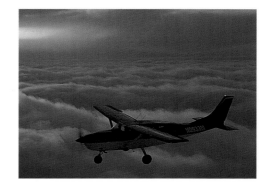

▲ Ellen Paneok flies a Cessna 207 near Barrow, Alaska's northernmost town, as fog moves over the Arctic Coastal Plain. ▶ A layer of broken stratus reflects in Raspberry Strait, separating Raspberry Islands and Afognak, part of the Kodiak Archipelago. Introduced to the islands, elk and Sitka black-tailed deer roam the hills.

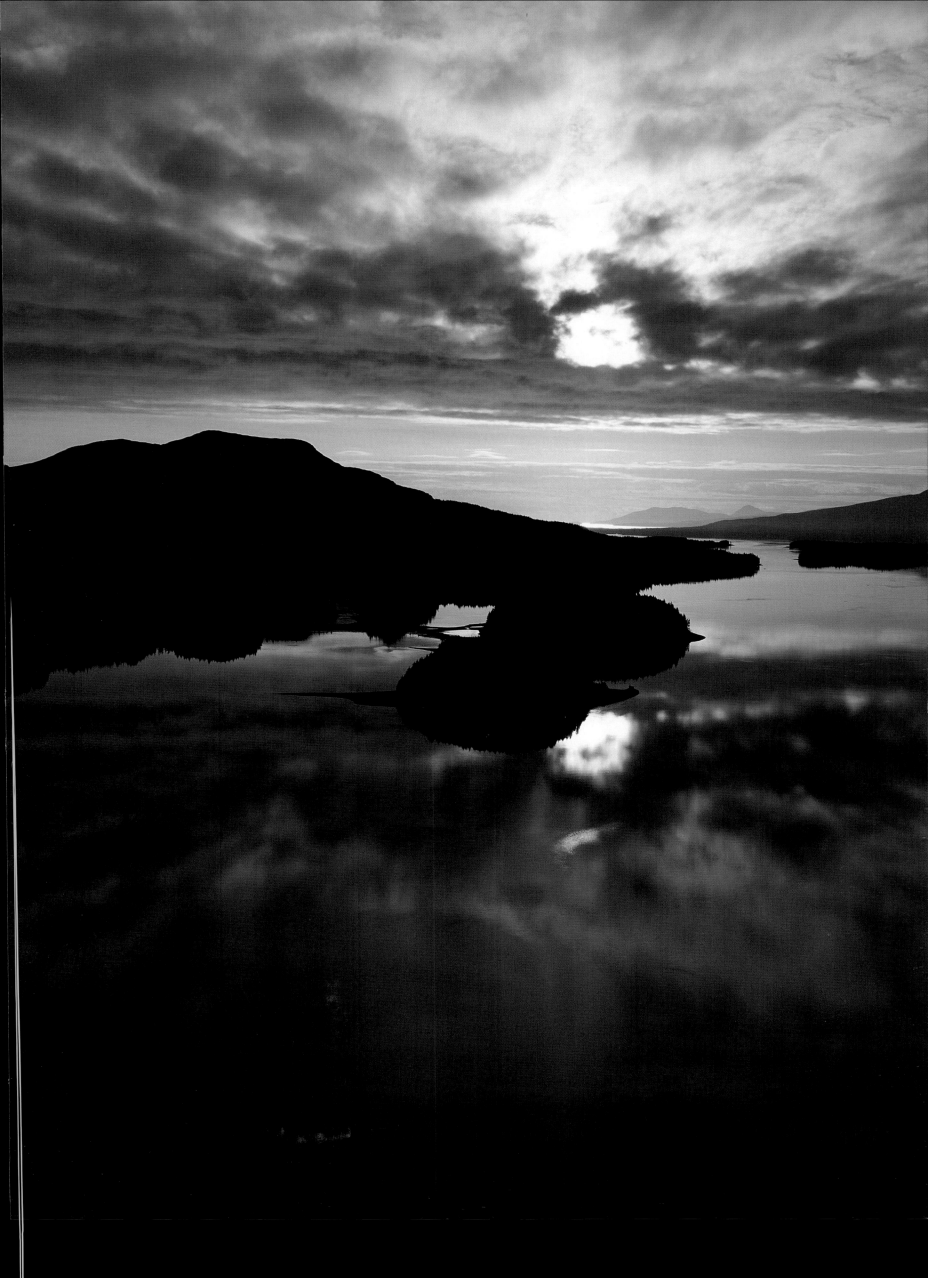

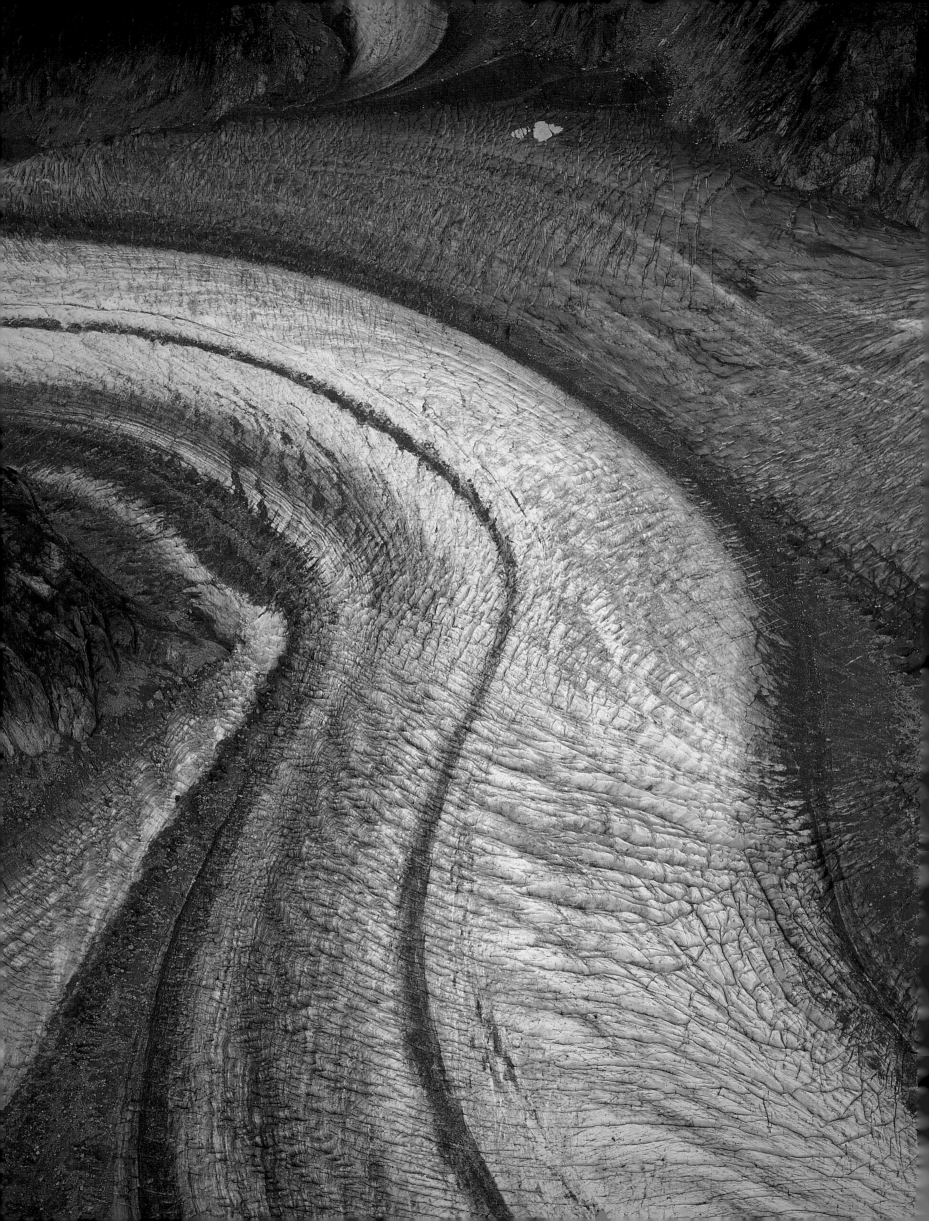

like he was falling or sinking, start flailing his arms, flip the kayak, and drown. There's a similar kind of vertigo when pilots are flying 'inside the milk bottle.' These are conditions in which it can be well above the minimums for VFR flight, but flat lighting and snow on the tundra make the world appear totally featureless, with no apparent shadows, contrast, or horizon. You are enveloped in a whiteout and need to depend totally on the gauges for safe flight."

The dangers of "kayak fever" come into play not only when flying in whiteout conditions so prevalent in the Arctic, but also when pilots are flying floats and making glassy-water landings. A calm lake may be beautiful as it serenely reflects mountains and sky, but its mirrorlike qualities can disorient a pilot attempting to land on such a glassy surface. The difficulty lies in determining the exact location of the water. "I try to land close to shore, where I can establish a point of reference," says Ellen. "I do a powered approach, keeping attitude correct and flying gently onto the lake. This is not a place to feel 'kayak fever.'"

Alaskan pilots occasionally witness unusual tricks of atmospheric phenomena without experiencing any sort of vertigo. Temperature inversions often occur, especially in winter, with layers of cold, dense air becoming trapped beneath lighter, warmer air. For example, downtown Fairbanks may shiver in a minus-forty-degree ice fog while the tops of surrounding birch-covered hills bask in twenty-degree-Fahrenheit sunshine. Just as light bends as it passes from air into a water-filled aquarium, light also bends when moving from less dense to more dense air. The resulting arctic mirages can be amazing.

One spring day, Wings of Alaska pilot Sam Wright was flying down Chatham Strait in Southeast Alaska when he witnessed an interesting mirage. The water was glassy, visibility was more than thirty miles, and there was a temperature inversion at an altitude of about five hundred feet above the water. "When I flew through the inversion, an island about thirty miles ahead of me appeared to double," says Sam. "A duplicate image appeared a degree or two above the island itself. When I descended, the bottom island would come into solo view. When I climbed fifty feet, then only the top image of the island would be visible. It was fascinating to change elevations and watch the island double."

Dan Klaes, owner of Bettles Air Service, has seen many odd temperature inversion phenomena during his many years flying the Arctic. On a winter evening in early March he was flying home to Fairbanks in Pacific Alaska's F-27 after servicing the DEW (Defense Early Warning) Line Station at Barter Island. A huge inversion was taking place, with the ground temperature at minus thirty degrees Fahrenheit while at two thousand feet above ground level it was thirty degrees above zero. "We were crossing the Brooks Range at about eighteen thousand feet," explains Dan. "To the east, a coppery orange full moon, like the harvest moon of autumn, was rising above the mountains. But this moon was absolutely square in shape! I turned on the intercom and told the eight or ten passengers, 'Look at the square moon rising in the east.'"

One of the most common visual effects of an inversion is to see the tops of mountains go flat and appear boxlike. Refraction of the light through an inversion can make the lights of a distant village appear suspended in the sky. "The sensation is like out of a *Star Wars* movie," says Dan. "It appears as if we could fly right under the village lights."

During cold weather, the air is so dense and clear that it transmits light extremely well. Without any pollution, the only limit to

◄ *Medial moraines and crevasses create a decorative pattern on the surface of Shakes Glacier as it spills toward LeConte Bay in the Stikine–LeConte Wilderness of Tongass National Forest.*
▲ *A small break in stormy skies illuminates Bettles Air Service's de Havilland Beaver as it flies past Sirr Mountain in the Brooks Range.*

visibility is the curvature of the earth, and because of inversions refracting or bending the light, pilots sometimes actually see beyond that curvature.

"When I'm training new pilots," says Dan Klaes, "I'll ask them to look at the lights of Barter Island and estimate their distance. The usual response is 20 or 30 miles when the lights are actually 130 to 140 miles away. Without any nearby references, a pilot's perception of distance can be really skewed."

Alaska's crystal-clear skies allow aviators to occasionally view another rare atmospheric phenomenon, the "green flash." At the first moment of sunrise or the last moment of sunset, if conditions are right, the very edge of the sun appears in a brilliant emerald green color. The earth's atmosphere acts as a giant prism, refracting the tiny sliver of visible sun into the colors of the rainbow. Because the atmosphere scatters blue light, the last hue seen in a rapid succession of spectral colors is green.

In more temperate latitudes, the green flash occurs extremely quickly as the sun rises or sets at a steep angle. Moving toward the poles, the path of the sun intersects the horizon at a much shallower angle. A sunrise that takes less than a minute in Hawaii can last for eighteen minutes in Barrow. Consequently, the green flash occurs for a longer period of time in the Arctic. Some observers in northern Alaska have reported seeing green flashes that lasted for more than one second. By climbing at sunset or descending at sunrise, a skilled pilot can increase the duration of the green flash's visibility by prolonging the time when the sun's rim is just clearing the horizon.

"Periods of really clear air produce good conditions for seeing the green flash," says Dan Klaes. "For fun, we would fly Pacific Alaska's F-27 to make the sun appear to go up and down perhaps a half-dozen or dozen times during a normal sunset. By changing elevation a couple of hundred feet back and forth, we could keep on seeing the green flash."

Similarly, pilots can see the green flash multiple times by flying at an elevation that allows the sun to appear and disappear between distant mountains and valleys. A person just needs to be careful not to burn his or her retinas by staring at the sun when more than just the tiniest portion of the disc is exposed. Never having seen the green flash, many people scoff at the idea that it occurs, but like the ice worms that inhabit the white, honeycombed ice of glaciers, the green flash is a fascinating piece of Alaskan natural history.

Alaskan pilots witness many other strange phenomena during the incredible number of hours they log in the air. Airborne ice crystals create all sorts of geometric displays, whether they be vertical pillars rising from city lights or mock suns, known as "sun dogs" or parhelia, appearing on either side of the real sun. The refraction of sunlight through airborne ice crystals beneath a plane can create a brilliant area of light below the actual sun called a "sub-sun." One of the most unusual plays of light occurs when ice crystals refract sunlight into an intricate collection of arcs and sun dogs surrounding the actual sun.

The "glory" is a very common atmospheric phenomenon seen by pilots when they fly above sunlit clouds. Directly opposite the sun, observers see alternating reddish and bluish rings with the shadow of the airplane appearing in the bull's-eye. The glory is created when water droplets in clouds diffract sunlight and scatter it back toward the sun and airplane. Mountain climbers witness the same effect while looking at their shadows in fog. The use of a

▶ *Wind breaks apart plates of thin sea ice covering Norton Sound, and then shoves them on top of one another to create intricate designs. Norton Sound is typically covered with ice more than six months of the year. Pack ice on the Bering Sea may move as far south as St. George Island in the Pribilofs.*

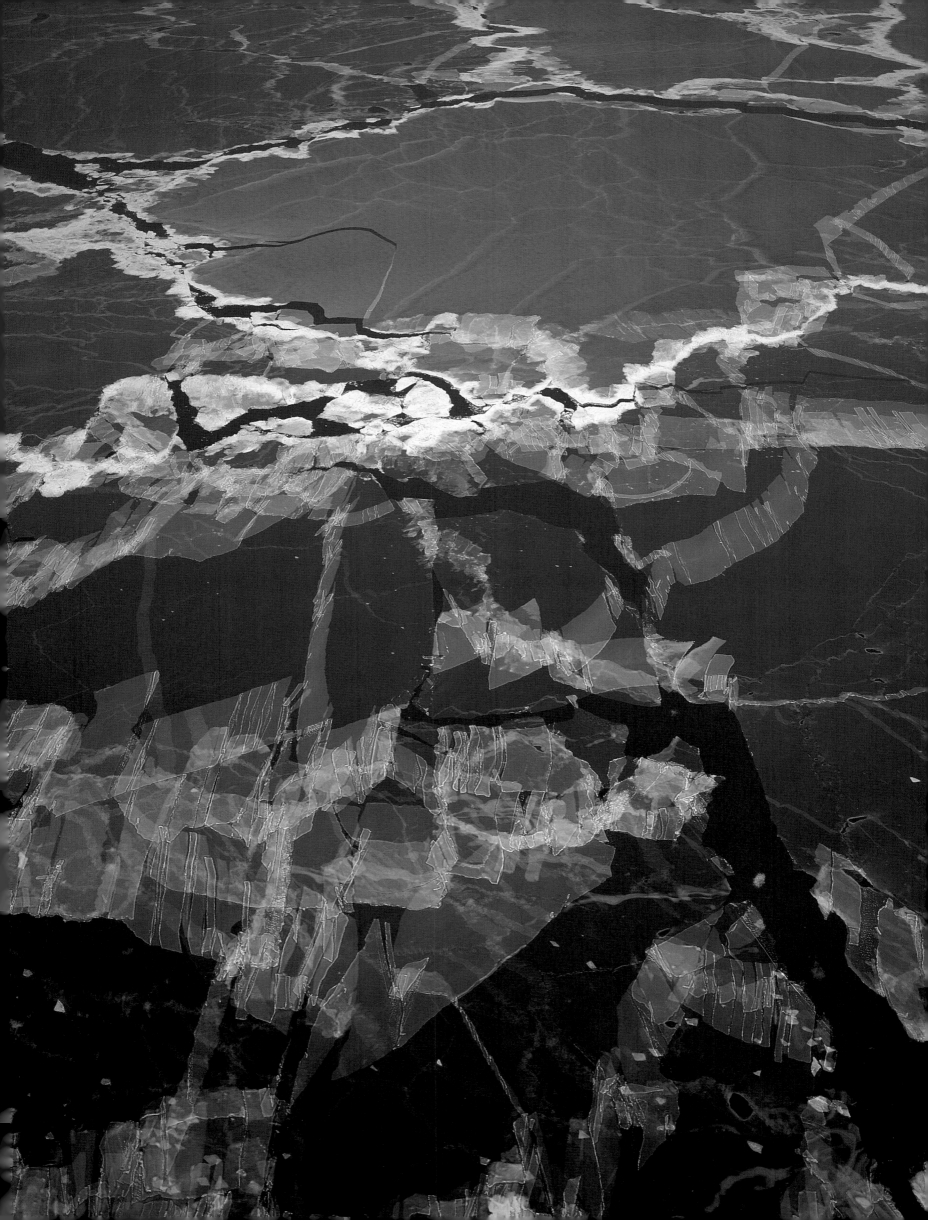

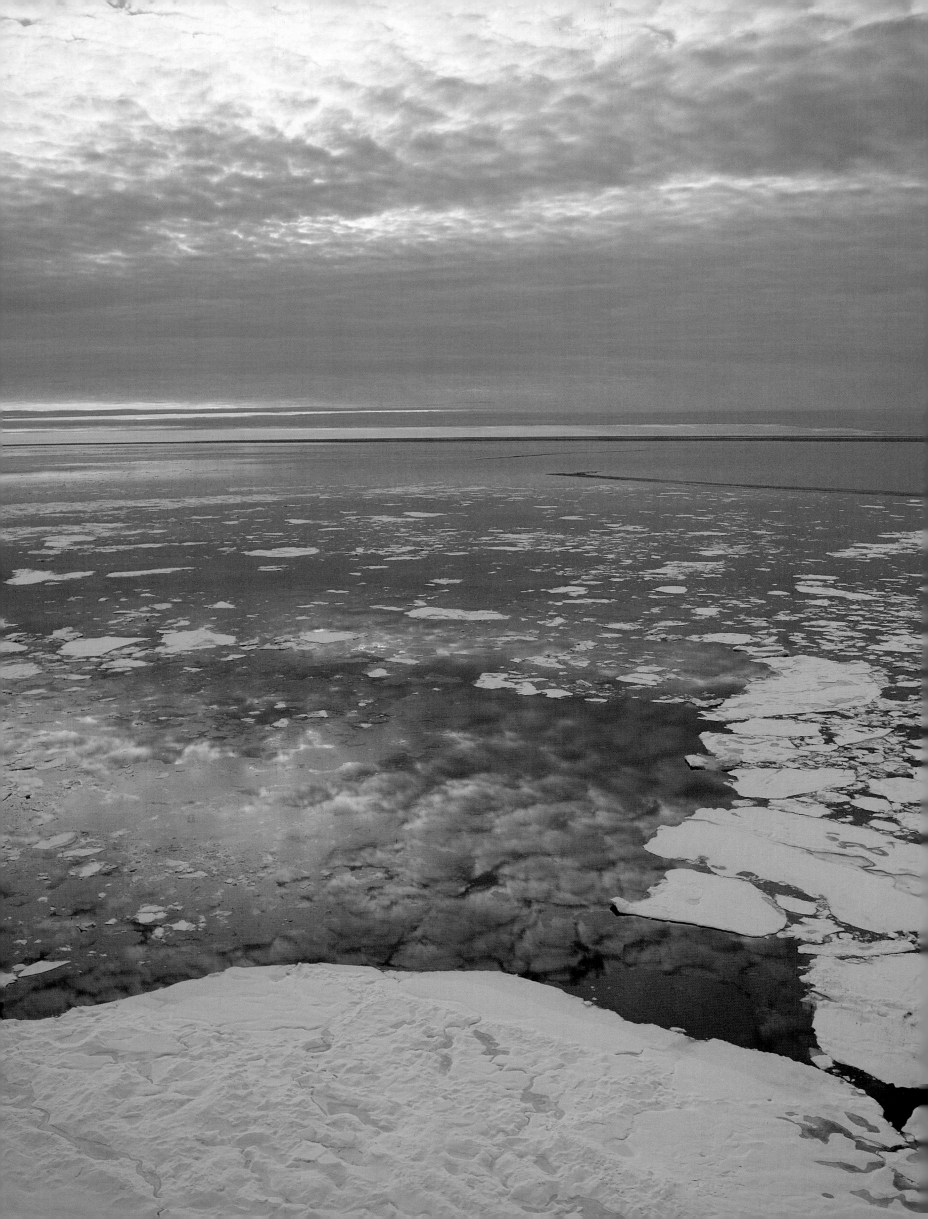

golden aura around religious figures in Byzantine paintings may have come from a priest climbing mountains to be closer to God and seeing a brilliant halo around his shadow in the fog below. Interestingly, whether you're flying in formation with multiple airplanes or you're in a group of people on a mountaintop, from your vantage point the glory appears only around your shadow and not the shadows of your companions.

Pilots, as well as fire lookouts and mariners, occasionally get to witness an eerie blue light in the dark of night. On an airplane, it appears as a flickering glow on the ends of the wings, a blue arc following the tips of rotating propeller blades, and unnerving blue sparks that race from the nose up across the windshield. The phenomenon is known as Saint Elmo's fire, named for the Italian bishop, martyr, and patron saint of sailors. The glow of Saint Elmo's fire is produced by a buildup of static electricity, and the dry air of the Arctic provides the perfect conditions for this phenomenon. Clear, dark nights in the dead of winter are often best for observing it.

Alaska Airlines pilot Gregg Dittmer believes that pilots saw Saint Elmo's fire more in the past because older, larger aircraft were not designed to effectively dissipate buildup of static charges. Gregg has had more than a decade to ponder the effects of Saint Elmo's fire. In October of 1984 he was flying PenAir's Twin Aztec from King Salmon to Anchorage. It was one of those drizzly fall nights when the air was smooth and Gregg was guiding the Aztec on instruments through the clouds. He was flying about seven thousand feet above Lower Cook Inlet, near Augustine Volcano, and had noticed Saint Elmo's fire playing on the aircraft. Then, Gregg says, "It was like a bolt of lightning leapt from the left engine to the cockpit. It was so quick and violent. This blinding white light illuminated the engine cowling, left wing, and cabin as if it were daylight. I felt this tingling warm sensation, and my hair stood straight up. The static charge traveled right through me, and then this ball of Saint Elmo's fire rolled down the aisle of the aircraft. It passed right between the legs of the last passenger before exiting the rear of the plane. I scanned the instruments and left engine. All checked out fine. After determining the plane was flying safely, I turned around to see if any of the five passengers had noticed.

"I thought they might have been asleep," Gregg continues. "However, I was greeted with five pairs of wild eyes with lots of white showing. Those eyes were as big as they could be. The passenger in the rear of the plane who had the glowing ball roll between his legs was really stressed. I don't want to repeat his exact words, but he let loose plenty of expletives during the last twenty minutes of the flight! I'll remember that night as one of the most bizarre of my flying career."

* * *

With Alaska's vast size and small population of just one person per square mile, pilots frequently are the first to witness fascinating natural phenomena. They are often in the air when the weather changes quickly, glaciers make dramatic changes, or volcanoes erupt.

The Alaska Peninsula and the Aleutian Islands are known to be cursed with some of the foulest flying weather in the state. With the Gulf of Alaska to the south and the Bering Sea to the north, the mixing of maritime climates breeds a seemingly endless succession of storms. This is the country of horizontal rains and twenty-four-foot seas.

Larry Zuccaro remembers a December day in 1994 when he was captain of the MarkAir Beech 1900 flight from Anchorage to

◄ *Pack ice partially covers the Chukchi Sea in September near Point Franklin, between Wainwright and Barrow. During summers of cool temperatures and little wind, the Arctic Ocean's polar ice cap may remain close to Alaska's northern shore. During warmer summers, the ice cap retreats far to the north.*

Sand Point, Dutch Harbor, and Cold Bay. "We were shooting our approach into Sand Point and flew past the huge waterfall on Corovin Island off Unga Strait. I mentioned to my copilot, 'Hey look, there's an upside-down waterfall. It's flowing backwards!' The southwest winds were blowing so strongly against the bluff that they picked up the entire eight-hundred-foot waterfall and carried the water five hundred feet into the air. You could have stood at the base of the falls and not gotten wet. Ice from the spray made a perfect white wedge on the brown tundra across the top of the mountain."

Wind always concerns Alaskan pilots, whether it's turbulence through mountain passes, crosswinds during landings, or wind-created chop on floatplane lakes. Getting a preflight weather briefing from the FAA is a smart idea, but often not possible in bush Alaska. Even when you do get a briefing, conditions can change very quickly.

"I had a flight scheduled across Baranof Island over to Kake," remembers Ken Bellows, who has flown out of Sitka for decades. "There was decent weather and not much breeze going across, but coming back in the Beaver the winds picked up to thirty knots. Listening to the marine radio, I heard all sorts of racket from fishing boats discussing the fierceness of this southeast gale. An hour after I departed for home, I had a nerve-wracking landing back in Sitka. The wind in the channel had kicked up from nothing to forty-seven knots within an hour. Farther out in Sitka Sound, a tug with a log barge off St. Lazaria Island reported eighty-knot winds. A million-dollar log barge was lost from this fast-moving cold front."

During his twenty thousand hours of flight time in the Homer area, Bill de Creeft of Kachemak Air Service has garnered great respect for winds. Often in the fall, clear, cold air flowing over the mountains from the northwest creates severe downdrafts called "williwaws." In the nearby village of Seldovia, williwaws, with winds punching over a hundred miles an hour, have snapped mooring lines of ships and pulled them from docks. When they strike the ground, these sudden bursts of wind can knock down virgin stands of Sitka spruce.

"If you look at the bowl areas between mountains, you can see areas of blowdown where williwaws happened in the past," says Bill. "These are places to avoid when conditions for williwaws are prime. You can be flying along at three thousand feet and never feel any turbulence. But straight below you, along the coastline, the water is frothed in white circles and lifted a hundred feet into the air. If you're flying lower and get caught in a williwaw, at first you feel a headwind, then a sinking downdraft, followed by a strong tailwind that can drop a plane right from the sky."

Pilots have always had a tricky time determining wind speed and direction while flying in Alaska. If bodies of water aren't frozen, wave direction, the degree of whitecapping, and gusting patterns give plentiful clues about surface winds. Snow blowing off peaks provides additional hints about the winds aloft. The advent of LORAN and GPS navigational aids has enabled pilots to compare their actual ground speed to that shown by their air speed indicator. The difference tells pilots whether they have a headwind or tailwind and its speed. Prudence in determining safe flying conditions is the best attribute a pilot can have.

"A pilot needs to have a mature attitude to say 'no' when conditions aren't safe for flying," says Bill. "In Alaska, you can't bluff and push the weather just to build your ego at the expense of passenger

▲ Bill de Creeft of Kachemak Bay Flying Service flies over the Harding Icefield in his 1929 Travel Air S6000B, the oldest commercially certified air taxi plane in the United States.
▶ The sheer granite walls of the Arrigetch Peaks rise in the central Brooks Range in Gates of the Arctic National Park.

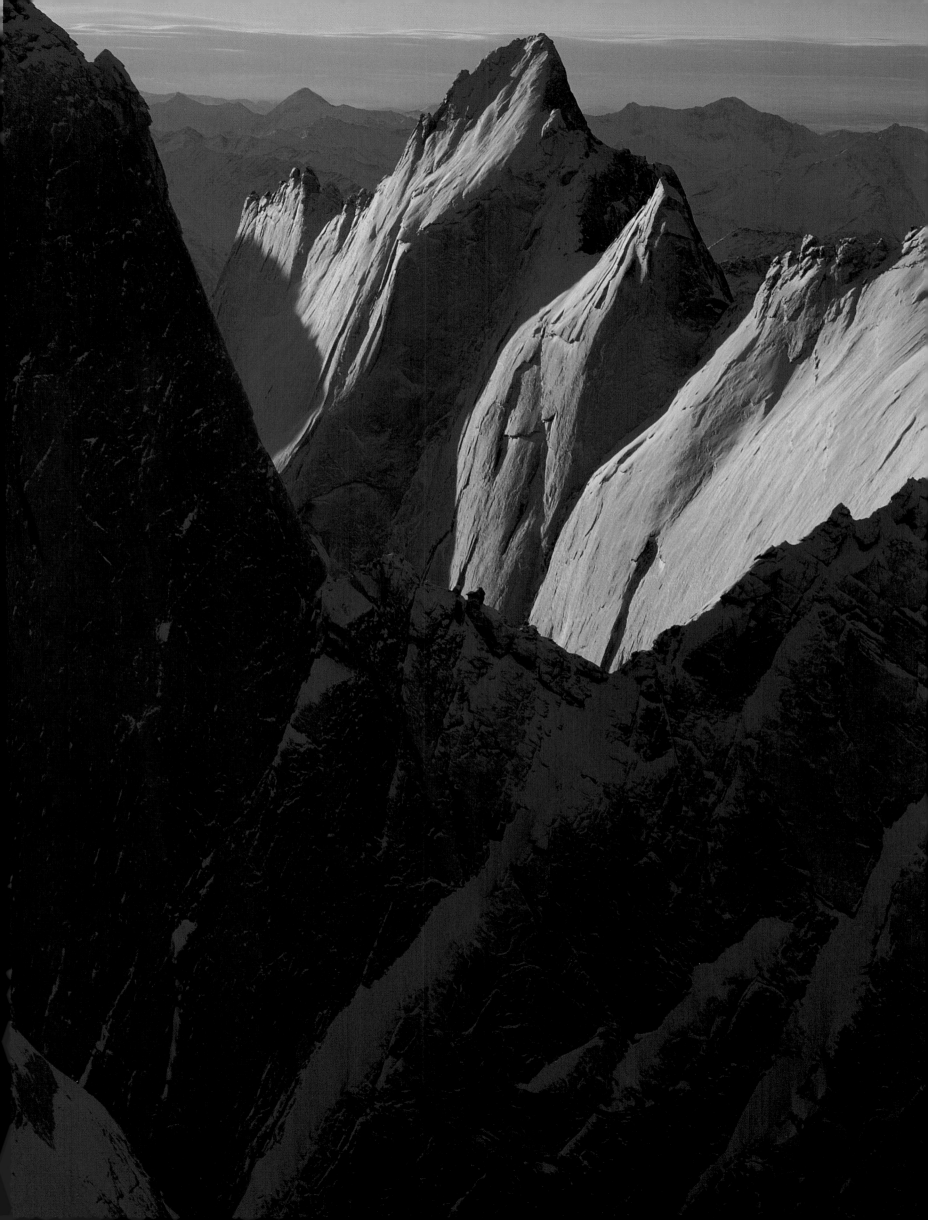

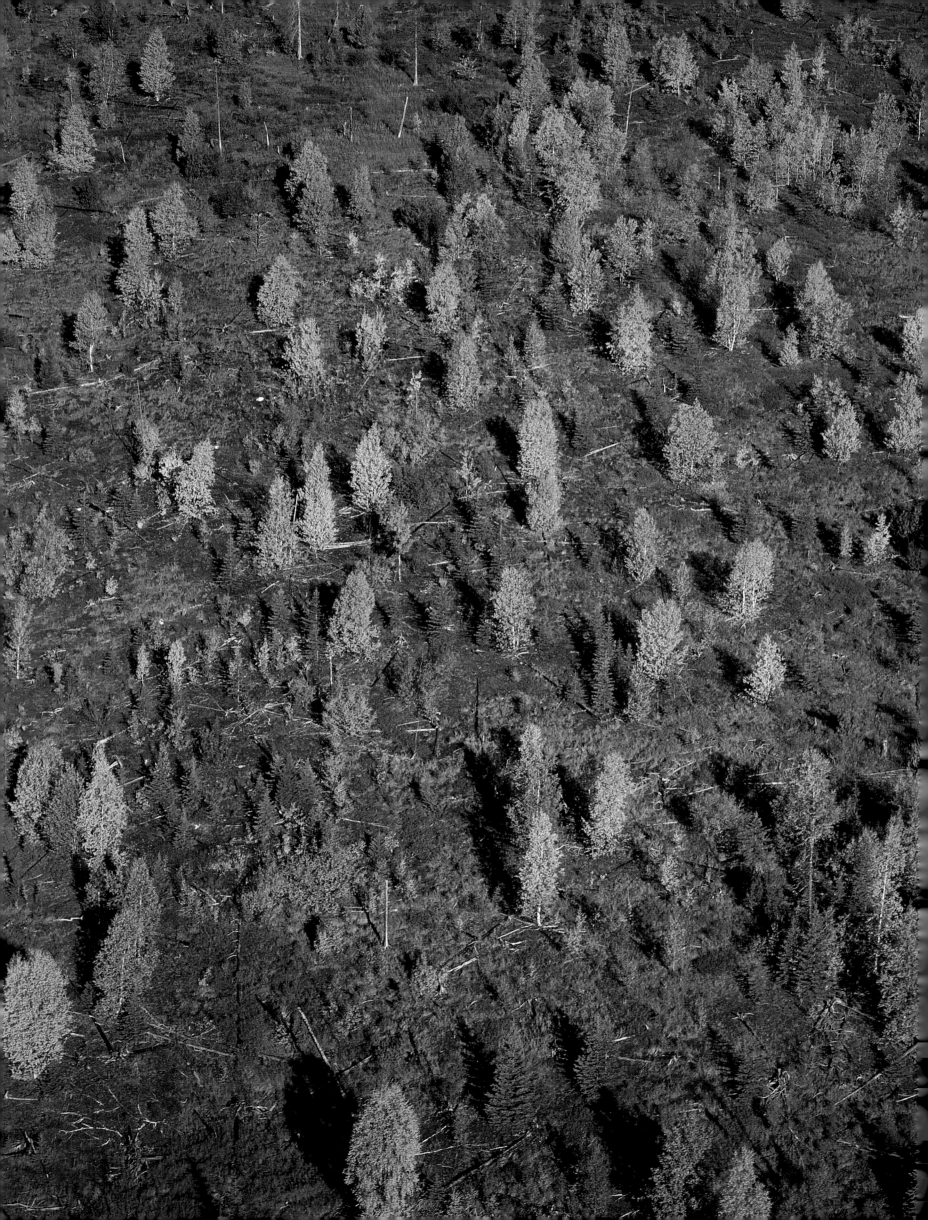

safety." At age sixty-six, Bill is living proof of a pilot who pays attention and recognizes what he can and cannot safely do with an airplane. To keep feeling young, Bill flies a 1929 Travel Air S6000B, the oldest air taxi–certified plane in the United States.

One of Bill's favorite flightseeing activities is to observe glaciers calving. With more than twenty-nine thousand square miles of glaciers in Alaska, and the roughly 525-square-mile Harding Icefield practically in his backyard, Bill has plenty of opportunities to watch glacial geology in action. When you observe a glacier for just a short period of time, it may seem like a static feature. But fly over a glacier daily and you'll see all sorts of changes. The river of ice acts as a huge conveyor belt that slowly moves snow that has compressed into ice at higher elevations and wastes that ice away through melting and calving at lower elevations. "What a great perspective to fly over a glacier and watch a big chunk of ice break loose from the face," says Bill. "Everything seems to go in slow motion. Ice falls from the glacier, hits the water, makes a huge splash, sinks beneath the water's surface, rises back up, rolls over, and becomes a beautiful crystalline-blue iceberg. Then big waves radiate out, jostling all the other bergs."

Northeast of Homer, in Valdez, pilot Chuck LaPage has spent thirty-five years watching the ever-changing Columbia Glacier from the air. Chuck arrived in Valdez soon after the 1964 earthquake to help move the town following the tsunami generated by the quake. He had planned on staying only three months, but has been there ever since.

"Since I moved here, the Columbia Glacier has pulled off its terminal moraine and retreated more than five miles," says Chuck. "Now the face is back to the Great Nunatak, which isn't a nunatak [an island of bedrock projecting through a mass of glacial ice] anymore. If you look on the most recent topographic map done in 1962, the Columbia Glacier's face is now where the map shows a thousand feet of ice."

During its rapid retreat across deeper water behind the terminal moraine, the Columbia Glacier has calved millions of icebergs. Most of the bergs slough off the face of the glacier. But occasionally Chuck has seen something much more unusual.

"When a really big berg comes off the glacier—one the size of four or five city blocks—it comes from underneath the water right at the glacier's face," says Chuck. "A giant piece from the bottom of the glacier looks like a huge monster surfacing from the depths. As the berg rises, all the smaller trash icebergs choking the glacier's face clear away. It looks like a huge, boiling pot where water wells above the rising berg. Giant bergs emerging from the bottom appear deep blue in color. If they flip over, you see grooves on their bottoms where they ground over rocks."

Directly north of the Columbia Glacier, pilot Mike Meekin keeps tabs on the Nelchina Glacier. About seven miles up its eastern flank, a three-mile-long valley periodically fills with water, creating a glacially dammed lake. Such ephemeral bodies of water are fairly common along Alaska's larger glaciers. The United States Geological Survey reports more than 750 glacially dammed lakes in Alaska. Water pools behind an ice dam until it rises high enough to float the dam, thereby opening a channel either beneath or through the ice. The lake then catastrophically drains, often creating huge floods below the glacier.

Most years, the Nelchina Glacier's lake drains in early September, although sometimes the plug has been pulled as late as October 10. Occasionally the lake doesn't drain at all. This was

◄ South of the Brooks Range near Lake Minakokosa, an old burn area displays brilliant colors during the brief autumn.
▲ Mike Meekin lands his Super Cub, equipped with large tundra tires, on the smooth glacial ice of the Nelchina Glacier in the Chugach Mountains.

the case during the summer and fall of 1996. By August of 1997, the lake had risen about six hundred feet high. "That was the most water I had ever seen in it," remembers Mike. "It was flooding onto the glacier and was about to spill over the top. Thousands of icebergs calved from the Nelchina floated in the lake. When the lake finally emptied, the icebergs were stranded along two miles of the lake's bottom. I found it extremely beautiful. All those bergs were a vibrant, brilliant turquoise blue. Some stood more than two hundred feet high."

Mike has logged more than ten thousand hours in his white-and-red Super Cub, N7580Y, flying hikers and hunters to the tundra strips and river gravel bars in the Chugach and Talkeetna Mountains. One year, he dropped off a party of hunters near the base of the Nelchina Glacier, but he forgot to tell them that the lake far up the glacier might drain. And drain it did. The hunters heard this immensely loud roar. The ground trembled, and through the rumble created by the turbulent, angry outpouring of water they heard the rolling, grinding, and crashing of huge boulders.

"The hunters were definitely worried," says Mike. "They had no idea what was going on and decided to head out of the hills to seek safety away from the glacier. When I flew over the site, a massive pool boiled at the toe of the glacier. It squirted water like a geyser, almost a hundred feet into the air. I circled for ten or fifteen minutes watching water fill the Nelchina River's three-mile-wide flood plain down below."

Observing glaciers from the air provides ever-changing geologic drama, but for a real adrenaline rush, nothing compares to flying past the full eruption of one of Alaska's more than eighty volcanoes, of which forty have erupted in historic times. In 1983, Gregg Dittmer was making regular flights out of the Alaska Peninsula community of Chignik. Just after Memorial Day, the nearby 8,225-foot Mount Veniaminof began erupting. On evenings when the weather permitted, Gregg would fly near the volcano to provide eruption updates for the United States Geological Survey and to try and take dramatic pictures of the sunset illuminating the volcanic plume.

On July 4, Gregg was treated to plenty of natural fireworks: "I approached from the north face of Mount Veniaminof, flying above the cinder cones in the center of the volcano. A lot of lava was flowing from the vent, and ash was shooting straight up. I looked higher into the clouds and saw huge rocks, bigger than the airplane, falling from the clouds. These rocks were a couple thousand feet above me. I was on the upwind side of the eruption, but I thought this activity was more than I bargained for, so I safely backed away."

Alaska's volcanic eruptions can sometimes catch pilots unaware. Pete Devaris, owner of Wilderness Air, was new to Alaska when he had to fly a hydraulic pump to the Alaska Peninsula community of Port Moller. He had extra room in the plane, so he decided to take along his dispatcher, Jeannie Dennis, to show off the country.

"We were flying down the peninsula and saw this cloud that was billowing higher and higher into the sky," describes Pete, with a touch of embarrassment. "I wanted to impress Jeannie with my scientific knowledge, so I told her all about cumulonimbus clouds and how they build into huge thunderstorms. It didn't dawn on me that thunderstorms were pretty unusual on the Alaska Peninsula. When we landed at Port Moller, everyone wanted to know what the eruption of Pavlof Volcano looked like from the air. I had to eat a little crow for my meteorological storytelling!"

▶ Hundreds of icebergs lie stranded on the floor of a glacially impounded lake that periodically empties beneath the Nelchina Glacier. The tallest icebergs stand more than two hundred feet high. Some 750 glacially dammed lakes are found throughout Alaska. When they drain, catastrophic floods can result.

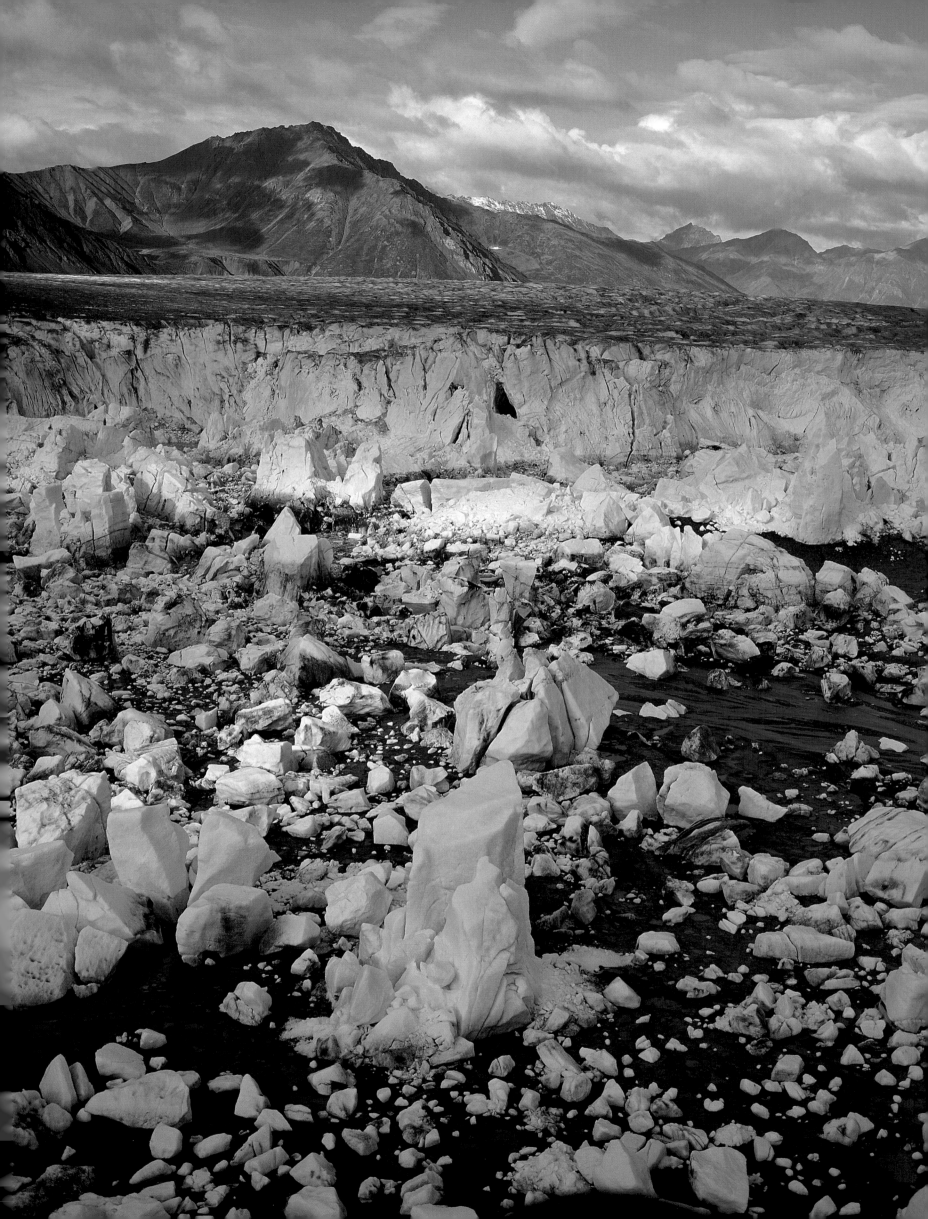

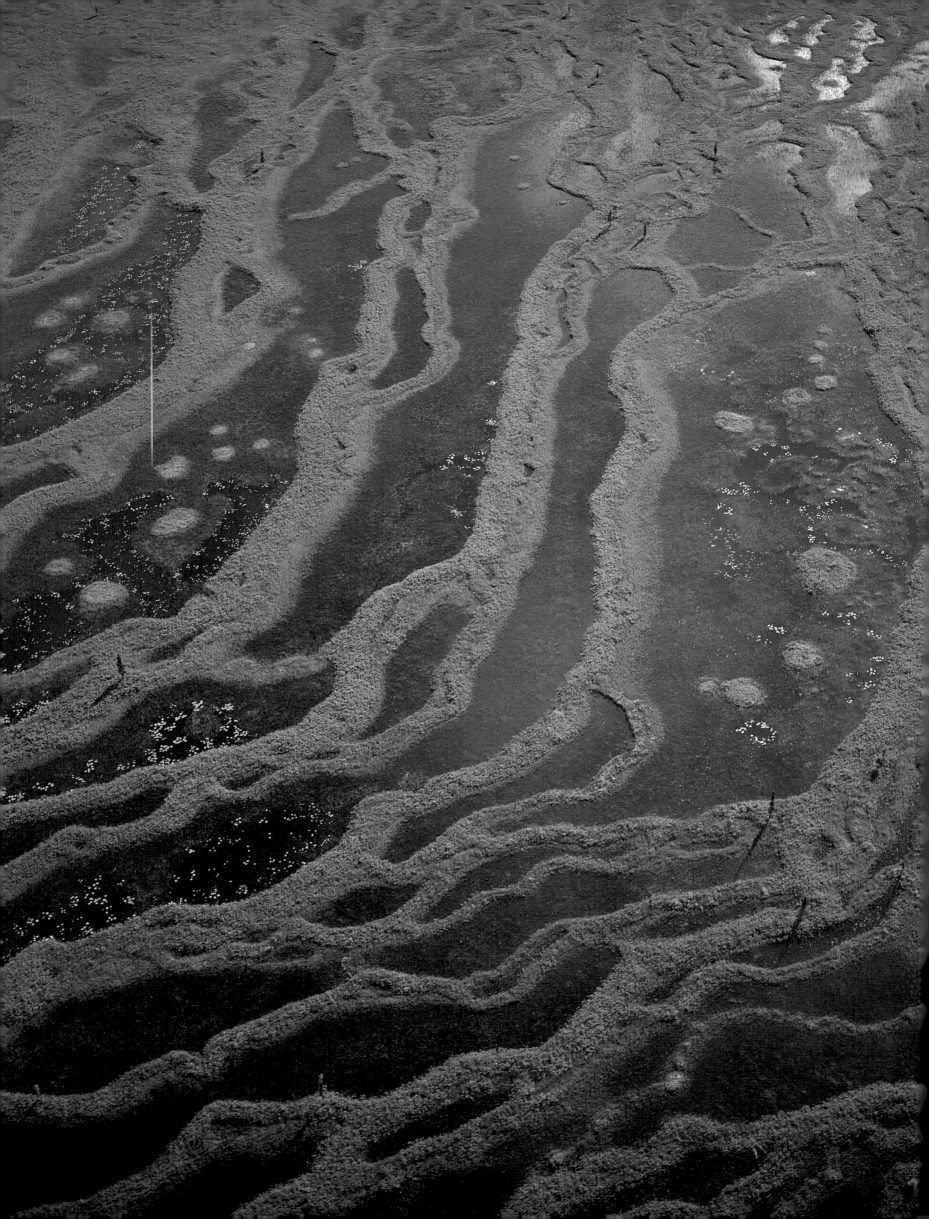

The crew and 231 passengers of KLM Flight 867 had a much more harrowing experience on December 15, 1989. They were on their descent into Anchorage when, at 27,900 feet, they encountered ash from an eruption of Redoubt Volcano that had begun some ten hours earlier. All four engines of the Boeing 747 shut down, and the jumbo jet began a silent, perilous, five-minute descent toward the knife-edge ridges of the Talkeetna Mountains. Luckily the pilots were able to restart the engines at 13,300 feet, less than a mile above the Talkeetnas. They made an emergency landing in Anchorage and found the four engines severely damaged by volcanic ash. It took more than eighty million dollars to repair the aircraft.

Because of the hazards volcanoes pose to air traffic as well as to Alaskan communities, the Alaska Volcano Observatory vigilantly monitors the state's volcanoes for any signs of impending eruptions. Since 1980, at least fifteen aircraft have been damaged while flying through volcanic ash on the busy northern Pacific air routes. Volcanic ash clouds are often difficult to distinguish from ordinary clouds consisting of water vapor. A network of seismometers on the sixteen most dangerous Alaskan volcanoes helps the observatory warn of future eruptions.

One event that caught just about everyone by surprise was an "eruption" of Mount Edgecumbe on Kruzof Island, near Sitka. This imposing volcano looks a bit like Japan's Mount Fuji. It had been dormant an estimated nine thousand years, but on April 1, 1974, Sitkans awoke to black smoke rising from the summit crater.

It just so happens that Sitka harbors a group of pranksters known as the "Dirty Dozen." One of its members, Oliver J. "Porky" Bickar, had been plotting for four years to stage a little excitement for the town.

"I stockpiled about a hundred or so tires to take over to Mount Edgecumbe," admits Porky. "I tried all the helicopter outfits in town, but none of them had the nerve to help me out. Finally, Earl Walker, a helicopter pilot with Temsco in Petersburg, said he would make the flights. In two trips we sling-loaded gas, Sterno, smoke bombs, and tires to the summit. I also took along ten cans of black spray paint. In the snow, I stomped out 'April Fools' in fifty-foot letters, then sprayed black paint in the footprints. We torched the tires and let the excitement begin!"

The "eruption" was announced on the local radio station, and pilots reported it to the FAA. The Coast Guard commander sent a chopper from Gustavus and a whale boat from Sitka. When the Coast Guard helicopter arrived on the scene, he radioed to the commander, "You've been had. All I see is a bunch of smoldering tires and 'April Fools' written in the snow."

* * *

When pilots are watching volcanoes and glaciers, they are often cruising at a high elevation to observe the larger geomorphic picture. When the flying involves watching for wildlife, pilots enjoy being closer to the ground, perhaps a thousand feet or less above the terrain. At lower elevations, it is much easier to spot a sow grizzly walking a ridge line with her yearling cubs, a bull moose feeding in the center of a pond, or a band of caribou marching across the tundra. Often, when spotting an animal, a pilot will make a leisurely turn toward the animal, not to harass the wildlife, but to observe what's happening, like a raven's watchful gaze while riding a thermal. A plane provides a wonderful platform from which to observe wildlife from the air.

One recent winter I asked Super Cub pilot Mike Litzen, who flies wolf surveys for the state, to keep an eye out for a wolf pack

◄ *Muskeg in Alaska, like this example near the Yentna River, results from poorly drained soils. An estimated 170 million to 233 million of Alaska's 365 million acres are composed of wetlands that include not only muskeg but also wet tundra, marshes, estuaries, mudflats, and the shores of rivers and lakes.*

that wouldn't mind a photographic overflight. It wasn't too long ago that Alaskan wolves were shot from airplanes. Many packs remember and are skittish when approached from the air. I didn't want aerial photos of wolves spooked and running. Two days later Mike told me he had found the perfect wolf pack just ten minutes from his house. The next day I drove to Nikiski on the Kenai Peninsula and off we flew searching for the wolves. By landing on skis next to their trail and inspecting recent moose kills, Mike tracked the direction the pack was moving. It took us an hour, but we found the nine wolves in a dense patch of birch, spruce, and willows. They could have cared less about Mike's Super Cub. For an hour we circled as they slept in the snow and went for leisurely walks through the brush. There were three frozen lakes nearby on which I was hoping they would wander. Their shadows cast by the low winter sun would have made beautiful designs on the snow. But that was not on the wolves' agenda, and we were content just to watch them in their wooded environment.

Ketchikan pilot Dave Spokely remembers one particularly bountiful trip when he was flying a Hughes 500 for Tundra Helicopters. A seasonal employee for the Tongass National Forest was ending his summer assignment, and he told Dave that he wanted to see lots of animals on his final flight to the work site.

"We didn't do anything special," says Dave, "but we stayed low and kept our eyes peeled. Four minutes into the flight over Vallenar Bay, off Gravina Island, we saw two humpback whales. Crossing Clarence Strait five minutes later, we passed over a pod of eighteen killer whales, including babies. At Grindall, on Prince of Wales Island, the rocks were covered with at least sixty Steller sea lions. About four minutes later, at the head of Kasaan Bay, two Sitka black-tailed deer watched us land in an area of muskeg before they headed into the woods. We dropped off some surveying supplies and, when leaving the muskeg, saw a black bear less than a hundred feet from the deer. Three or four minutes later, we were making our approach to Thorne Bay and flew over four gray wolves on the tidal flats. Once we landed, the wolves split into two groups and walked past us on either side. The nineteen-minute trip was a continuous 'wow,' and I haven't even mentioned the dozens of eagles we passed on the flight. Eagles are pretty common here in Southeast Alaska, and we often don't pay them much notice."

With more than four thousand hours in the air, Dave has accumulated many other wildlife stories. One of the most thrilling occurred soon after he saw the movie *Jaws 2*, in which a great white shark comes out of the water and grabs a helicopter. Dave was flying a group of Forest Service employees across Moira Sound toward the southern end of Prince of Wales Island. The weather was miserable Southeast soup, with seventy-five-foot ceilings and visibility of two hundred to five hundred feet in drizzle and fog.

"In uncontrolled air space, there are no restrictions on the conditions in which you can fly a helicopter as long as you keep things safe by using intelligence and prudence," says Dave. "We were doing thirty miles an hour at a forty- to fifty-foot elevation and utilizing the shoreline and rocks in the water for visual reference. Suddenly one of the 'rocks' appeared to lunge out of the water right at the helicopter. I made a turn for a better look as a breaching humpback whale splashed back into the water. In my excitement to tell the passengers about the whale, I inadvertently transmitted on the Forest Service network frequency instead of the onboard intercom. All of southern Southeast Alaska heard my

▲ Humpback whales bubble-net-feed on small fish in Frederick Sound near Kuiu Island. The whales blow circular strings of air bubbles beneath schools of fish, concentrating their prey for easier capture.
▶ In Kenai National Wildlife Refuge, a pack of gray wolves walks through deep snow blanketing the floor of a birch and spruce forest.

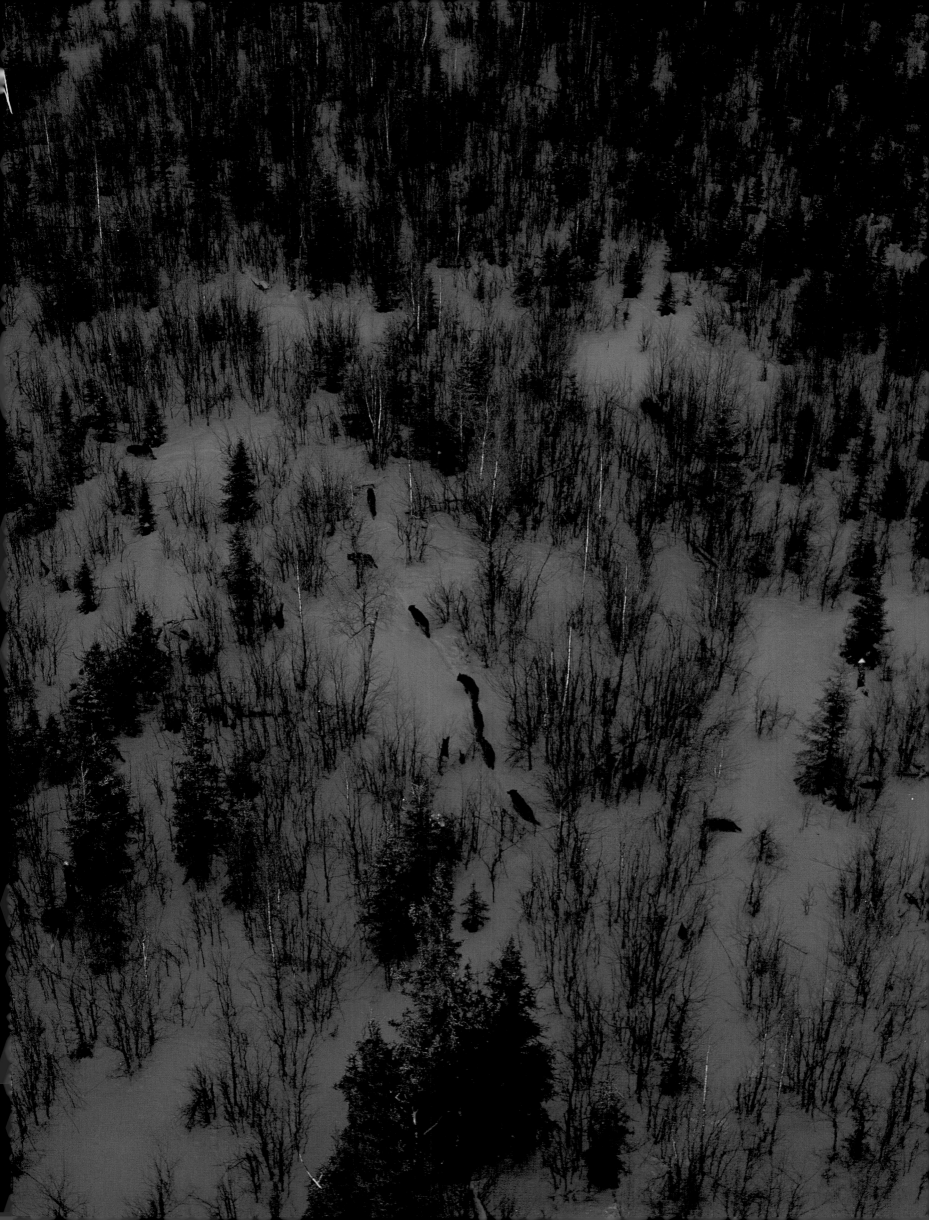

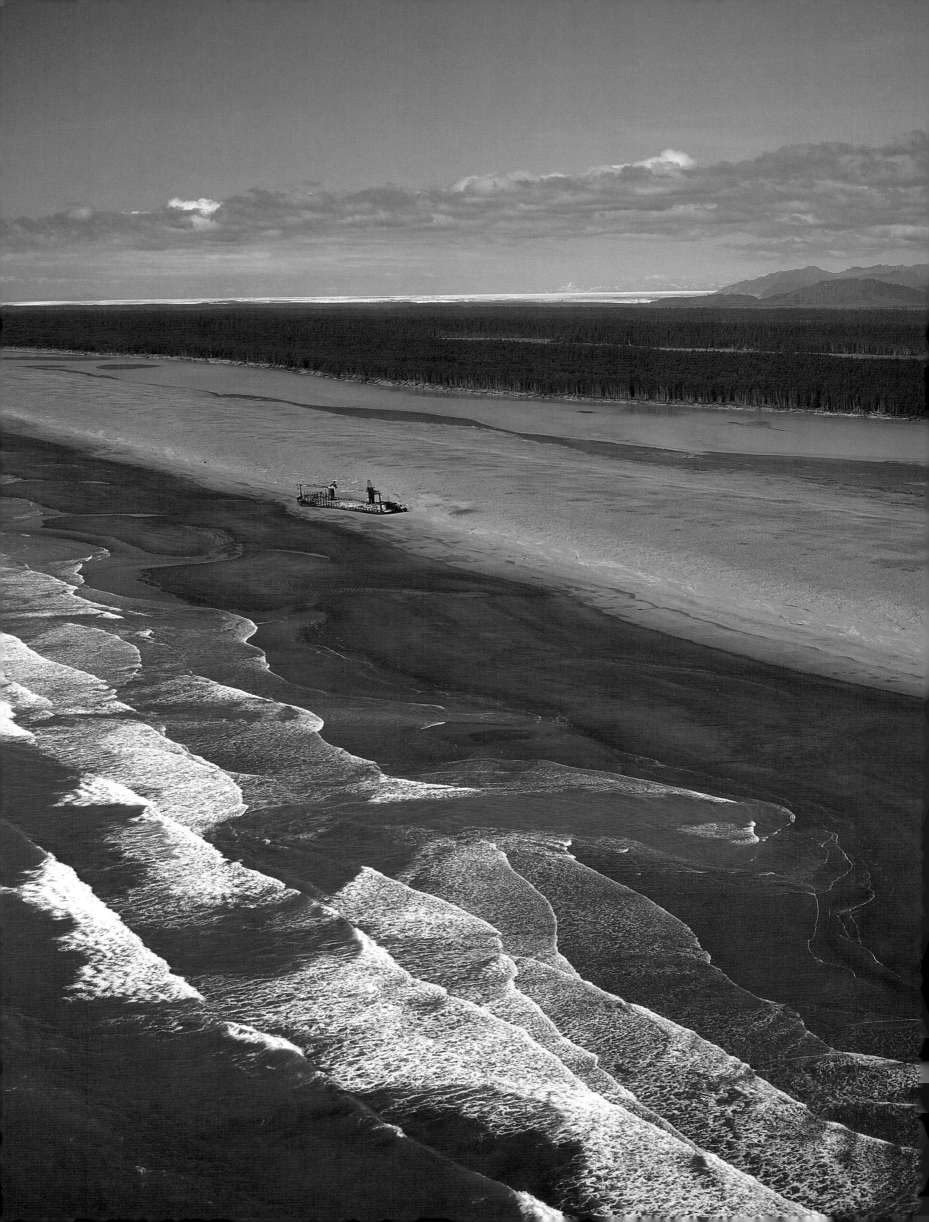

accidental broadcast: 'Did you see the size of that [expletive deleted] whale!'"

An airplane provides a vantage point for watching wildlife not available to ground-based observers. Sooner or later, Alaskan pilots see amazing predator/prey interactions. Ken Bellows, piloting a de Havilland Beaver past Morris Reef on his way to the village of Angoon on Admiralty Island, noticed two transient orcas, or killer whales, chasing a harbor seal. "It was just awesome watching the pair of killer whales work closely together to take the seal," says Ken. "One would harass the seal on the surface while the other would dive underneath the water and then shoot up vertically and try to grab the seal. Eventually it came up with the seal in its mouth and then tossed it into the air once. The other whale came over to feed too, and that was it."

In the Interior of Alaska, Dale Erickson, owner of the village store in Tanana, witnessed a different predator/prey interaction. Dale was flying to Ruby to visit his in-laws one September day when he noticed ripples on the water of one of the numerous small lakes south of the Yukon River. "I thought there was a bull moose in that pond," remembers Dale. "It looked like it had big floppy antlers. I circled in my Super Cub for a closer look and realized what I thought were light-colored antlers was actually a light gray wolf. The wolf was hanging on to a cow moose's head. The cow would shake her head vigorously, trying to get the wolf off, but the wolf just flopped around. Along the shore a half-dozen more wolves ran back and forth excitedly. A few swam to the moose and bit her on the rump. Eventually the wolves gave up their efforts and swam to shore while the moose sought refuge in the middle of the pond."

The pilots who most often see animals are those flying wildlife surveys and research projects for assorted state, federal, and private concerns. Much has been learned about Alaskan wildlife through using airplanes and helicopters. By placing radio collars on cow caribou and moose, individual females can be watched over many years to study their calf production and mortality. Radio collars also help track the migration patterns and distribution of various herds. One year the small Denali caribou herd dispersed over a vast area of Alaska. About seventy-five of the herd's twenty-five hundred members were broadcasting their position with small transmitters contained in their collars. Receiving antennas attached to the struts below both wings of a plane allowed a skilled pilot to fly to an animal and pinpoint its location. Sandy Hamilton of Arctic Air Alaska says, "It took us a whole week to find all the caribou—they were so spread out. To determine which direction to fly, we would circle really high and pick up the signals. We heard one caribou's transmitter from an amazing 125 nautical miles away. We tracked her all the way to the high hills above the Shushana River. Other caribou showed up as far away as Livengood, Beaver Creek in the White Mountains, over by Delta, and in Broad Pass."

Sandy thoroughly enjoys watching wildlife while flying his Cessna 185 and Piper Super Cub during surveys. His view from the air allows him glimpses of wildlife behavior that otherwise might be totally missed. One Fourth of July along the Hulahula River in the Arctic National Wildlife Refuge, he was flying his Super Cub on a Dall sheep survey. "It was so hot," Sandy remarks, "that even the bugs weren't flying. We were looking for sheep to count when we flew over a bunch of limestone caves southwest of Grasser's Strip. The sound of the Cub's engine brought about twenty ewes, lambs, and a few rams all running from the caves for a look. The sheep had been lying down in the caverns to cool off."

◄ Between Cordova and Yakutat, Alaska's Gulf Coast includes 220 miles of lonely, sandy beaches and one tiny community, Cape Yakataga. Near the Kaliakh River west of Cape Yakataga, shifting sands expose a shipwreck.
▲ In the Farewell Burn northwest of the Alaska Range, five moose trot through shallow snow.

While aerially tracking wolves in Denali National Park one March, Sandy found the East Fork Pack up the east side of the Shushana River. The wolves were chasing a group of Dall sheep rams in a little rock outcropping. Sandy tells the story: "Sheep were running everywhere, and wolves were running everywhere. Three and then four rams were perched on a ledge with wolves above them and wolves below them. The higher wolves backed off and lay down. One ram then jumped up and walked right past the wolves that were resting only a few feet away. A second ram did the same thing, and then all the rams walked past the wolves without further incident."

One of Sandy's favorite incidents happened during a wolf study he was flying with wildlife biologist Bruce Dale in Gates of the Arctic National Park. The previous day they had watched from the air as two adult wolves killed a caribou high in a glacial cirque bowl above Walker Lake. The next day they flew back to the kill site to determine how much caribou the wolves had consumed. One adult wolf stood near the caribou carcass while its pups watched from fifty to sixty feet away on a hillside. A big grizzly bear was trying to take possession of the kill. Sandy describes what he and Bruce saw as they circled in the plane: "The bear attempted to drag the caribou away, and the lone adult wolf came up and bit the bear on the butt. The bear then dropped the caribou and turned on the wolf. The wolf just jumped out of the way and proceeded to ignore the bear. The bear returned to chew and drag on the carcass, and the adult wolf bit him in the rear again. This went on for fifteen minutes until the bear finally gave up his attempt at pilfering the carcass. Once the bear left, the pups came down and just mobbed the adult wolf. Then the group walked over and fed on the caribou carcass."

Another Gates of the Arctic group of wolves, the Sixty-Mile Pack, became quite accustomed to aerial visits by Sandy and Bruce. Sandy says he has never seen this behavior before, but "the five youngsters in the pack were just like roadside dogs waiting to chase cars. Any time we would fly past the group and they were on a slope where they could run in the open, the youngsters would take off with great enthusiasm and chase behind my airplane!"

Wildlife biologists are not the only people flying Alaska's vast backcountry with the welfare of wildlife in mind. The Alaska Department of Fish and Game's state troopers, the National Park Service's rangers, and the U.S. Fish and Wildlife Service's special agents patrol Alaska's skies looking for poachers. Just as an airplane is a marvelous tool to help understand the behavior of wild critters, it is an effective conveyance for catching the bad guys who violate our fish and game laws.

Larry Van Slyke, former chief ranger of Lake Clark National Park and Preserve, was flying from Anchorage to Port Alsworth via a scenic route that follows the west side of Cook Inlet and then runs across Tuxedni Glacier and into Lake Clark. "I wanted to patrol coastal areas of the park because many brown bears live out there," says Larry. "Even though it wasn't hunting season, people occasionally get interested in taking one of them."

Larry passed a fishing trawler anchored in the mouth of Tuxedni Bay and, flying halfway up the bay, saw a small skiff maneuvering oddly where the bay starts to narrow. "What caught my attention," says Larry, "was a person in the bow of the skiff poised like Hercules ready to throw his spear. Initially I thought the spear was a harpoon. I was closing in on him at 120 knots in the Cessna 185, and my attention focused on what he was aiming at in the water—

▶ Several dozen members of the Mulchatna Caribou Herd trail through the snow near the Chilchitna River.

44

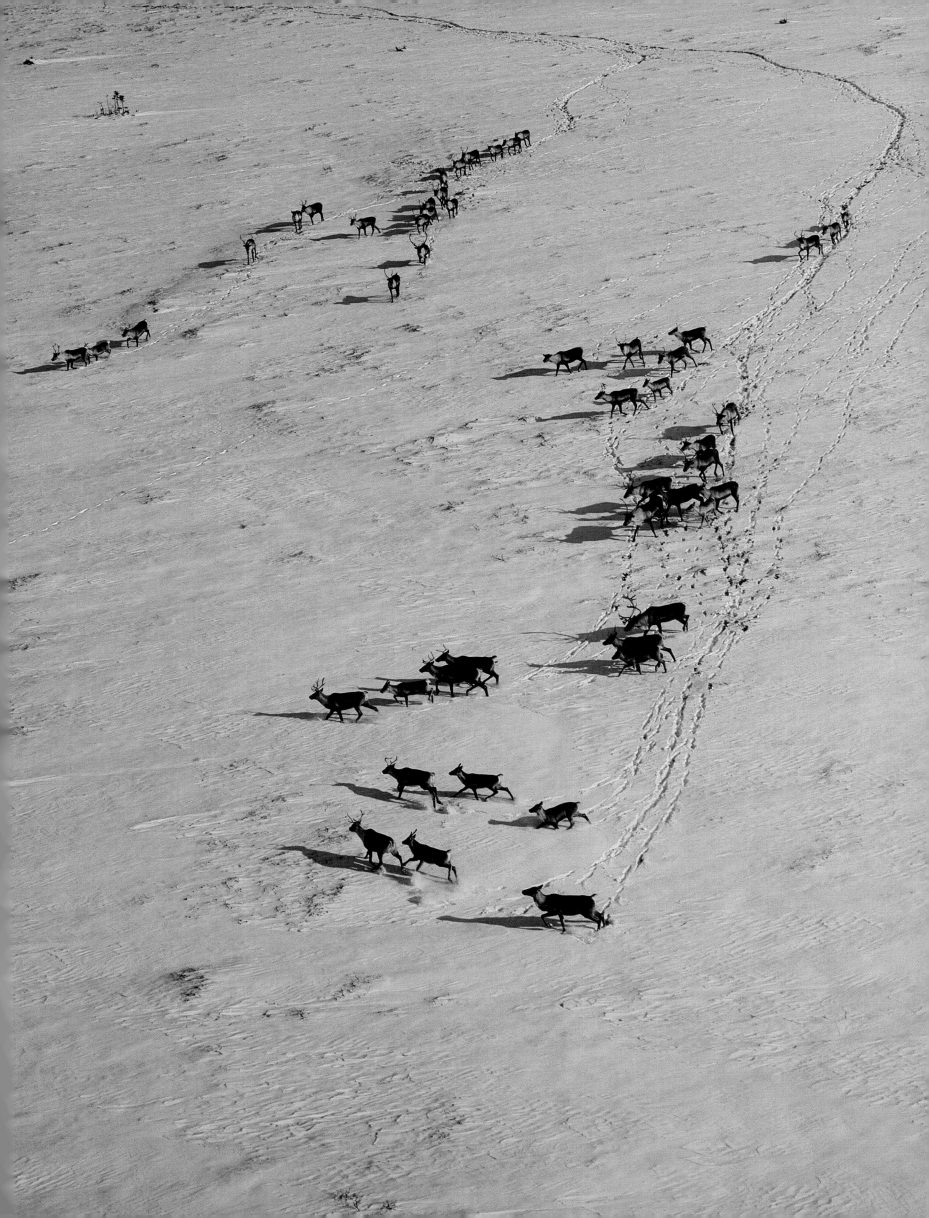

a big brown bear's head. The spear turned out to be an oar, and I watched the guy throw it with all his might at the back of the bear's neck. I did a tight turn and saw two individuals turning the skiff in tight circles with the bear in the center. I realized they were going to haze the bear until it drowned. It was so clear what they were doing, it just infuriated me.

"At the end of my second pass the men looked up, realized I was there, and broke off their attack. They started heading toward the trawler at the mouth of Tuxedni Bay. I landed in their path and spun the plane toward them so it would be very evident that I wanted them to stop. Once the prop quit spinning and the mags were off, I jumped out on the floats and identified myself as a federal officer. I asked them, 'What were you doing to that bear?' and they responded, 'We were just looking at it.' I said, 'I saw you throw that oar and hit the bear in the back of the head and haze it with the boat. There's no doubt in my mind that you were trying to kill that bear. Right now you're going to get cited for harassing wildlife. But if that bear doesn't make it to shore, the ante is going up, and I'll charge you with destruction of wildlife.'

"The bear barely swam the few hundred yards to shore. It was totally exhausted, and its head hung down low as it slowly moved into the alders. My citation book was at the bottom of a big pile of gear stowed in the airplane, so I told the guys that I'd mail them their tickets. One fellow gave me his correct address and paid the $250 fine after receiving his ticket. The other was a little more troublesome. He told me he lived with his aunt in Kenai and gave me her address, to which I mailed the citation. Just like the lyrics to the Elvis Presley song, my letter came back 'return to sender, address unknown.' I had the aunt's phone number, and when I called, she was rather evasive about her nephew's whereabouts. Then I remembered a little trick used by the U.S. Marshal Service. I told her I was John Rutter from Sunrise Travel Agency and that I had a free, all-expenses-paid trip to Hawaii that her nephew had won. She got very excited and told me he was out fishing, but would be in Wednesday. I sent the citation to the Lake Clark National Park and Preserve ranger stationed in Kenai, who hand-delivered the ticket that Wednesday. The following day the fellow called me in Anchorage to tell me he had received the ticket but wanted to know about his free trip to Hawaii. I told him there really wasn't a trip to Hawaii. He said that was sure a sneaky way of doing business. I agreed with him that it was, but I told him it worked, and he paid his citation."

The annals of flying in Alaska contain many fascinating wild-life stories. Some are as exciting as when former Governor Jay Hammond was transporting a tranquilized brown bear down the Alaska Peninsula in his Cessna 185 floatplane. In the middle of the flight the bear woke up, and Jay had to perform an emergency landing to safely let the bruin off his plane. Most flights tend to provide more thrills outside the plane's windows, with passengers and pilots enjoying views of Alaska's wildlife living in spectacular landscapes.

The real Alaska lies beyond the end of the state's scant road system. Here stretch the vast wilderness lands of the Last Frontier, where humanity has barely left an impression. Aircraft provide people with a convenient and quick way to access the bush. And while nearly every flight's destination holds the promise of adventure, often the flight itself can be just as memorable. Whether you are a person who has flown hundreds of times in rural Alaska or an armchair explorer dreaming of your first journey, sit back and enjoy the flight.

◄ *Extremely active calving of the Johns Hopkins Glacier leaves Johns Hopkins Inlet in Glacier Bay National Park choked with pan ice. Inspection of bergs near the top of this photo reveals at least two harbor seals that have hauled out on the ice. The Johns Hopkins Glacier has slowly advanced following a catastrophic retreat over the past two centuries.*

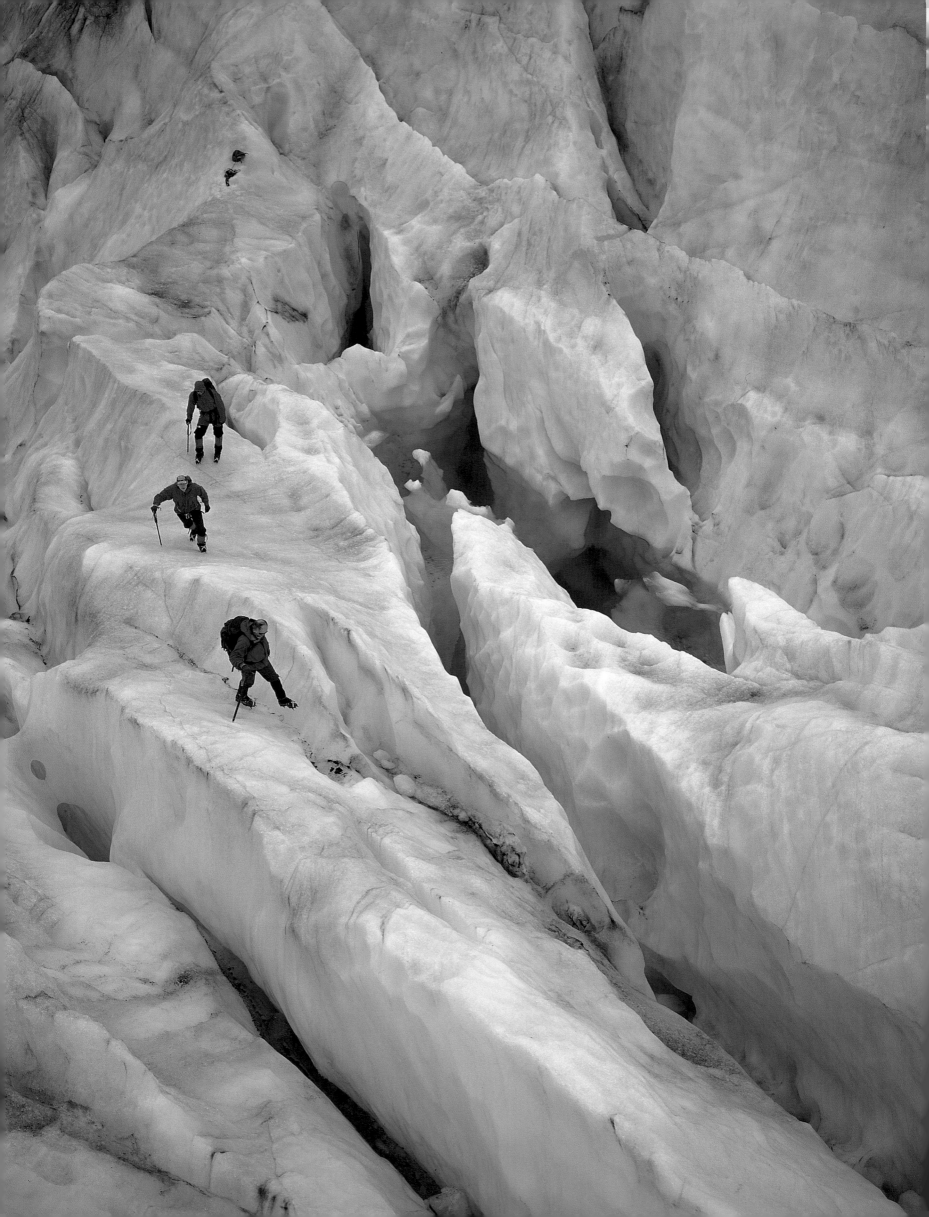

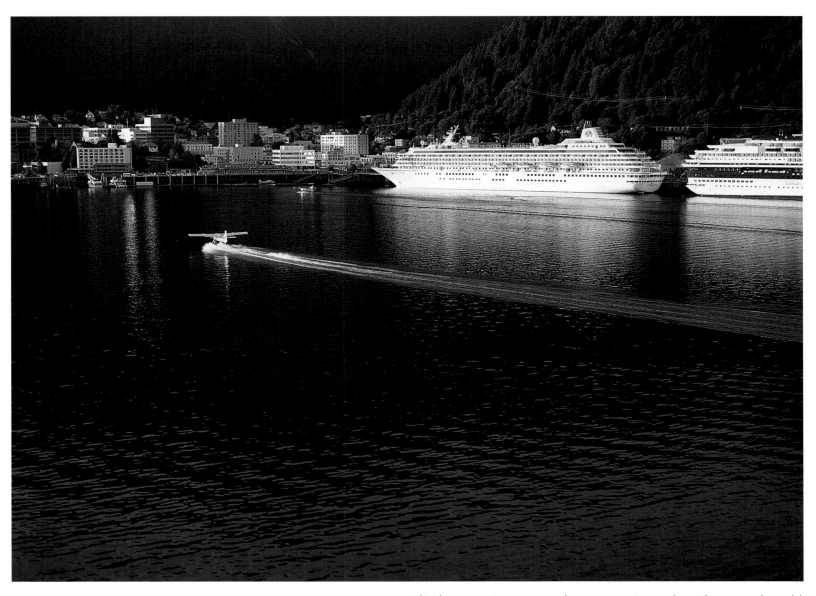

◄ Climbers use ice axes and crampons to explore the surreal world of seracs and a blue pool contained in an icefall on the Mendenhall Glacier. Using helicopters, which are permitted by Tongass National Forest, Northstar Trekking flies adventurers onto Mendenhall Glacier.
▲ Wings of Alaska's de Havilland Otter lands on Gastineau Channel, with luxurious cruise ships and the city of Juneau beyond. Ice trekking and flightseeing tours are two of the many shore excursion activities offered to cruise ship passengers and independent travelers in Alaska.

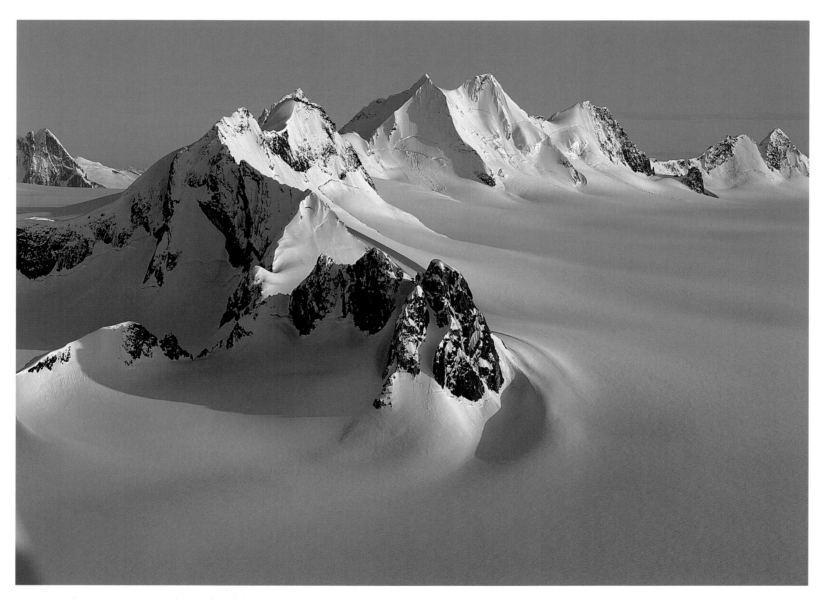

▲ Nunataks (mountain peaks with all but their very tops encased by glaciers) rise from the fifteen-hundred-square-mile Juneau Icefield, part of Tongass National Forest. More than thirty valley glaciers— including the well-known Mendenhall, Eagle, Herbert, Taku, and Norris Glaciers—descend from the Juneau Icefield to near sea level. In places, the icefield is more than thirty-five hundred feet thick.
▶ The Juneau-Douglas Bridge spans the Gastineau Channel. With a population of more than twenty-nine thousand people, Juneau is the third largest city in Alaska. It is the only state capital in the nation that is not connected to other cities by a road system.

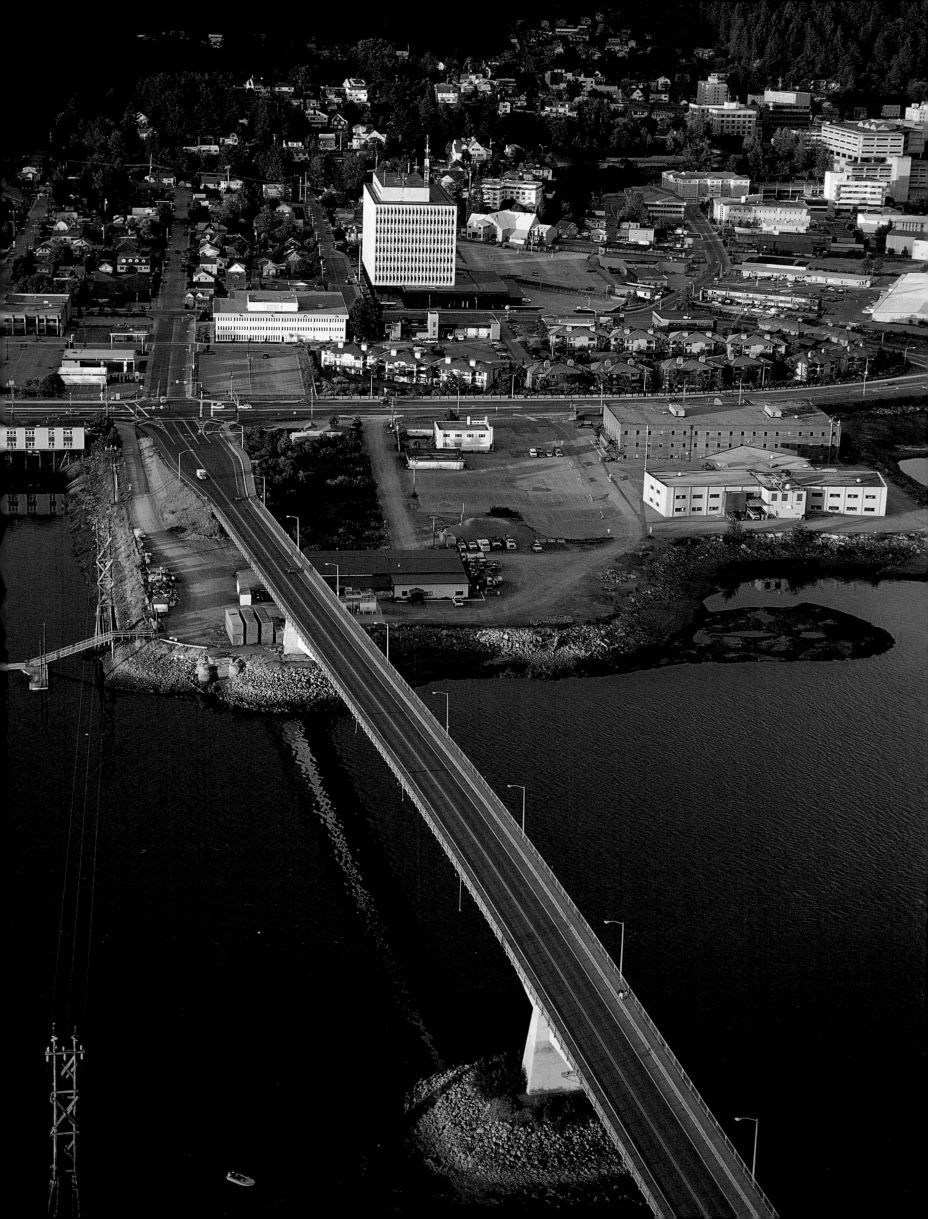

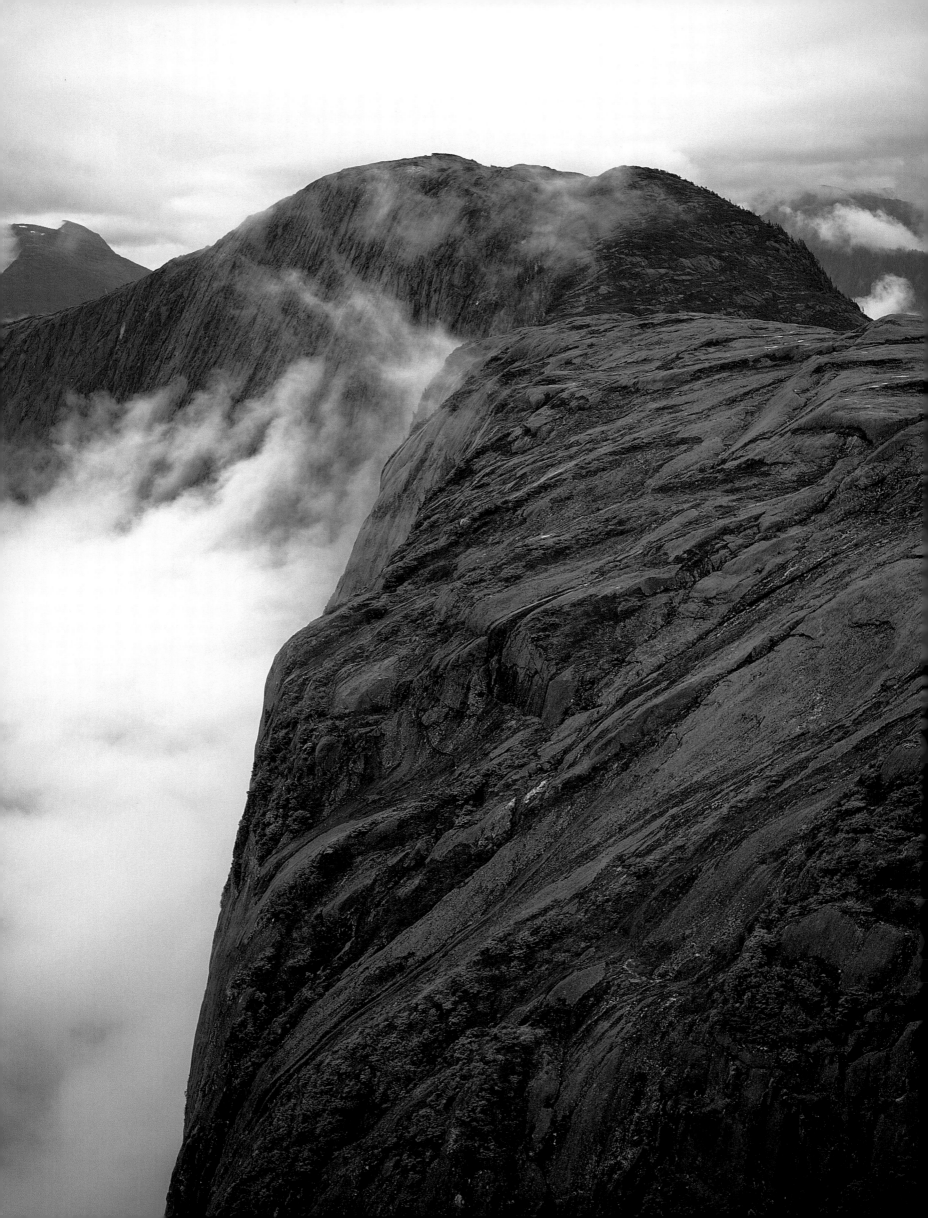

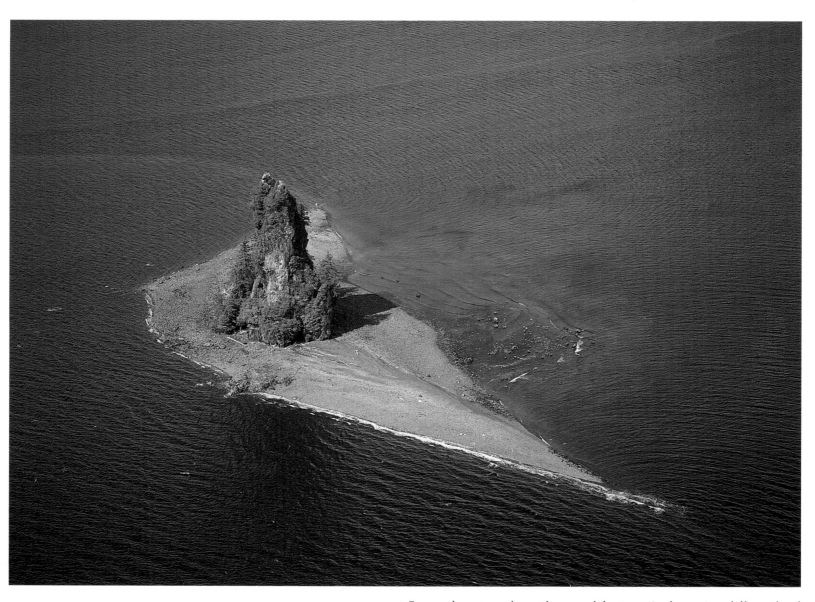

◄ Fog embraces a three-thousand-foot vertical granite cliff south of Rudyerd Bay in Misty Fiords National Monument. With an average 160 inches of annual precipitation, Misty Fiords is one of the wettest places in North America. In a sense, the fjords could be considered a rain forest version of Yosemite National Park in California.

▲ A natural beacon located in the center of the Behm Canal, New Eddystone Rock is the 230-foot remnant of an ancient volcanic plug. In 1793, Captain George Vancouver named the rock for its resemblance to the Eddystone Lighthouse in Plymouth, England.

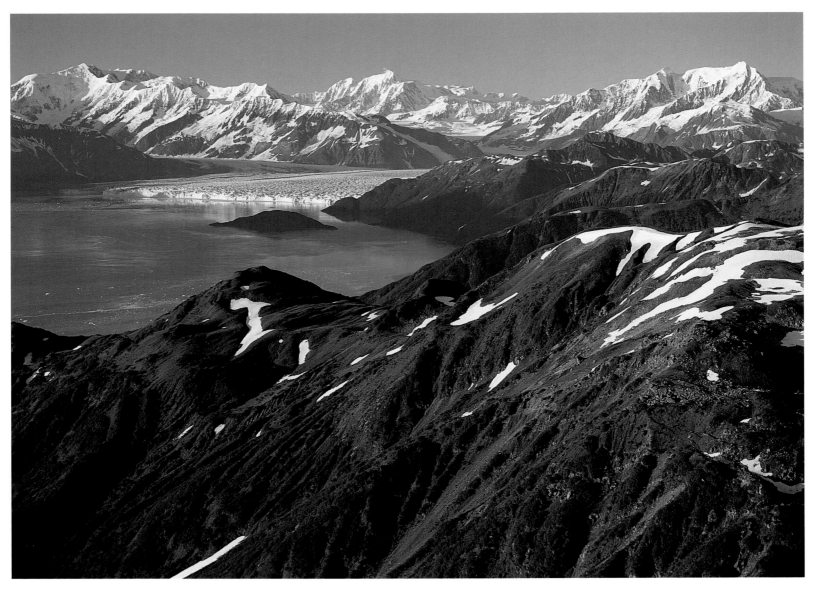

▲ From above the Russell Fiord Wilderness, a grand panorama unfolds, including Disenchantment Bay, Hubbard Glacier, and Mounts Foresta, Hubbard, and Seattle. The scene includes portions of the Tongass National Forest and Wrangell–Saint Elias National Park.
▶ Gateway to Southeast Alaska, Ketchikan embraces the forested slopes of Revillagigedo Island and Tongass Narrows. Approximately fifteen thousand residents live in the area surrounding Ketchikan.
▶ ▶ On a stormy evening, sunset gives warmth to Mount Wrather, located about fourteen miles north of Juneau in the Coast Mountains.

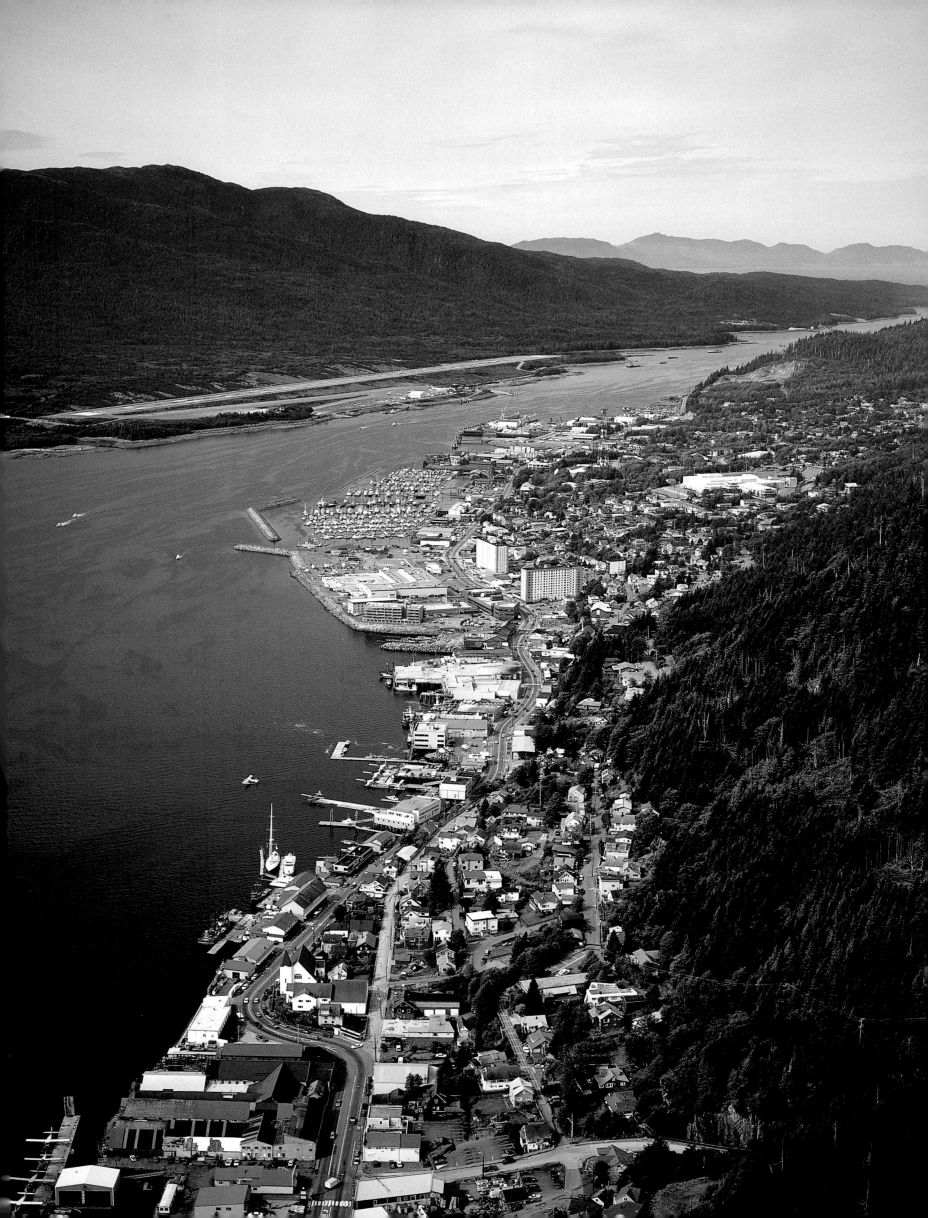

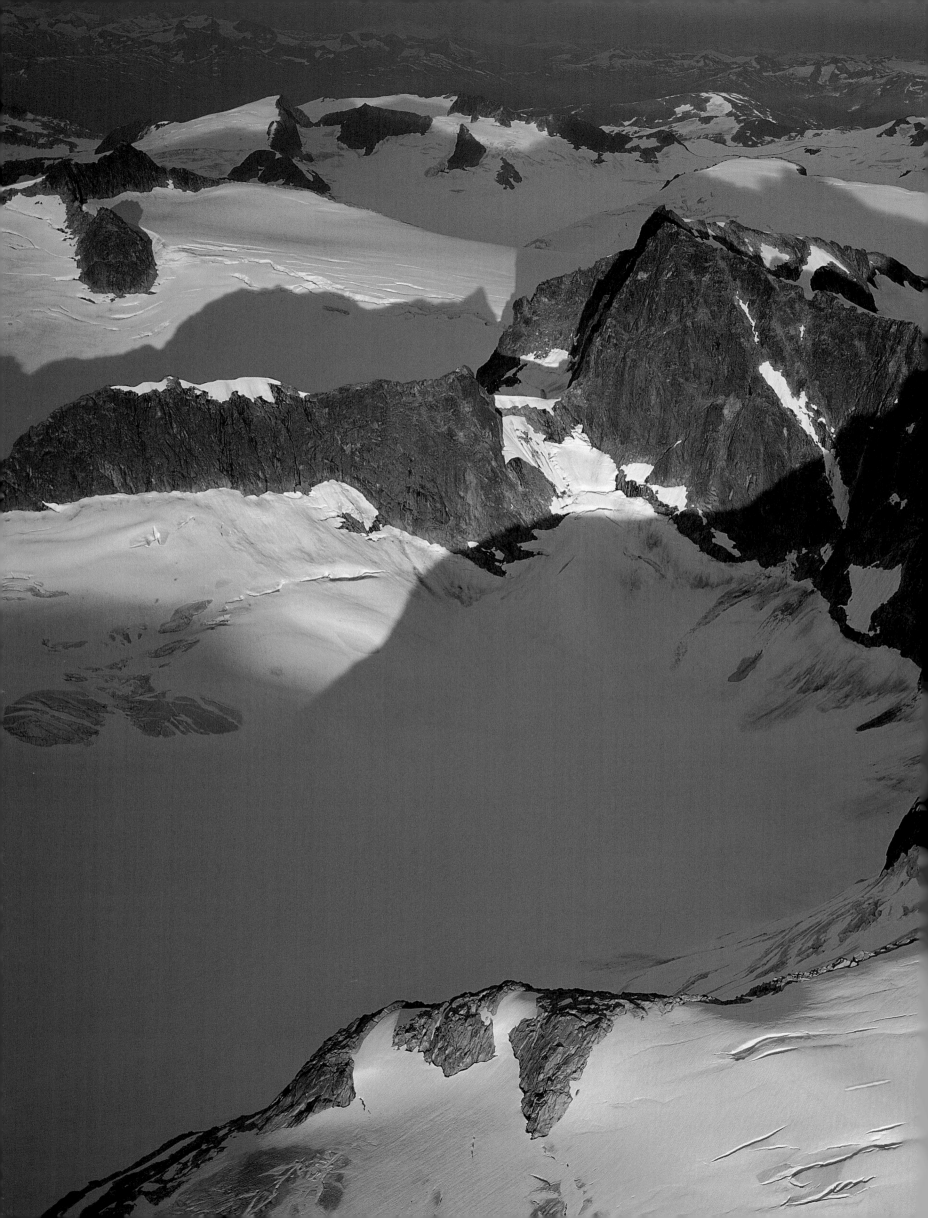

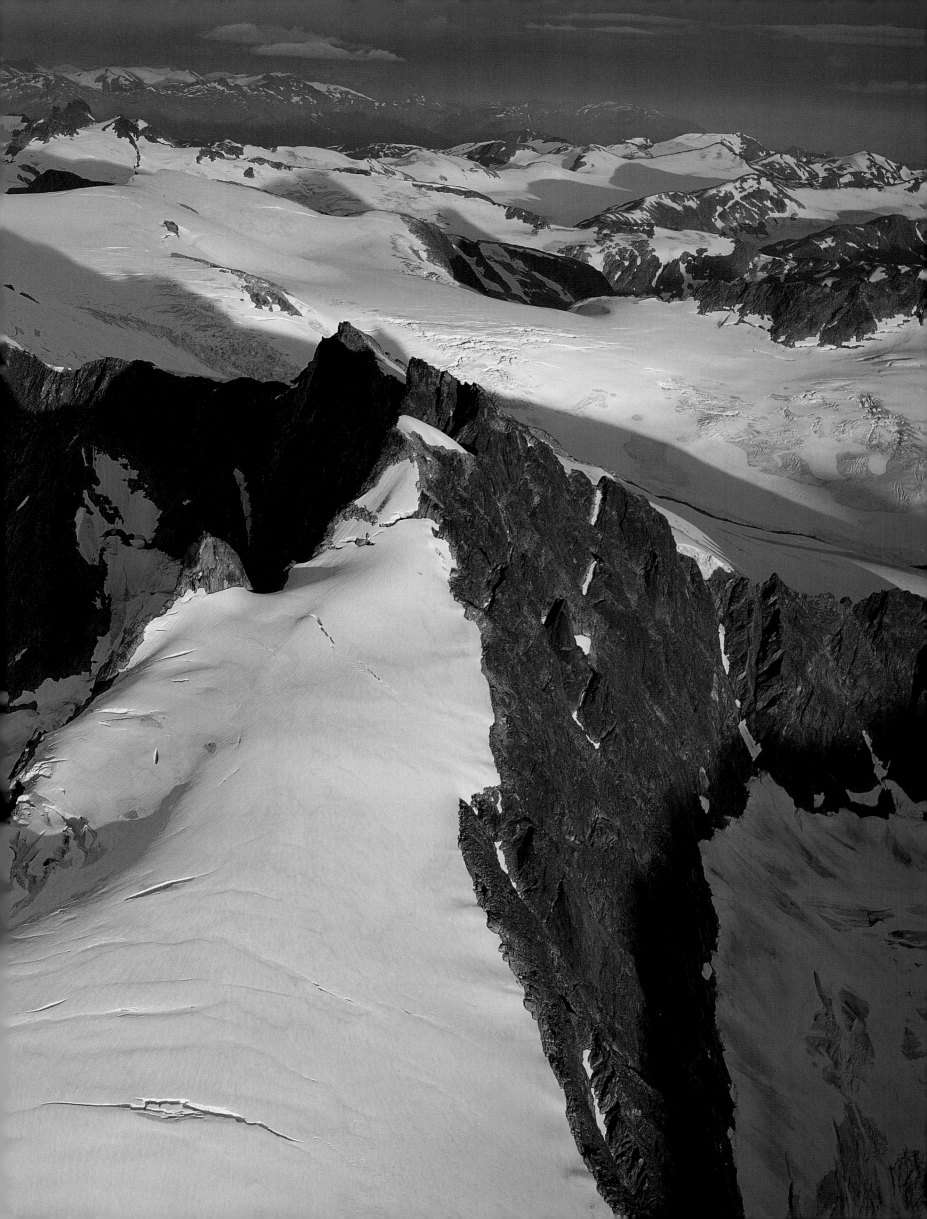

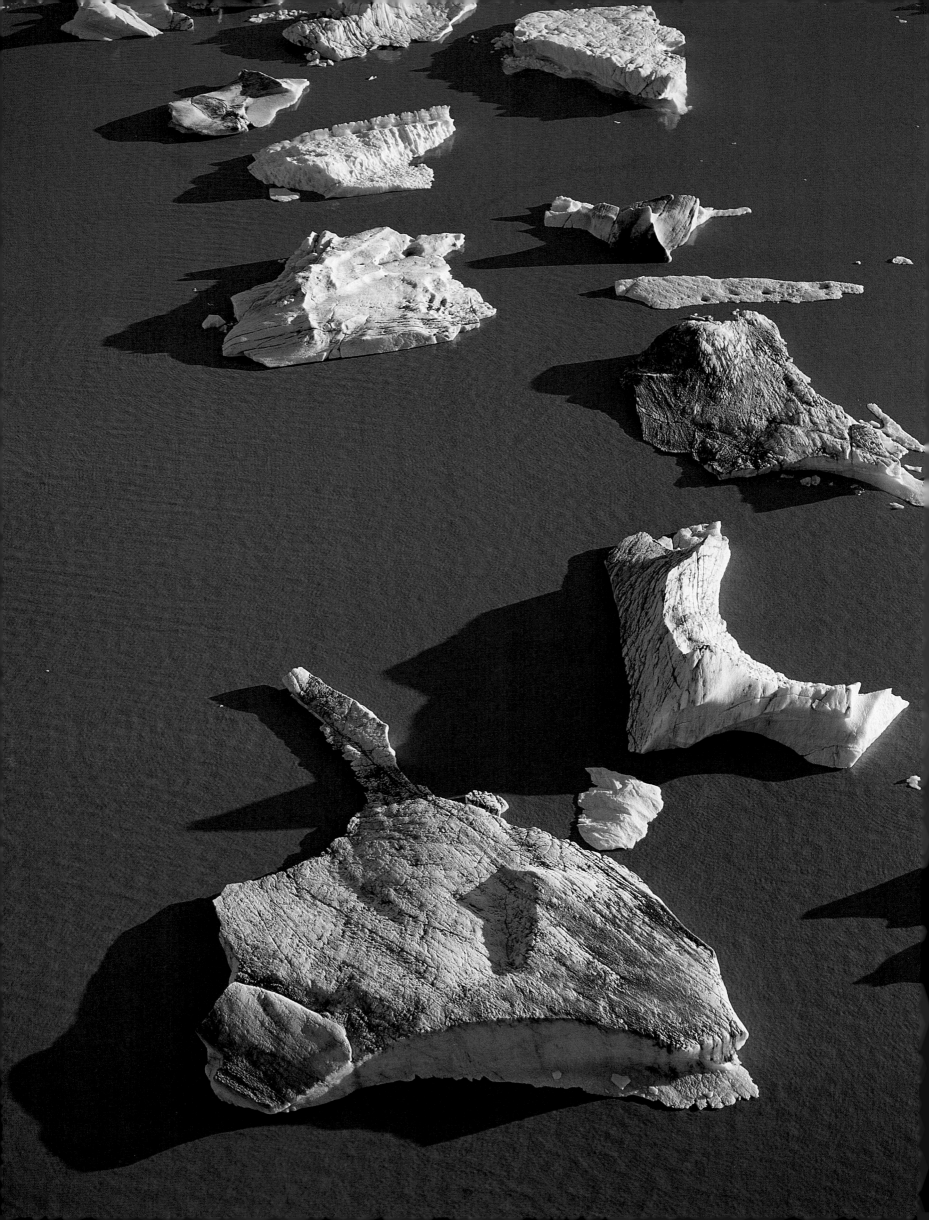

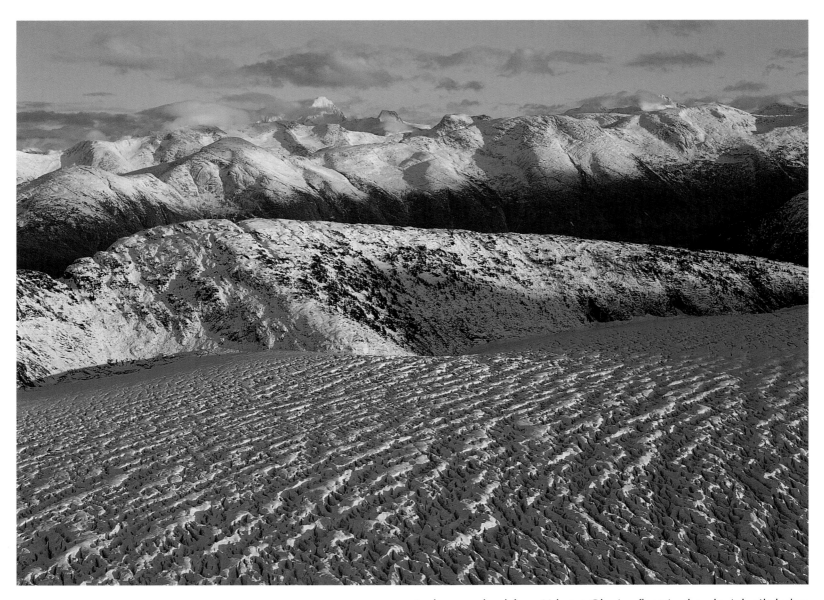

◄ Icebergs calved from Yakutat Glacier float in the glacial, silt-laden water of Harlequin Lake, part of Tongass National Forest's Russell Fiord Wilderness. Only 20 to 25 percent of an iceberg's mass is visible above water—leaving 75 to 80 percent to the imagination.
▲ Along Goat Ridge, the highly crevassed Taku Glacier spills toward Taku Inlet. More than thirty miles long, Taku Glacier is Juneau Icefield's largest glacier. John Muir once wrote, "To see this one glacier is well worth a trip to Alaska." About 15 percent of Southeast Alaska's Tongass National Forest is covered by glaciers.

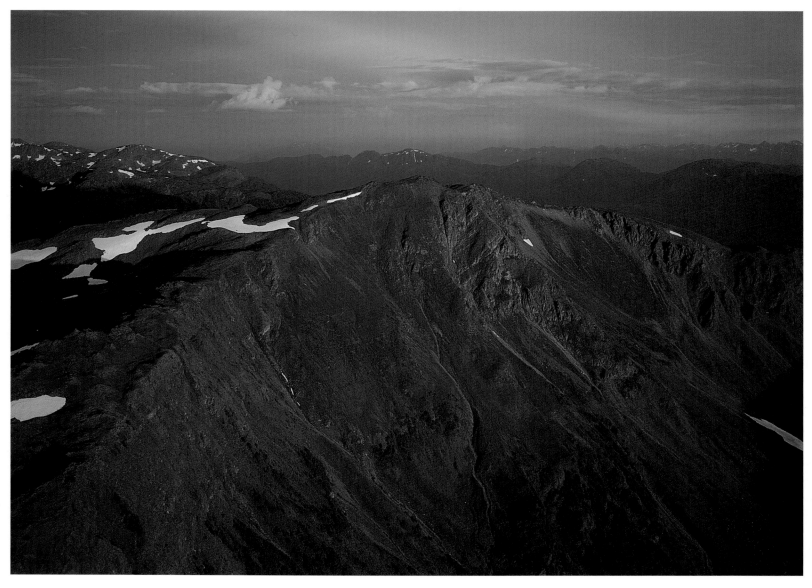

▲ Thunder Mountain, in Southeast Alaska's Coast Mountains, basks in the warmth of the setting sun. The range, which includes this part near Juneau, runs for a thousand miles, from the Frasier River east of Vancouver to just southeast of Haines Junction in the Yukon Territory.
▶ The Tusk is one of a collection of spires on an arête east of Battle Glacier. *Arête,* a French term originating in the Alps, means a serrated rock ridge that runs between two steep, glacially carved slopes.

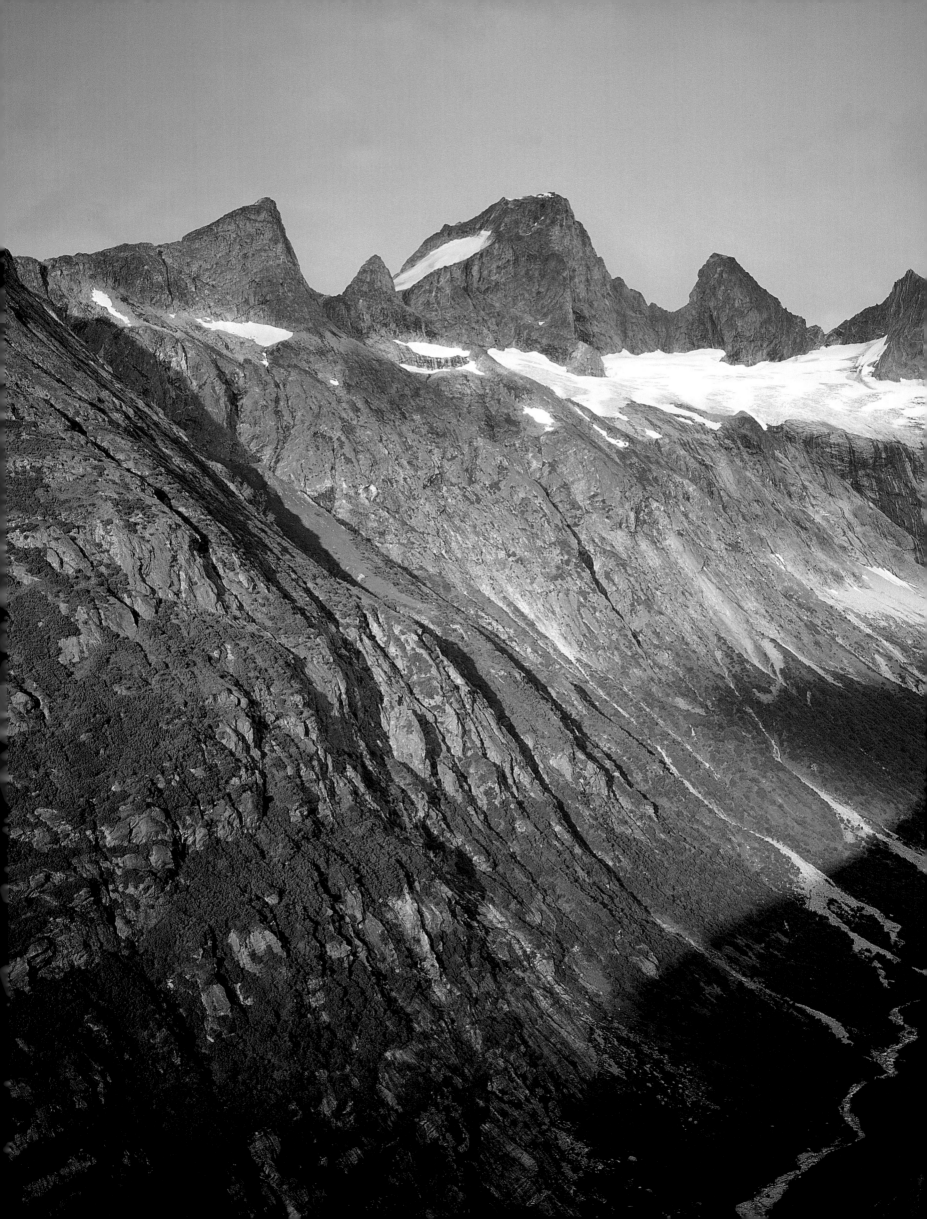

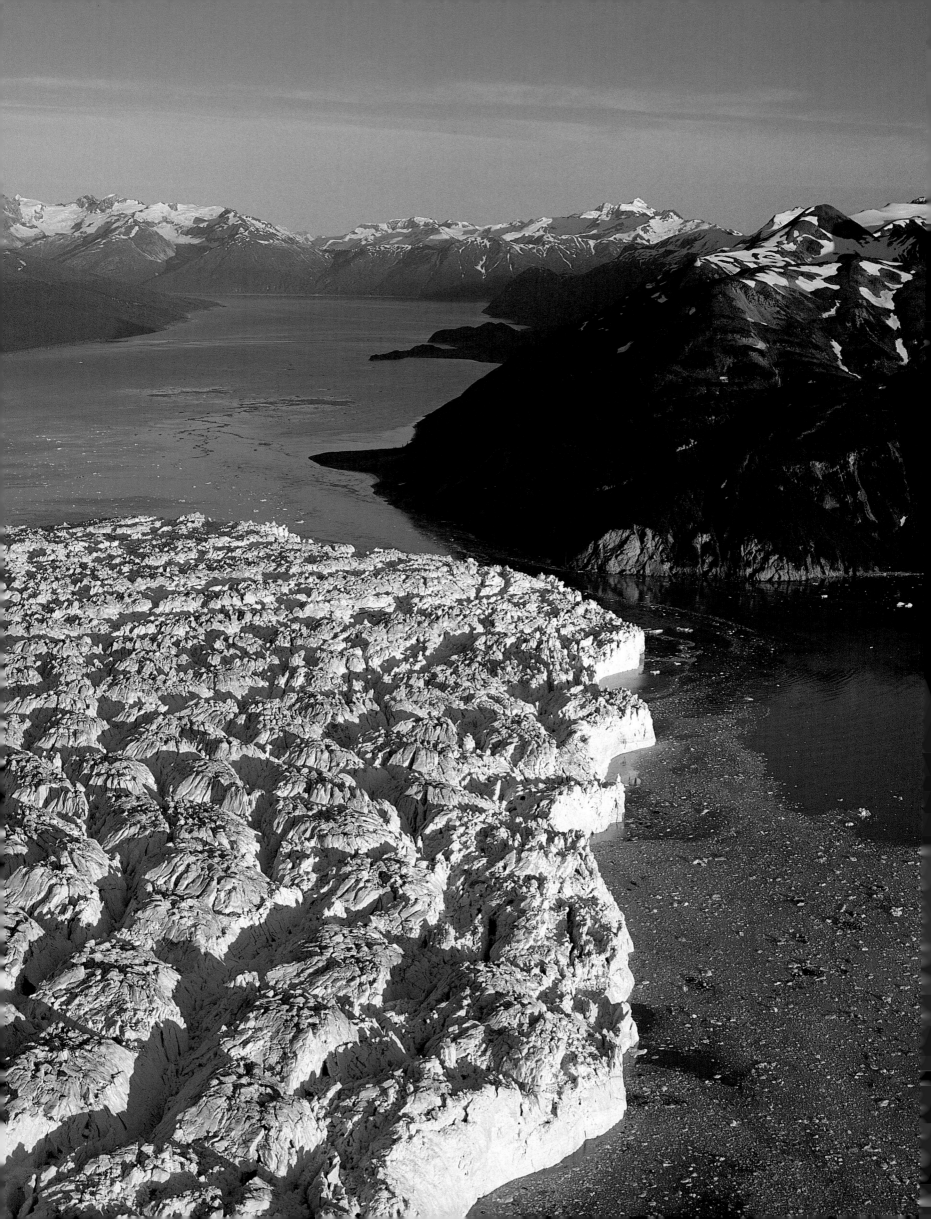

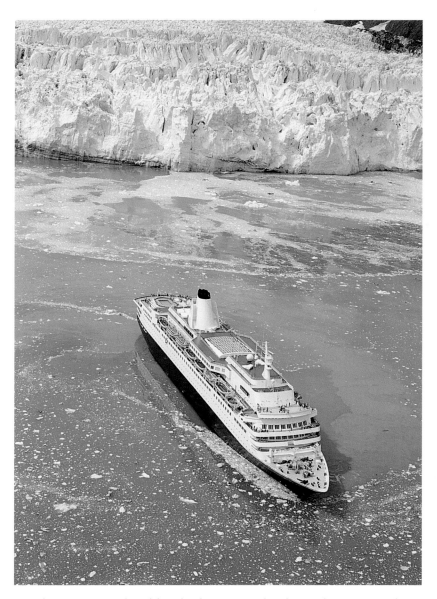

◄ Advancement of Hubbard Glacier nearly closes the passage from Disenchantment Bay into Russell Fiord. The ninety-two-mile-long Hubbard Glacier, North America's longest valley glacier, has sealed the waterway in the past. In 1986, the glacier dammed Russell Fiord for six months. When the dam broke, geologists estimate 3.5 million cubic feet of water per second spilled into Disenchantment Bay.
▲ Up to two cruise ships a day explore the West Arm of Glacier Bay National Park. One favorite stop is near the Margerie Glacier in Tarr Inlet, where passengers watch icebergs calve from the glacier.

▲ Fog shrouds valleys on the western side of Admiralty Island in the Kootznoowoo Wilderness of Admiralty Island National Monument. The Tlingit name *Kootznoowoo* means "Fortress of the Bears." Roaming the island and hidden beneath the temperate rain forest canopy of spruce, hemlock, and cedar are an estimated seventeen hundred brown bears, about one for each square mile of Admiralty Island.
▶ The historic city of Sitka, once Russia's capital of the territory, is on Baranof Island. Sitka's population numbers more than nine thousand.

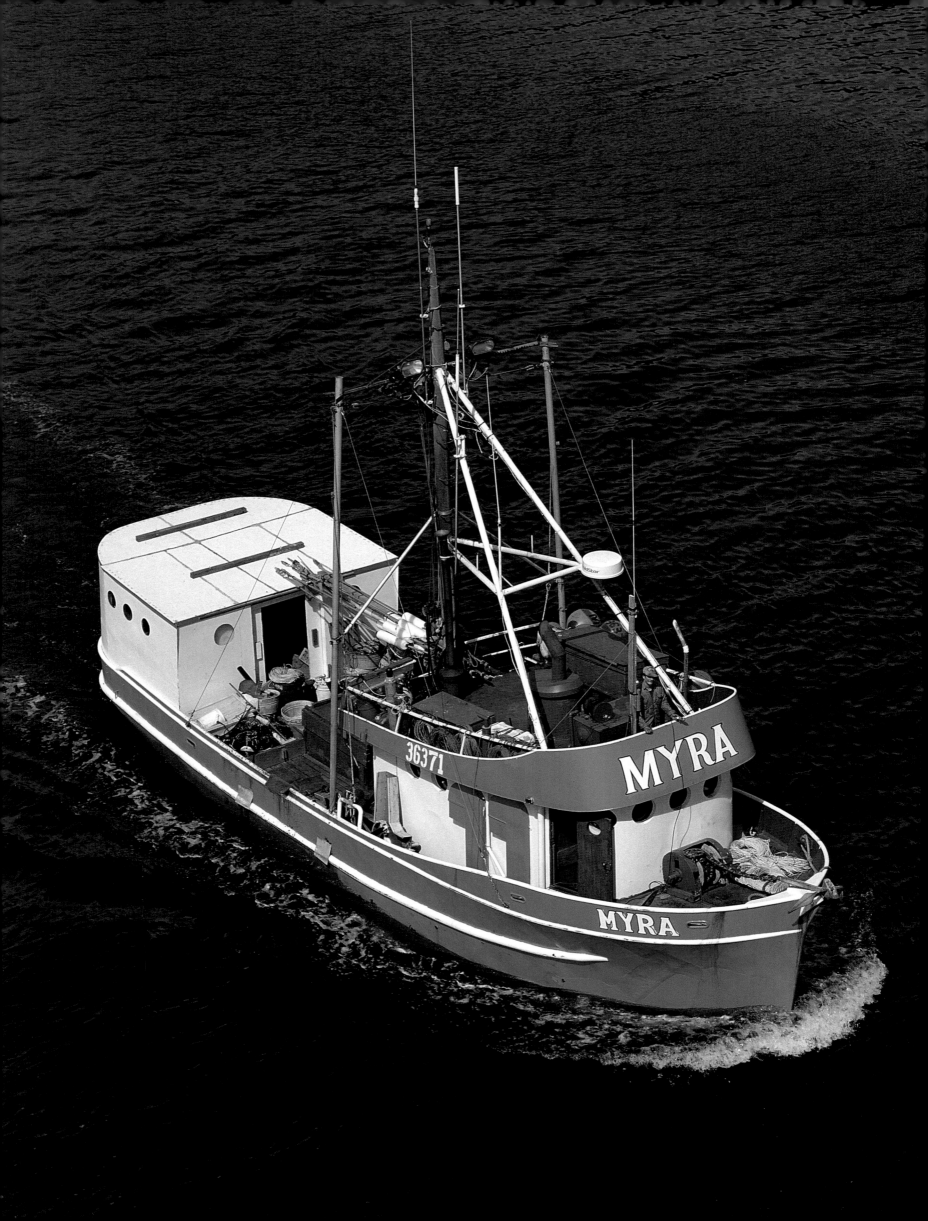

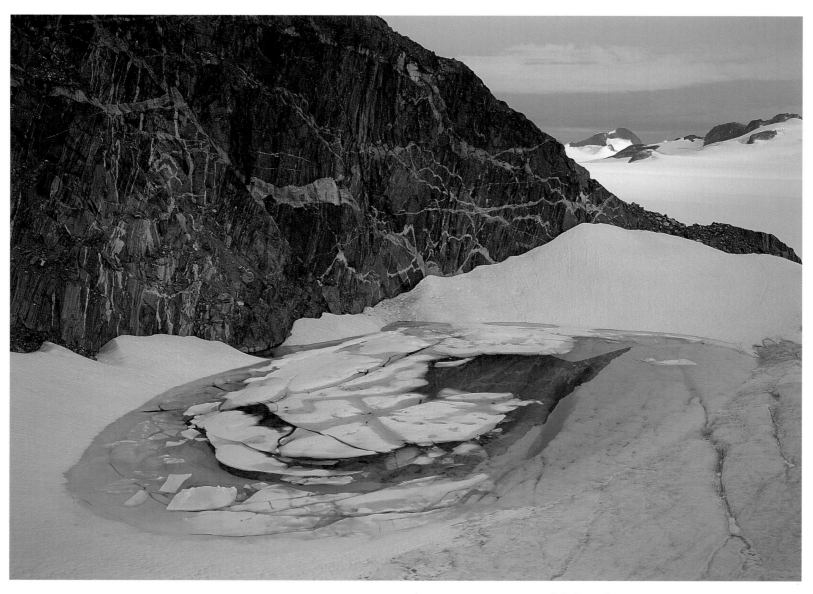

◄ The *Myra,* a commercial fishing boat, returns to harbor in Sitka. Approximately 56 percent of the total seafood in the United States is caught in the waters of Alaska. This billion-dollar industry harvests between five and six billion pounds of fish and shellfish annually.
▲ Next to Echo Mountain, a glacial meltwater pond rests on ice of the Juneau Icefield. The deep blue color comes from the natural property of both water and ice to reflect blue light back to the eye. Such meltwater pools are usually ephemeral in nature, draining through the glacial ice before the next season's snow arrives.

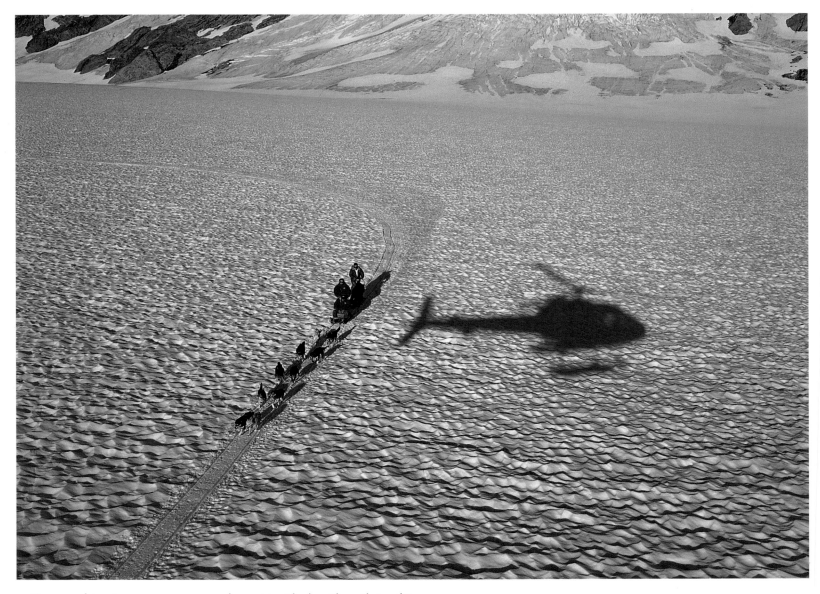

▲ Dog mushing is now a year-round sport in Alaska. The pilots of Era Helicopters land visitors on the summer snows of the Norris Glacier so they can personally experience dog sledding. Musher Lorraine Temple and ten of her enthusiastic sled dogs take a group for a ride.
► The Alaska Marine Highway's newest ferry, M/V *Kennicott,* departs Auke Bay. Nearby, a Wings of Alaska Beaver step taxis. Planes and ferries provide transportation to link Southeast Alaska's communities.

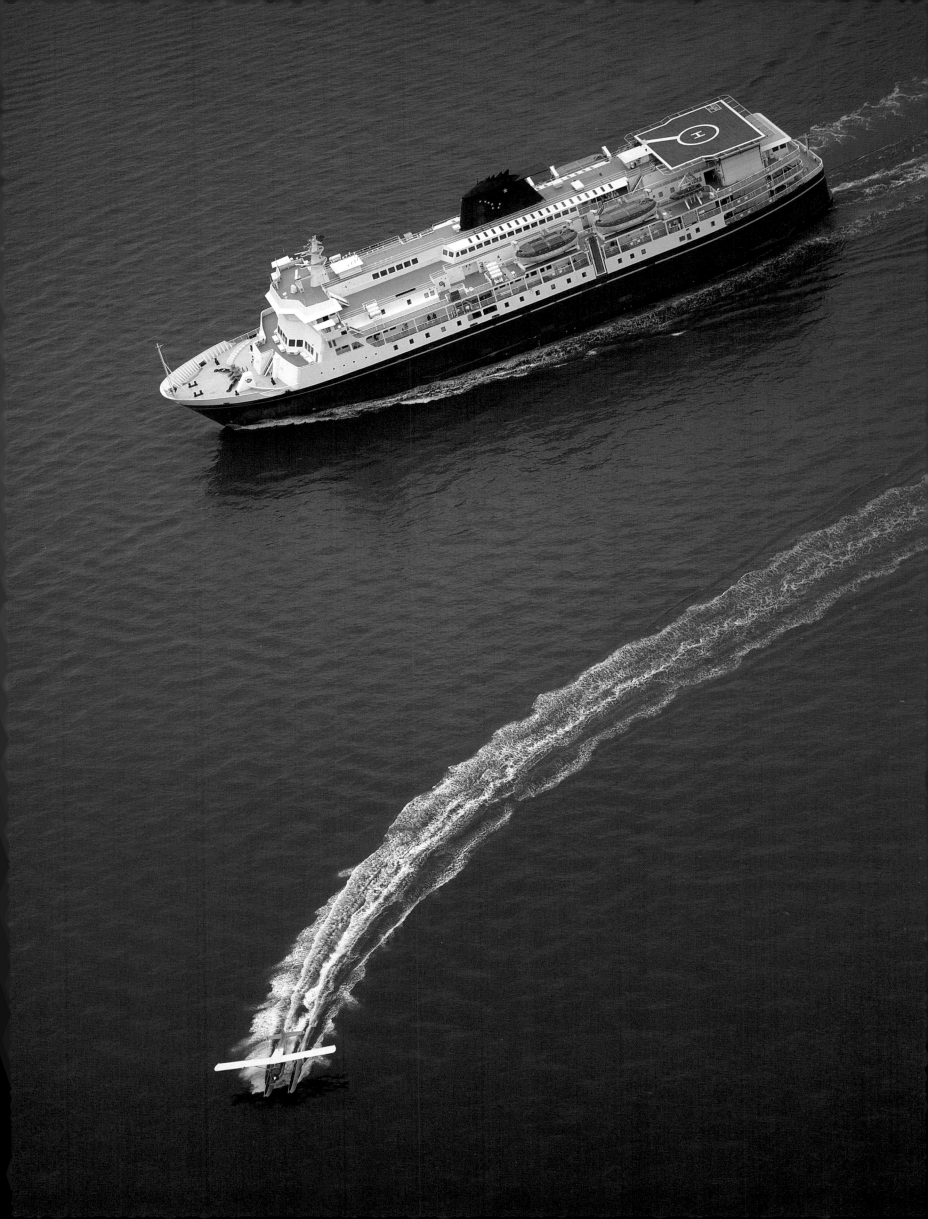

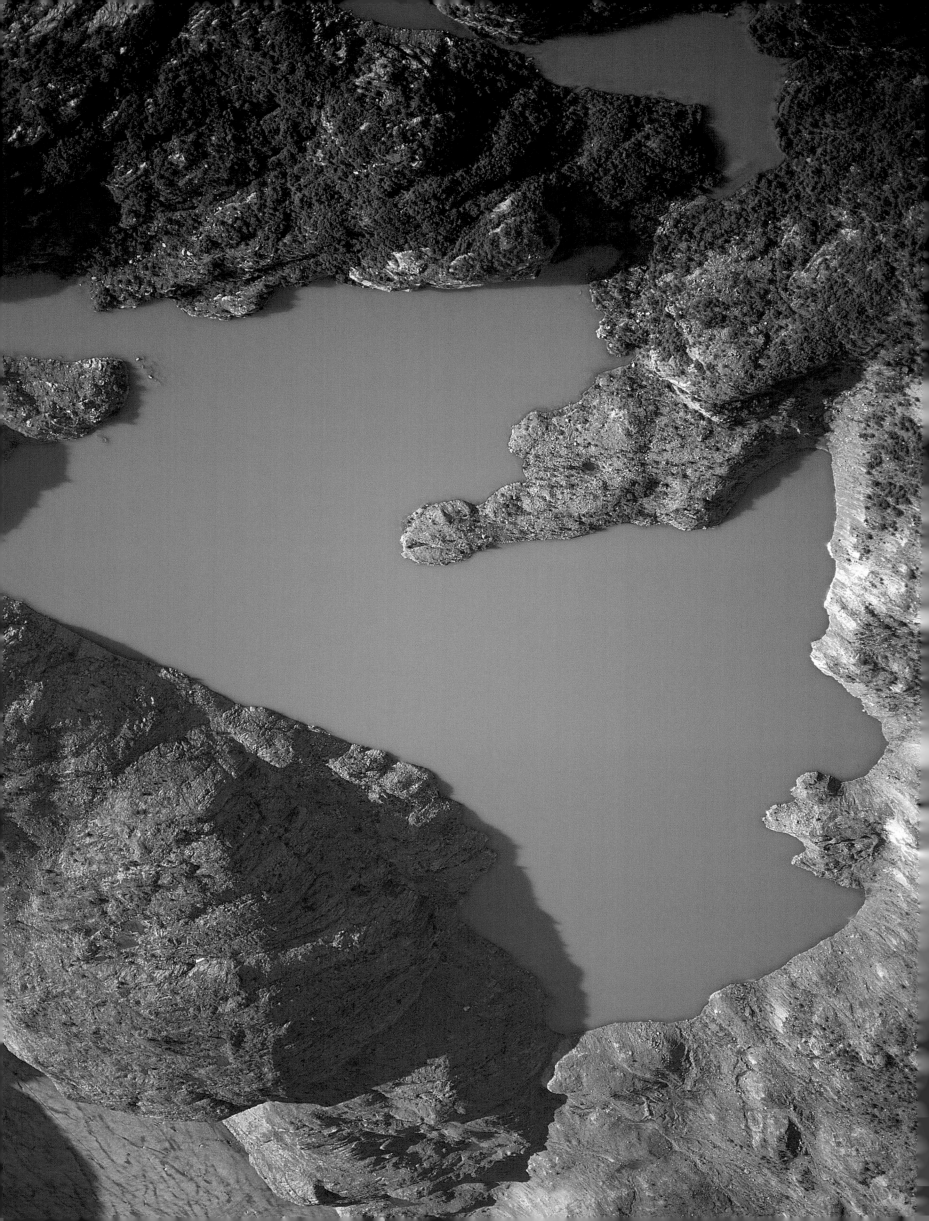

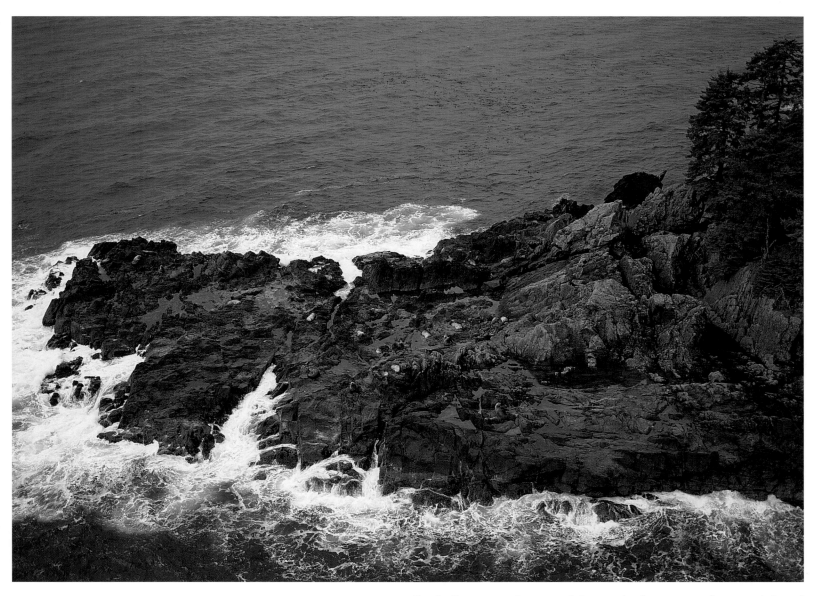

◄ Rock flour—rock ground beneath the tremendous weight of a glacier—imparts a turquoise color. This small lake in Glacier Bay National Park has been impounded by White Thunder Ridge.
▲ Steller sea lions, whose numbers have greatly declined in parts of Alaska, haul out on the rocky shore of Yasha Island where Chatham Strait and Frederick Sound converge. This largest species of sea lion dines on pollock, cod, salmon, herring, octopus, and squid.
► ► In Glacier Bay National Park, the Johns Hopkins Glacier begins to break apart, forming deep crevasses as it flows toward tidewater.

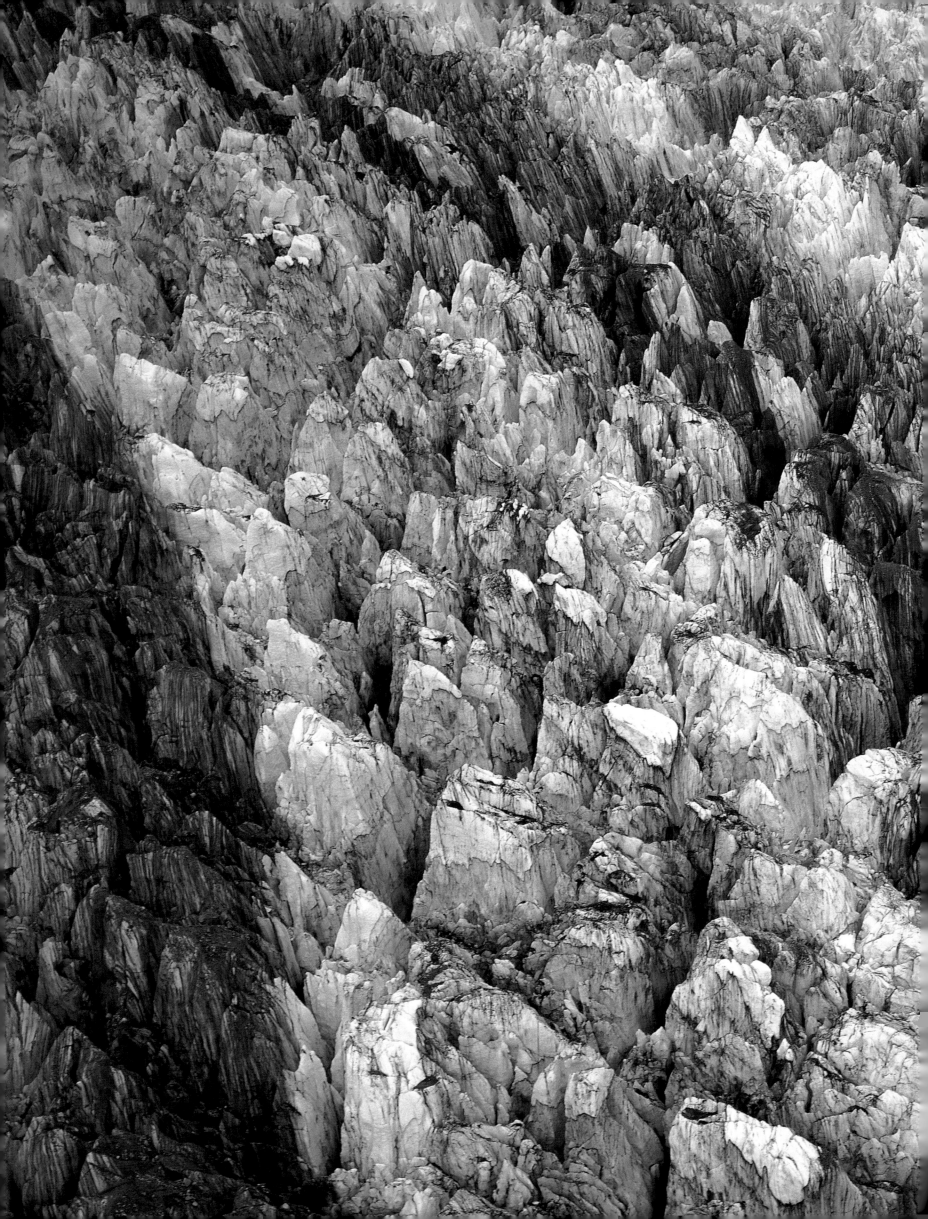

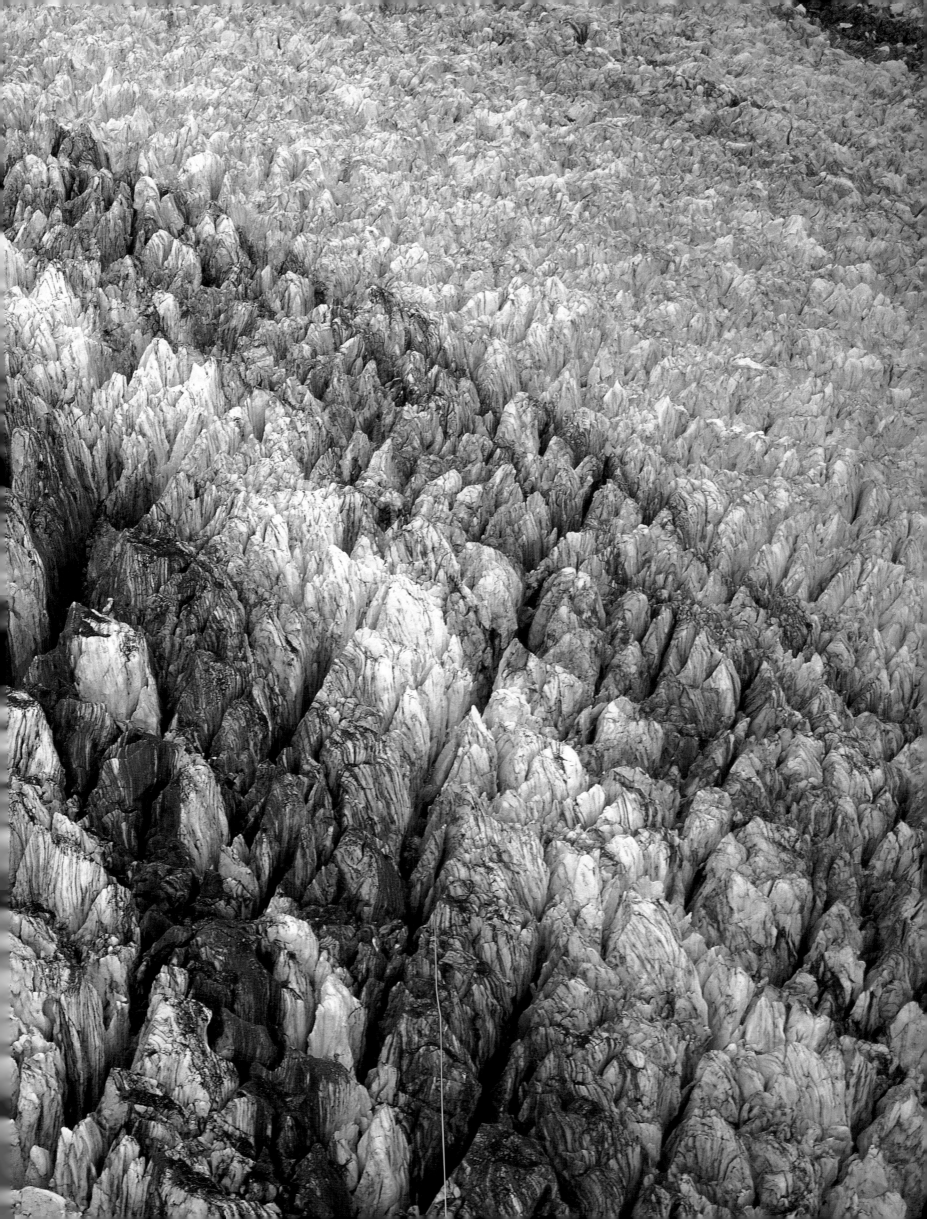

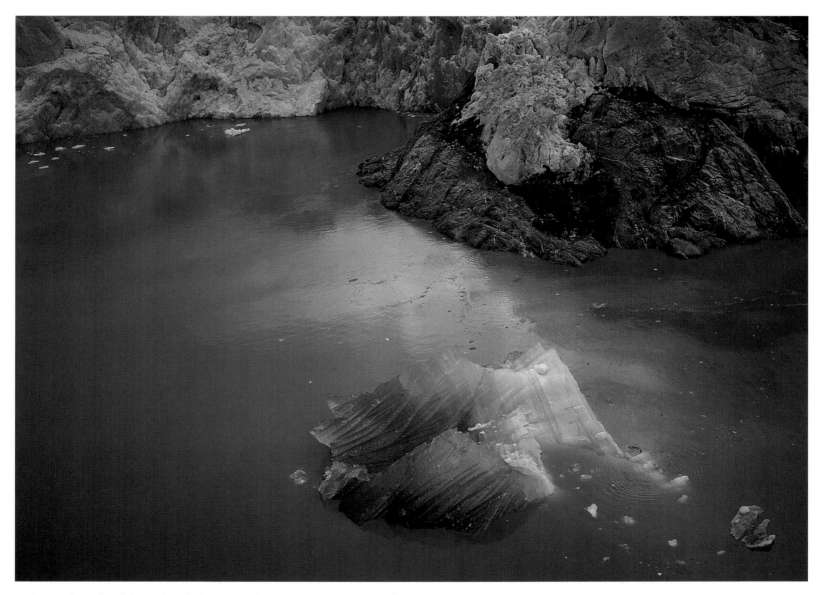

▲ Recently calved from South Sawyer Glacier, a water-saturated iceberg appears a vibrant blue in the waters of Tracy Arm. Tiny air bubbles within a glacier make the ice appear white rather than blue.
▶ Ribbon waterfalls lace through the temperate rain forest that clings to the steep, rocky slopes of Tracy Arm. The Tracy Arm–Fords Terror Wilderness preserves some of the most spectacular scenery to be found within the Tongass National Forest. To perpetuate and protect the natural ecosystems, 5.7 million acres—approximately one-third of the Tongass National Forest—have been preserved as wilderness.

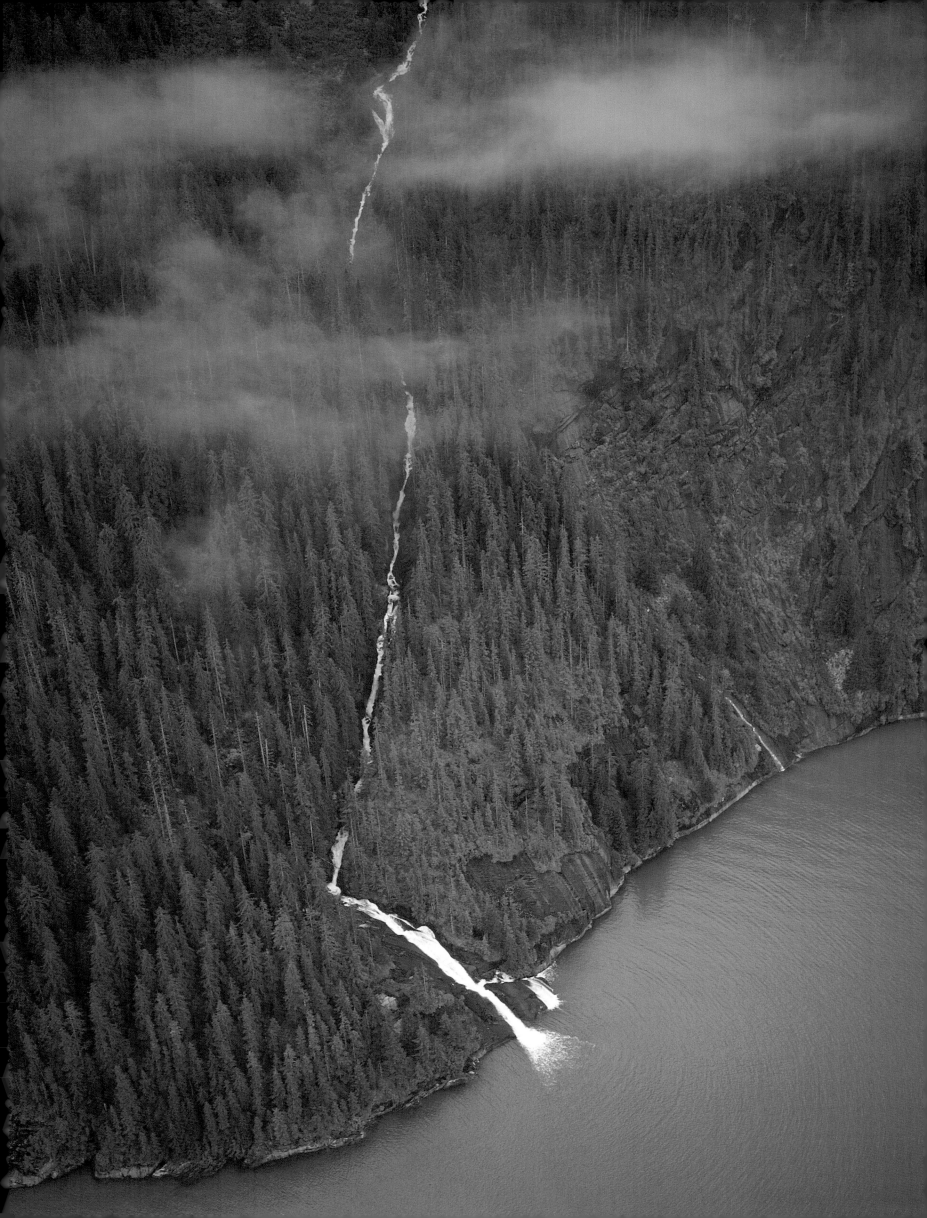

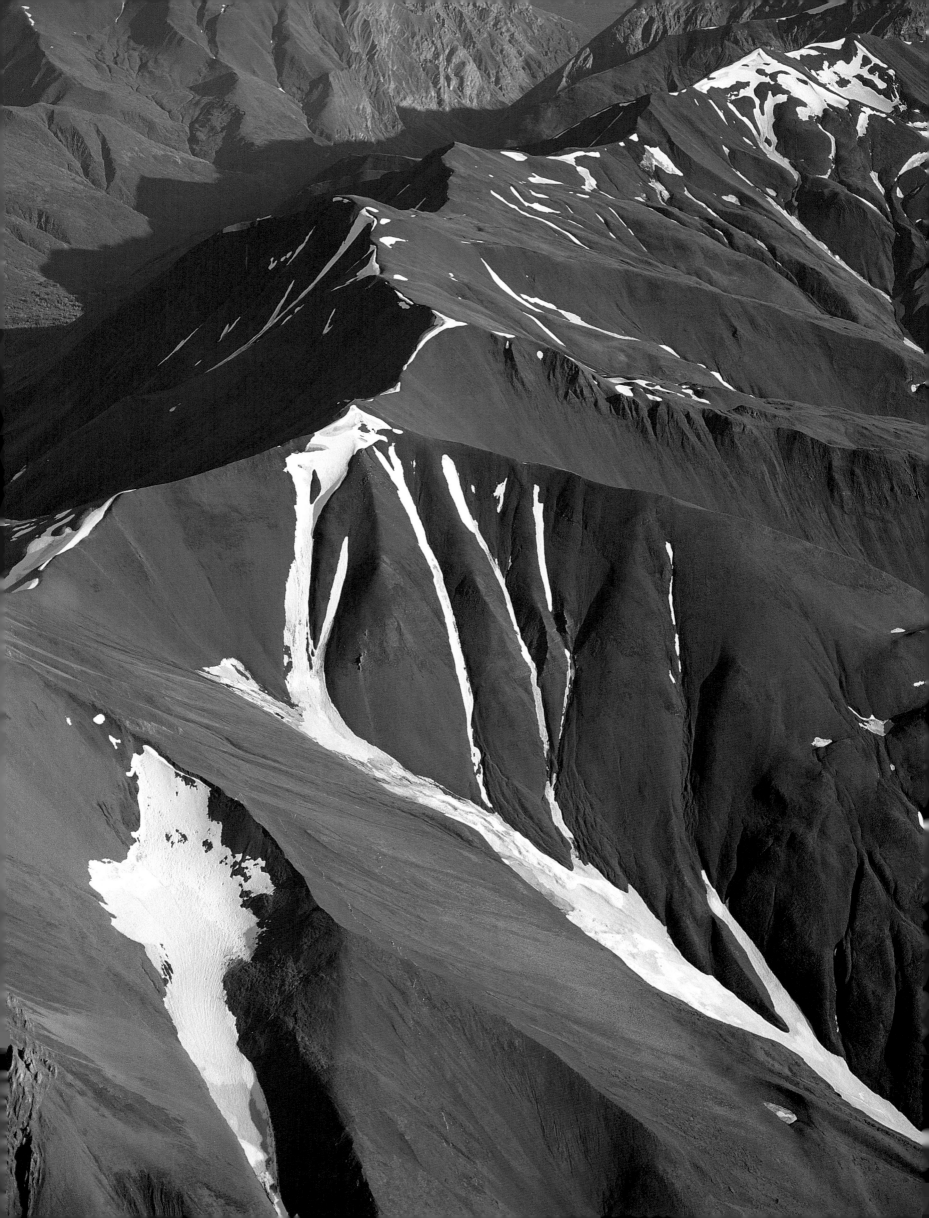

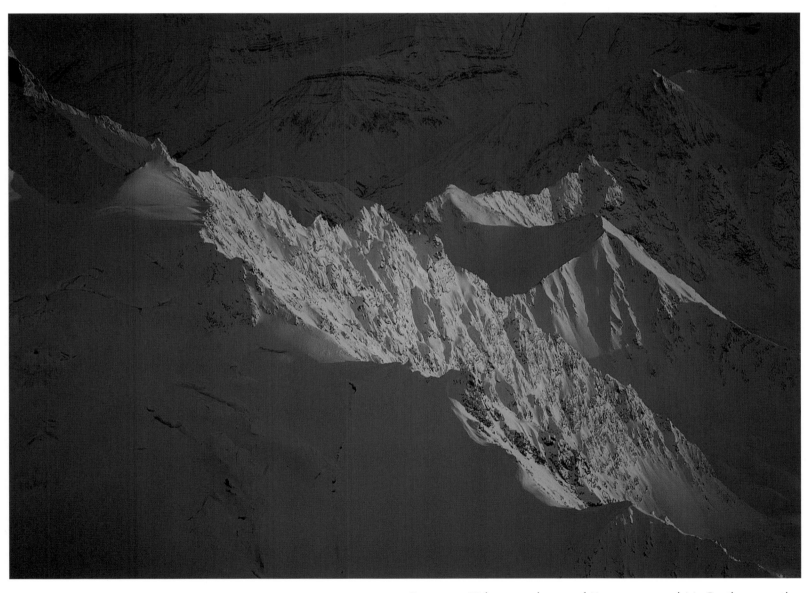

◄ Bonanza Ridge, northeast of Kennecott and McCarthy, was the site of the richest copper strike in the world. Bonanza Ridge is now included in the largest national park in the United States—the 13.2-million-acre Wrangell–Saint Elias National Park and Preserve.
▲ A winter sunset illuminates a ridgeline of the Talkeetna Mountains near the headwaters of the Sheep, Kings, and Kashwitna Rivers.

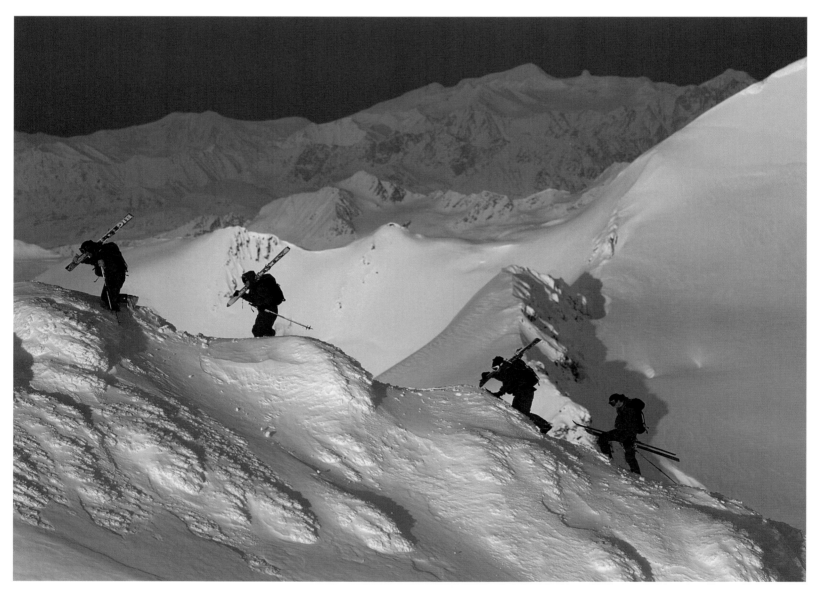

▲ Heliskiers climb a ridgeline after being dropped off by Chugach Powder Guides in the backcountry of the Chugach National Forest.
► Covered with snow in the middle of winter, Barnard Glacier flows from the Saint Elias Mountains in the Wrangell–Saint Elias National Preserve. The ridge in the center of the glacier is a medial moraine. In summer, such a longitudinal stripe appears dark; it consists of rock debris carried from the merging of two glaciers.

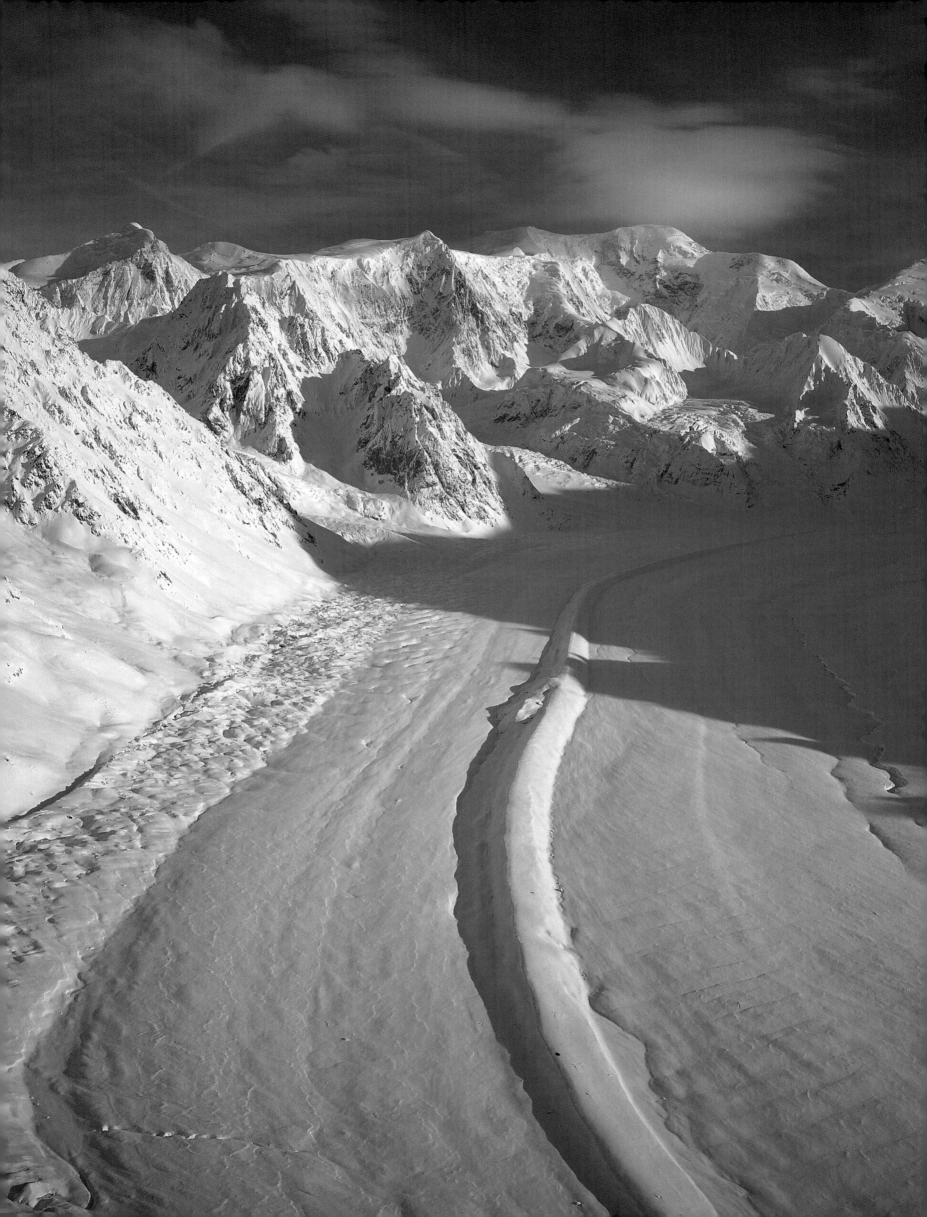

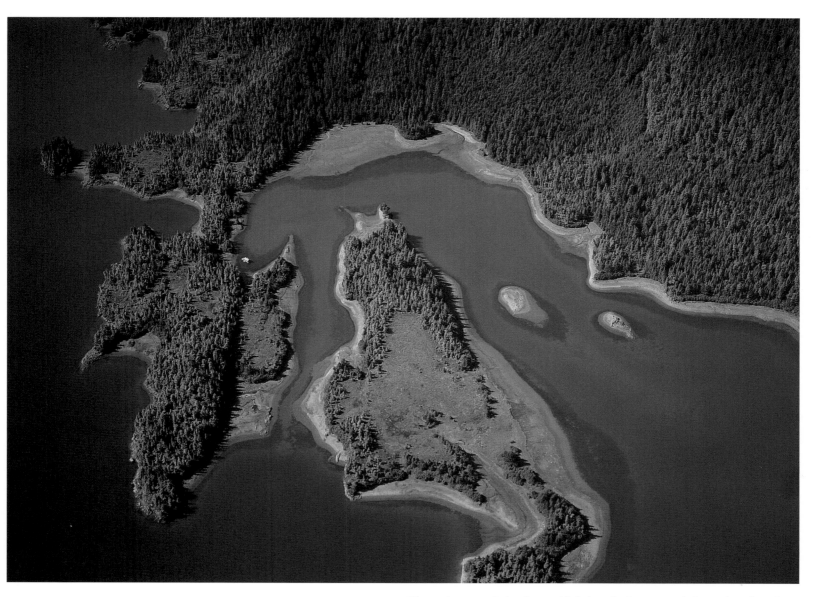

◄ Though certainly beautiful in their own right, clouds often obscure aerial views of the Alaskan landscape. Sunrise showcases a layer of stratocumulus clouds east of the Alaska Range and illuminates a cumulonimbus cloud rising above the range itself.
▲ The pristine shores of Simpson Bay in Prince William Sound protect a lone float house that is designed to go dry when tides recede.

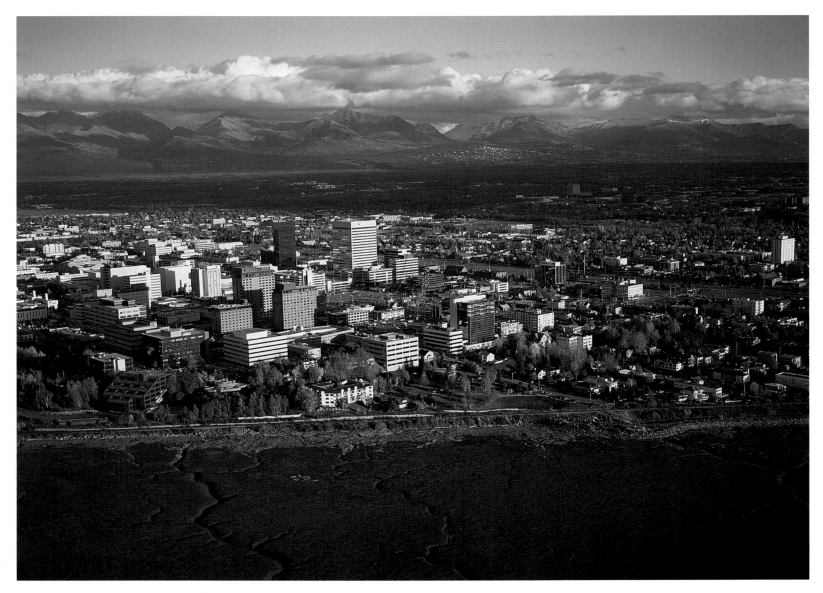

▲ An outgoing tide in the Knik Arm of Cook Inlet leaves Alaska's largest city, Anchorage, high and dry. With a population of 260,000, Anchorage is home to nearly half the residents of Alaska. In recent years, the city has become a major hub for international air freight.
▶ A bank of stratocumulus clouds partially conceals the Knik River northeast of Anchorage. Beyond stretches a stunning view of Twin Peaks, Goat Mountain, Eklutna Lake, and the Chugach Mountains.

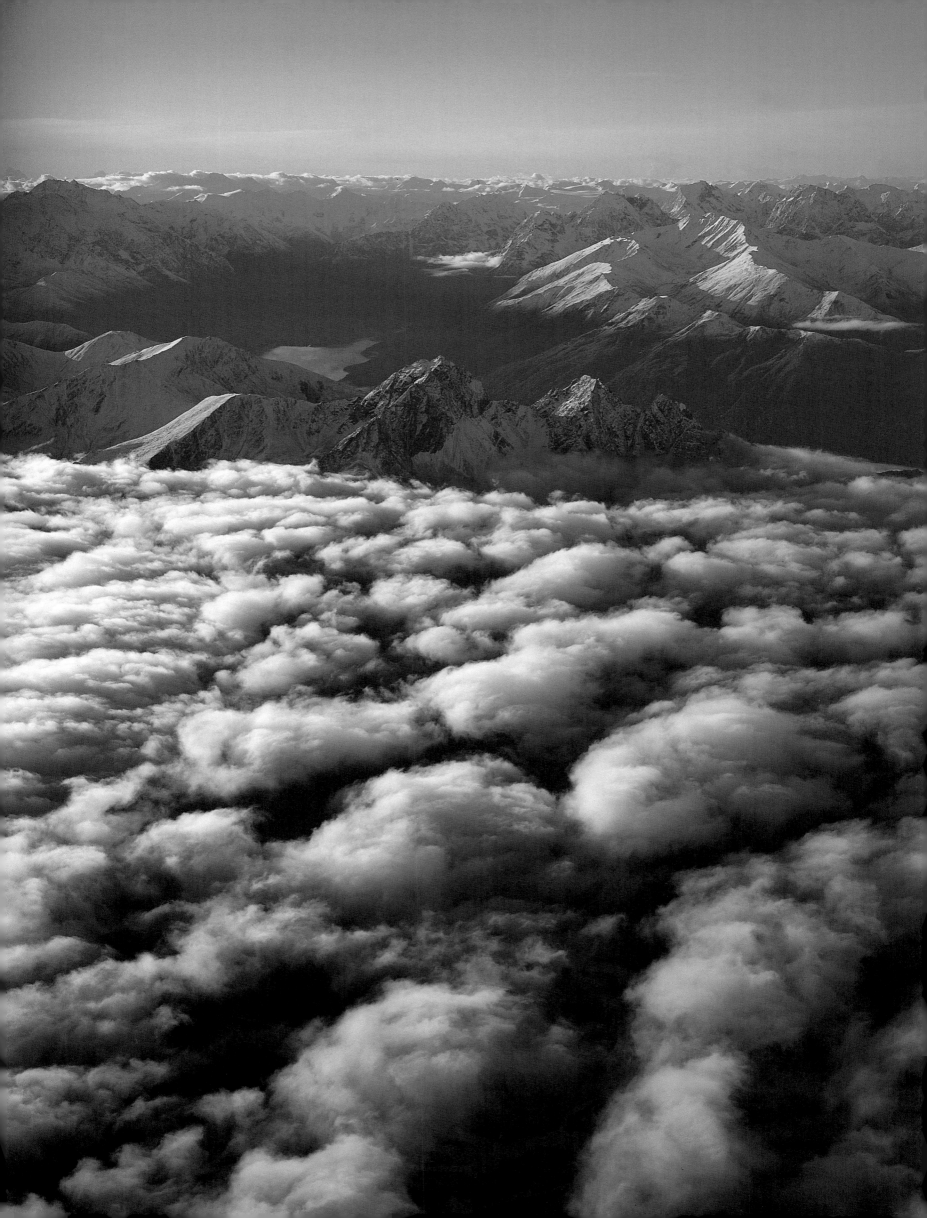

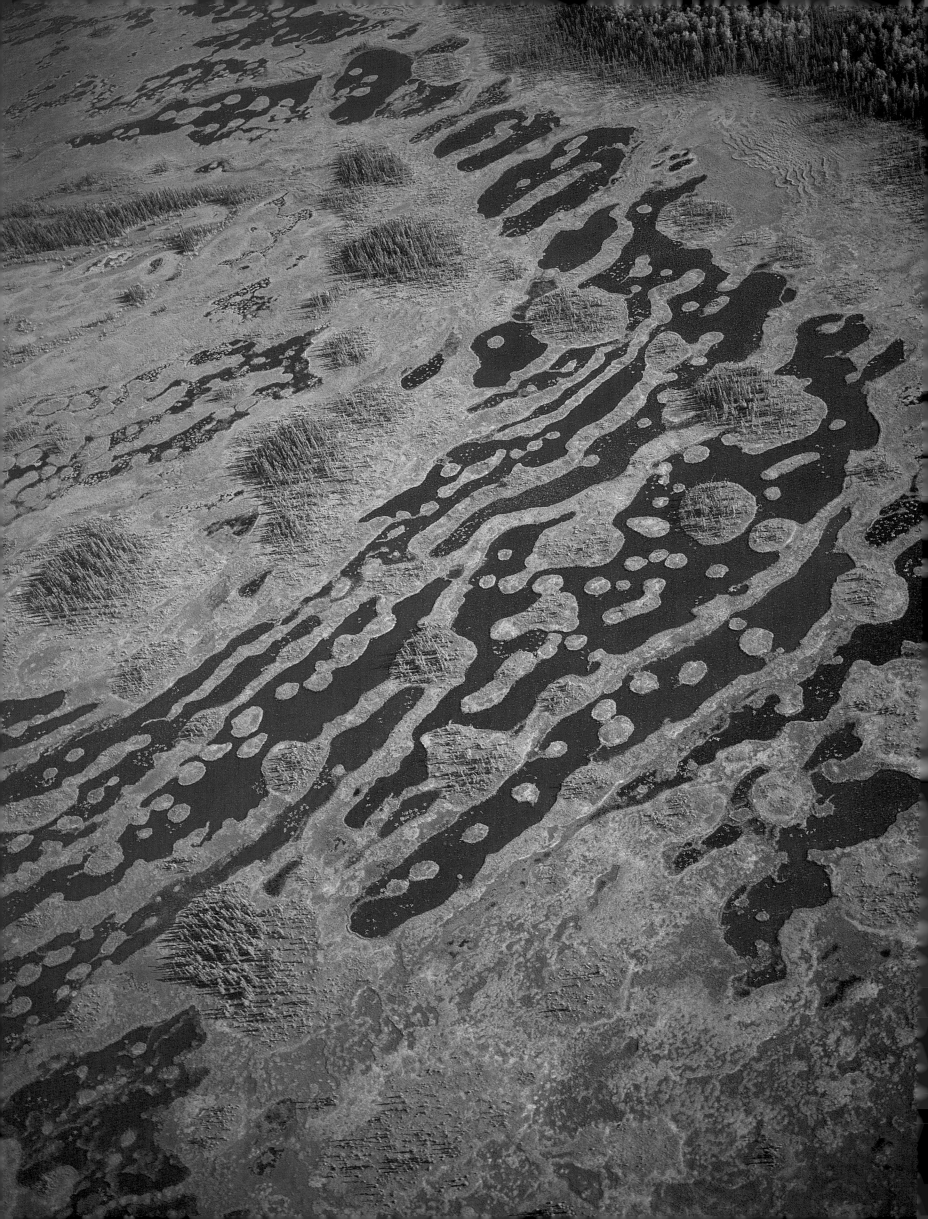

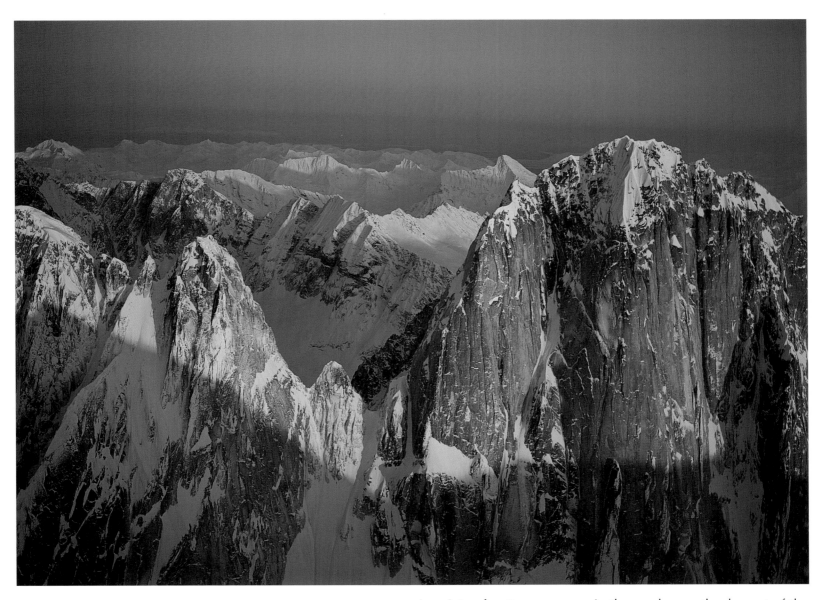

◄ A variety of patterns appears in the muskeg wetlands west of the Susitna River and east of the Alaska Range. On raised islands, small stands of black spruce take decades to grow a few feet in height.
▲ Situated in the southwest corner of Denali National Preserve, the Kichatna Mountains are one of the most spectacular features of the Alaska Range. Here, the sheer granite faces of the Cathedral Spires rise three thousand feet above numerous valley glaciers.

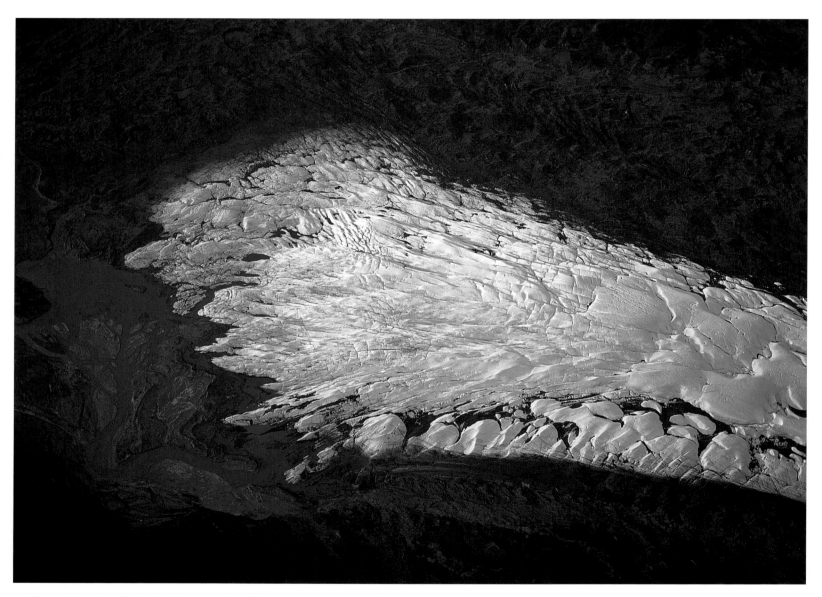

▲ The white "toe" of the Matanuska Glacier rests among darker, till-covered ice and lateral moraines. Located below Glenn Highway between Palmer and Glennallen, the Matanuska is one of Southeast Alaska's few glaciers that are accessible from the highway system.
► A portion of the piedmont lobe of the Bering Glacier calves thousands of icebergs into a lake. Huge bergs that have flipped over reveal grooves caused by rock scraping along the bottom of the glacier.
►► A textbook example of a syncline, Mile High Cliffs in Wrangell–Saint Elias National Park show sedimentary layers folded inward.

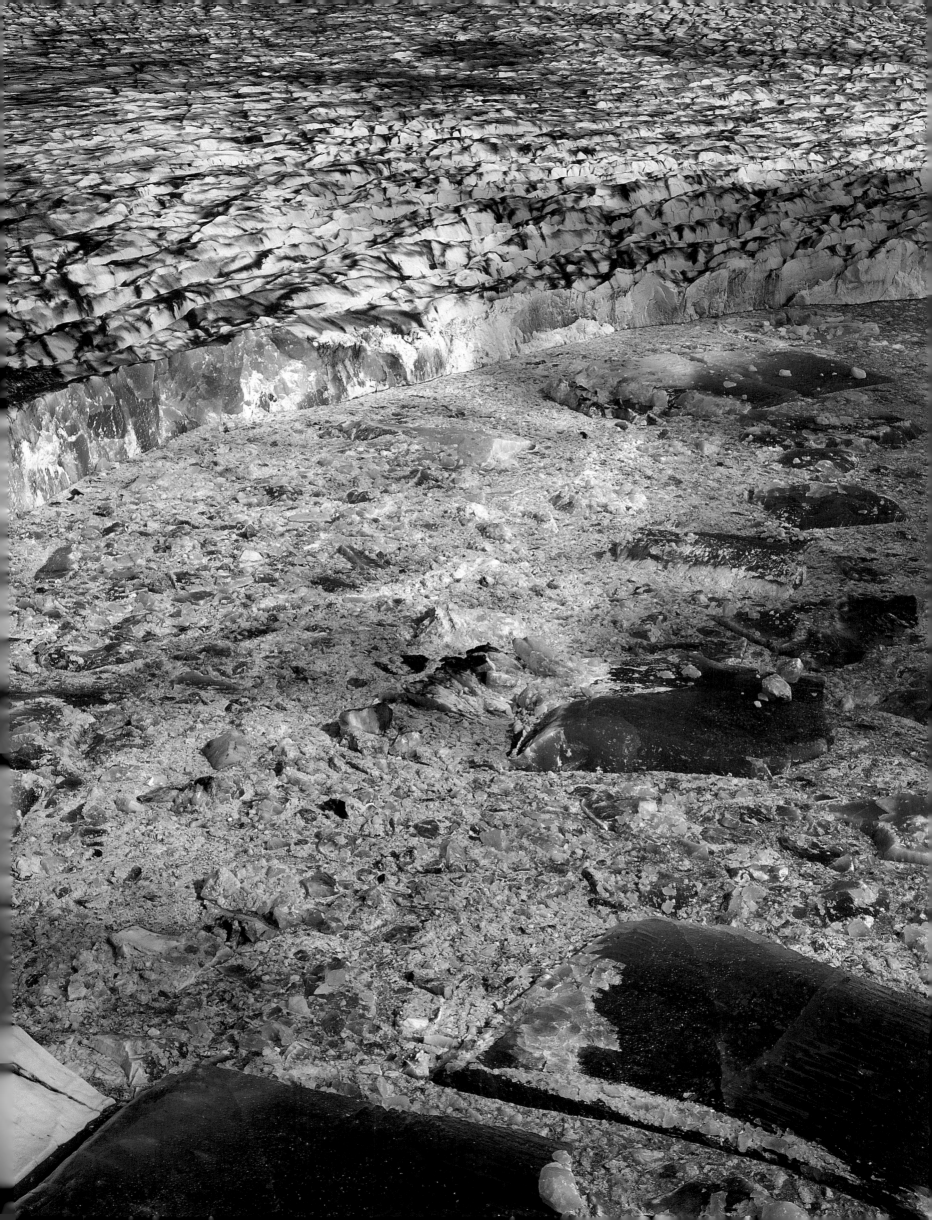

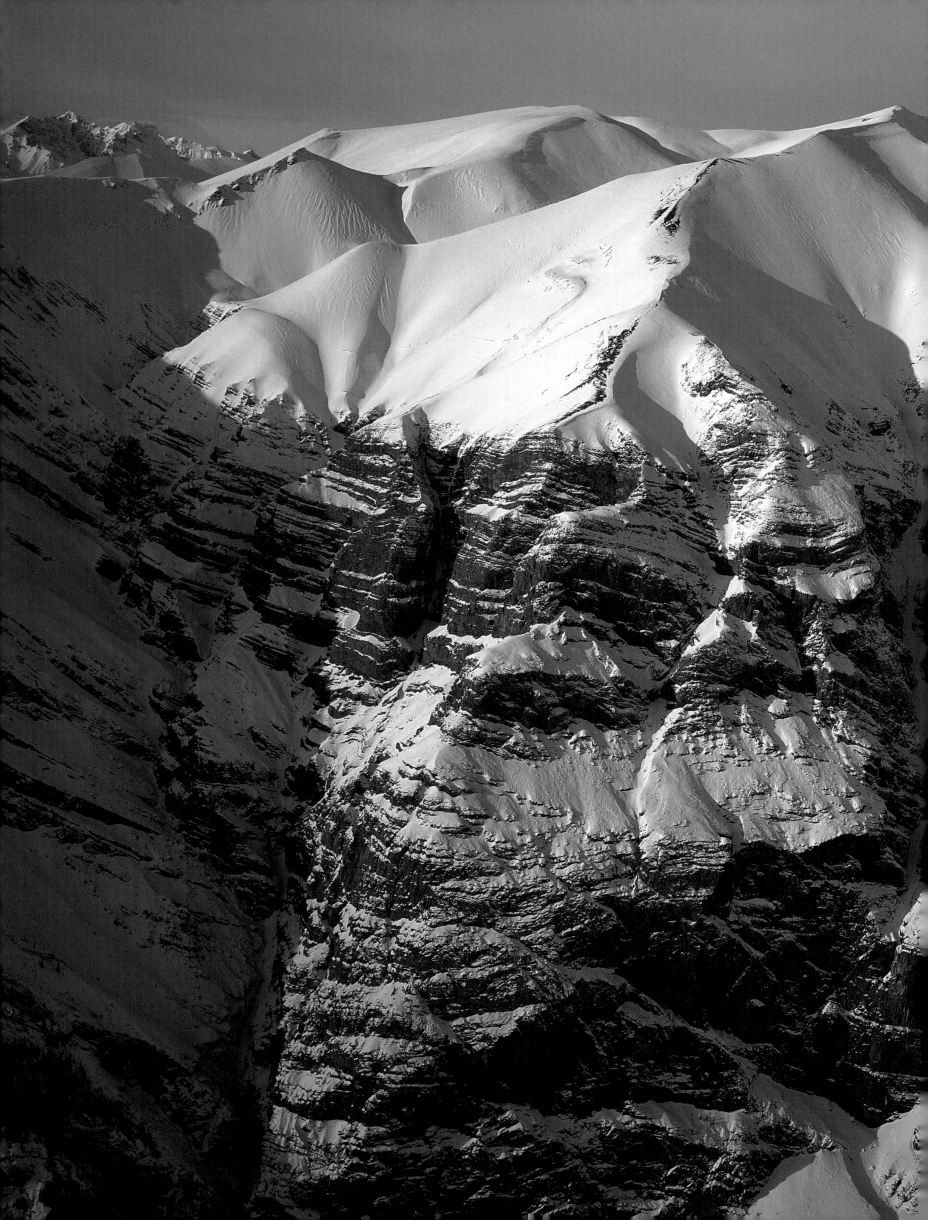

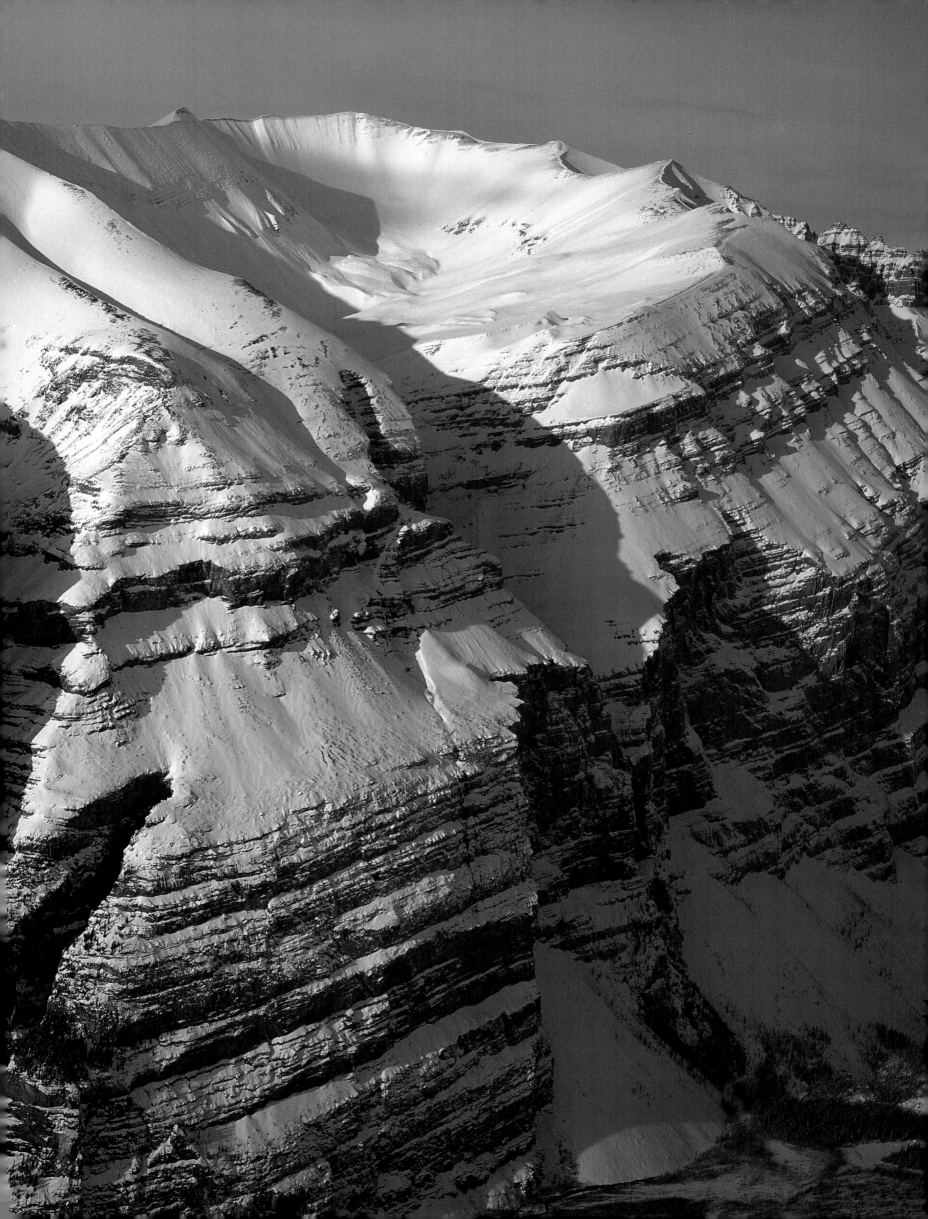

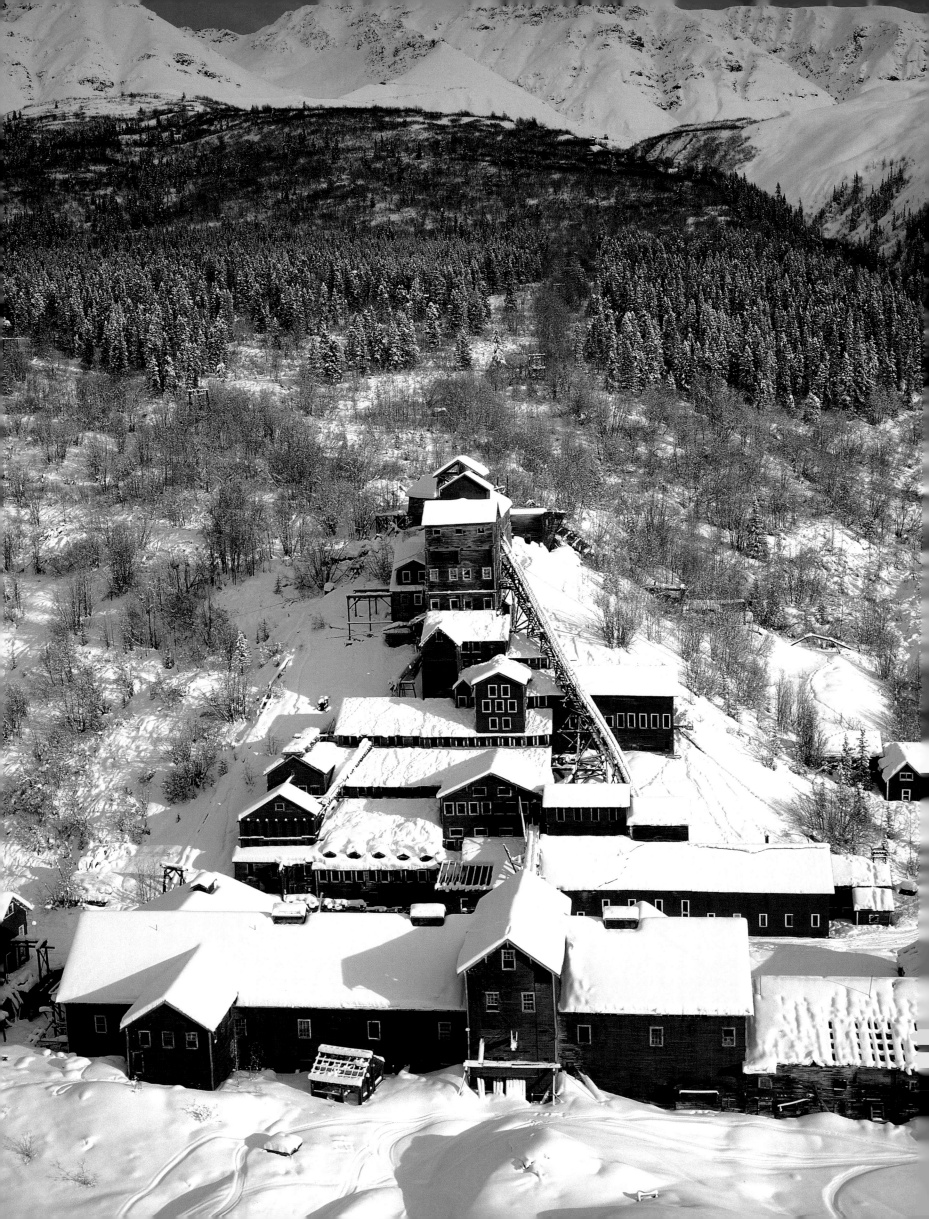

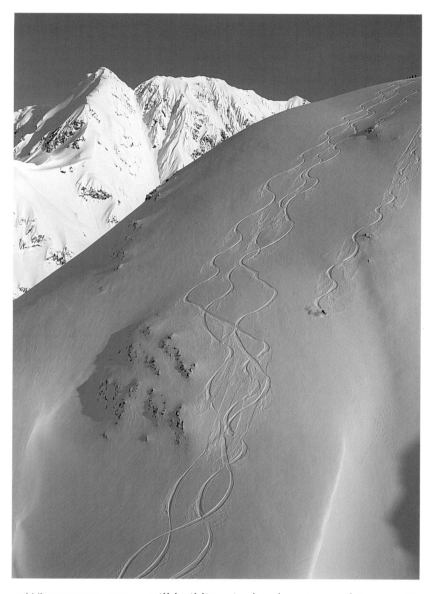

◄ Winter snow covers mill buildings in the ghost town of Kennecott. From 1911, when the first shipments of copper reached Valdez via railroad, to 1938, when the Kennecott Mine closed, more than one billion pounds of copper and 9.7 million ounces of silver were produced.
▲ Helicopter-supported downhill skiers carve turns through virgin powder in the Chugach Mountains near Girdwood. Nearby Alyeska Resort is Alaska's largest developed and maintained downhill ski area.

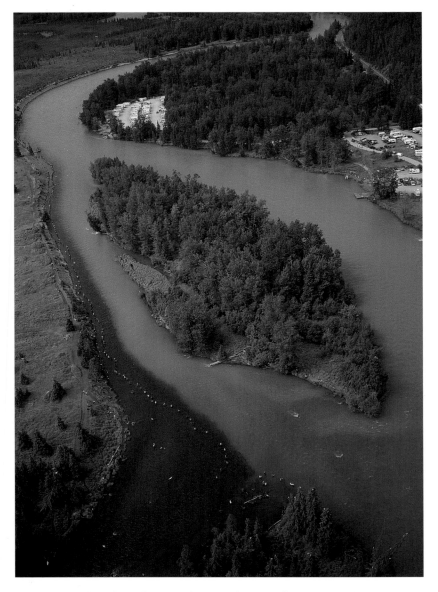

▲ Thousands of anglers gather at the confluence of the Russian and Kenai Rivers to catch sockeye salmon. "Combat fishing" is the term used to describe such large concentrations of sport fishermen.
► An early winter sunset illuminates peaks of the Alaska Range including Mount Hunter and the tallest mountain in North America, 20,320-foot Mount McKinley. Alaskans generally refer to Mount McKinley by its Athabascan name, *Denali,* which means "Tall One."

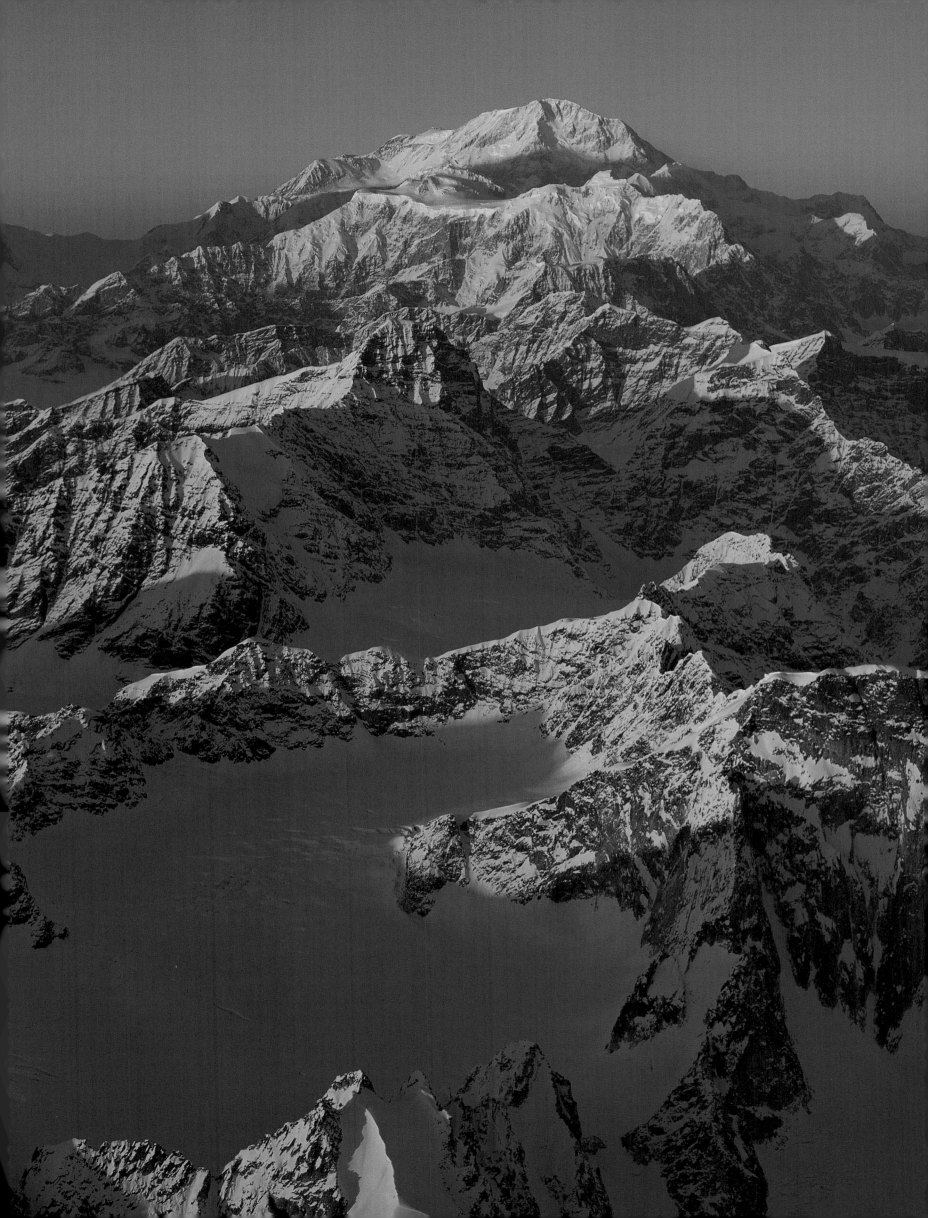

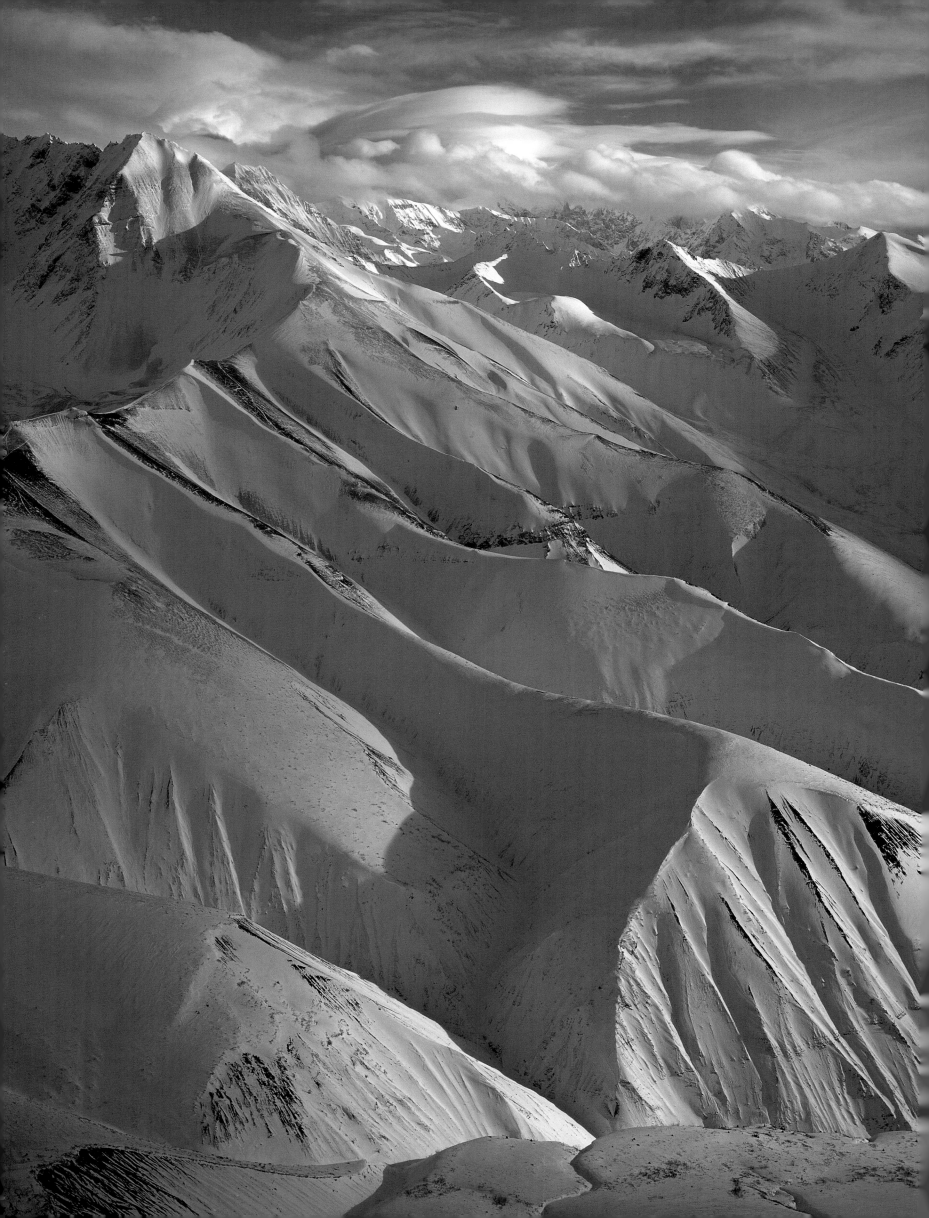

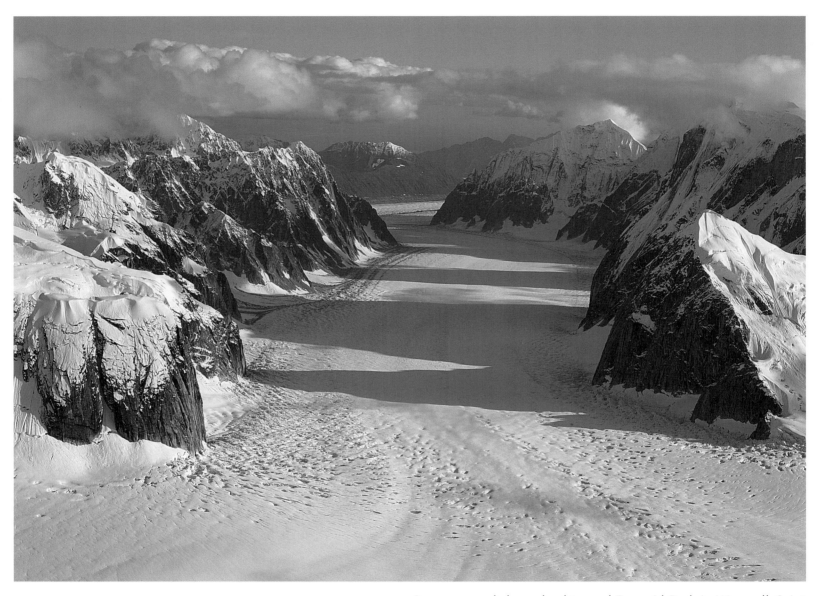

◄ Snow-covered slopes lead toward Pyramid Peak in Wrangell–Saint Elias National Park and Preserve. Beyond, wind-driven lenticular clouds build over the University Range of the Saint Elias Mountains.
▲ The mile-wide Ruth Glacier snakes between the mile-high walls of the Great Gorge in Denali National Park. Much of the snow that falls on the southeast side of Denali is compressed into glacial ice in the Sheldon Amphitheater before flowing down the Ruth Glacier.

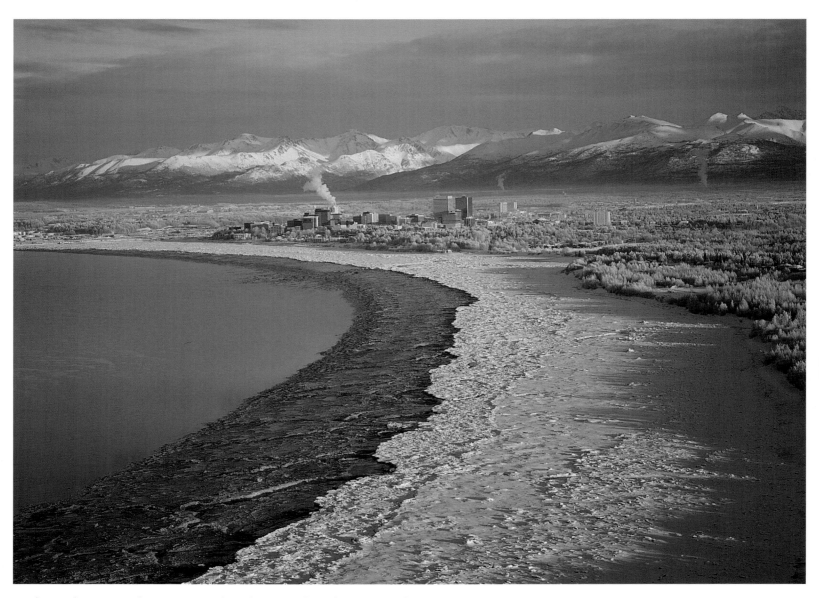

▲ Shown here on a frosty winter day, the city of Anchorage nestles along the icy shore of Cook Inlet. Beyond the Anchorage Bowl rise the lofty three- to five-thousand-foot peaks of the Chugach Mountains.
► The volcano closest to Anchorage, 11,070-foot Mount Spurr is just eighty miles west of the city. Its most recent series of eruptions began on June 17, 1992, when 1.75 billion cubic feet of ash and rock exploded into the sky. Subsequent eruptions occurred on August 18 and September 16 of 1992. All three outbursts ejected ash forty to fifty thousand feet high, lightly covering parts of Southcentral Alaska.

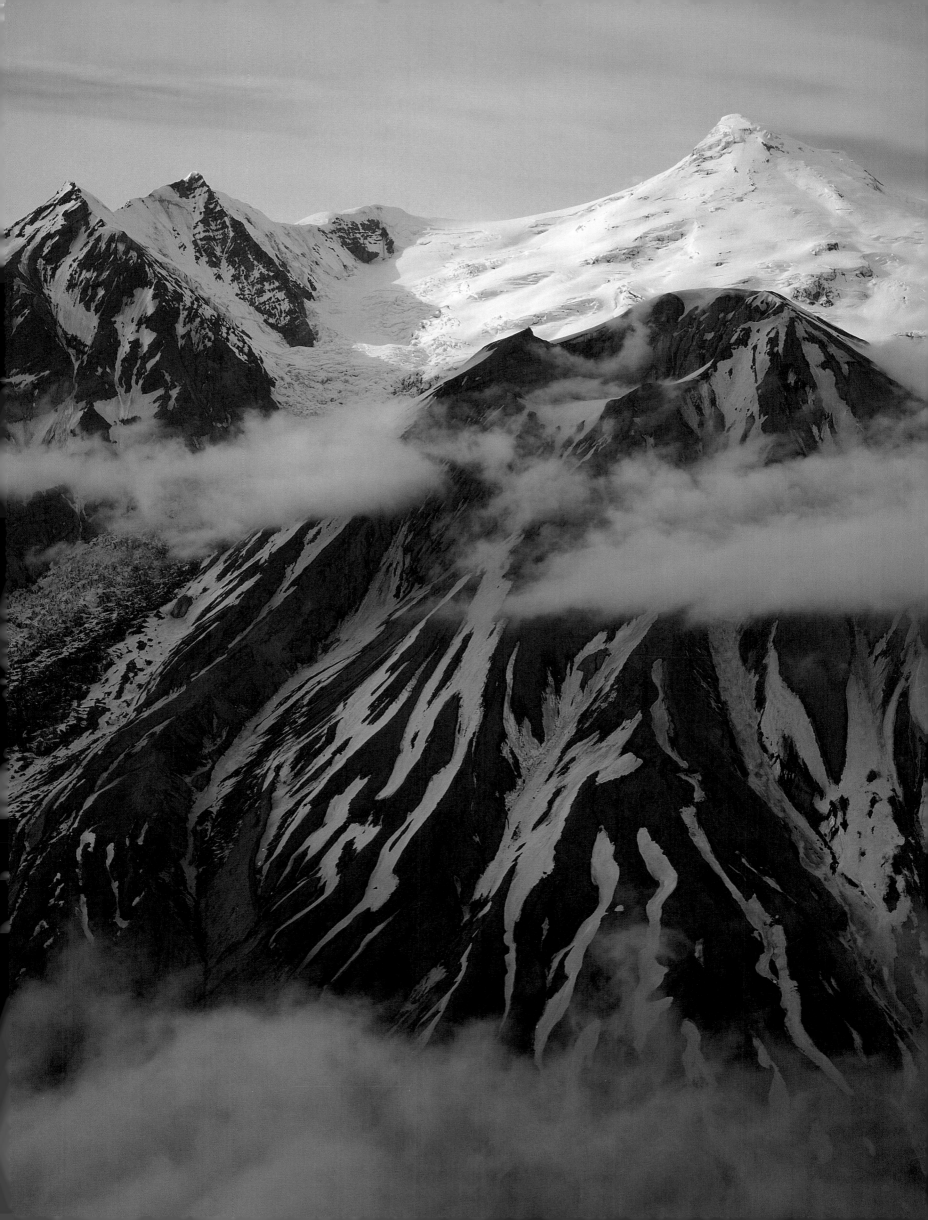

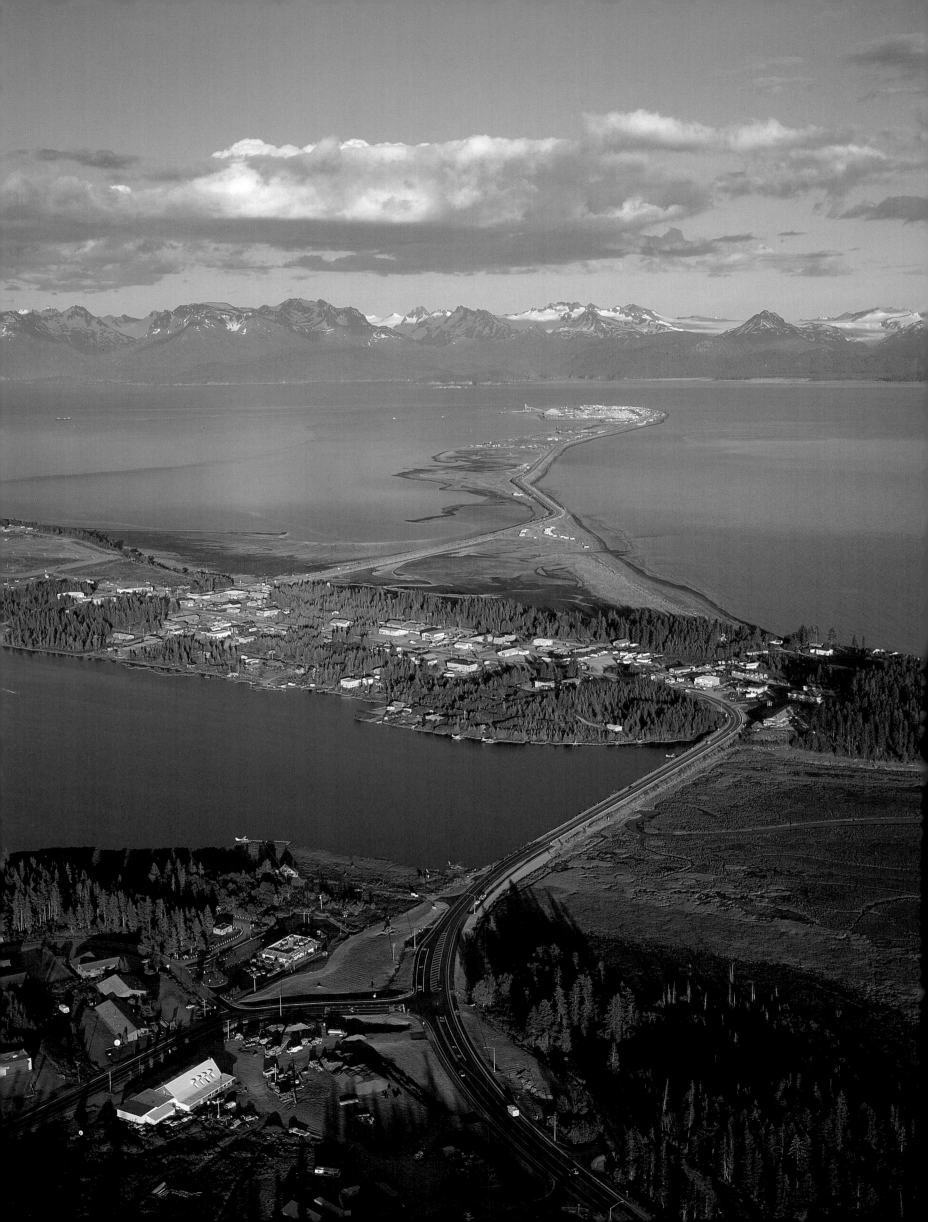

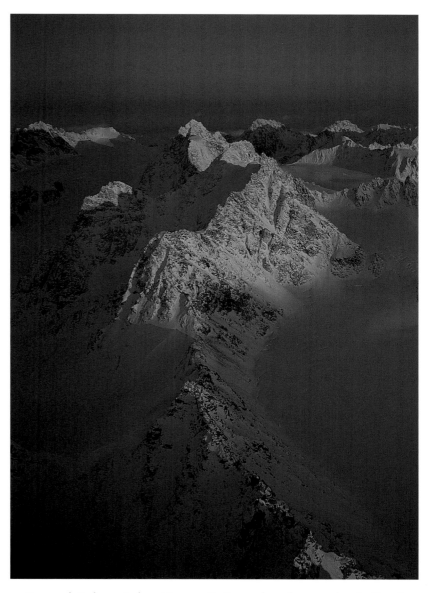

◄ Beyond Beluga Lake, Homer Spit reaches four and a half miles into Kachemak Bay. The town of Homer was founded in the late 1890s when coal was mined in the area. Today, the town bustles with commercial and sport fishing, tourism, and a thriving arts community.
▲ Encroachment of the earth's shadow is visible as the setting sun heralds dusk over the glaciers and peaks of the Talkeetna Mountains.

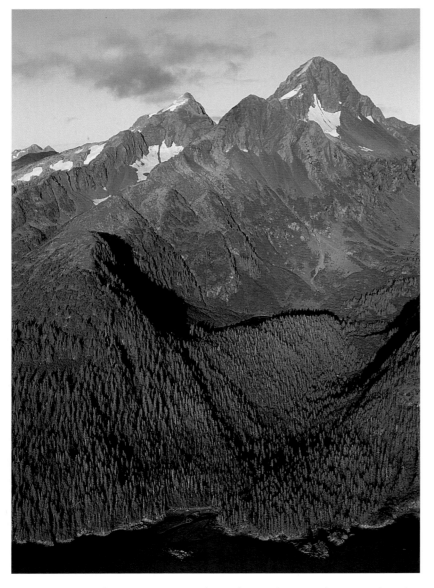

▲ Palisade Peak towers 3,510 feet above the North Arm of Nuka Bay in Kenai Fjords National Park. At 669,000 acres, this park on the southern end of the Kenai Peninsula features deep fjords, an extensive icefield, tidewater glaciers, and wild coasts. Visitors view humpback whales, orcas, and puffins on day cruises from Seward.
▶ On Turnagain Arm, drainage channels in the tidal mudflats of Chickaloon Bay create intricate patterns best seen from the air.

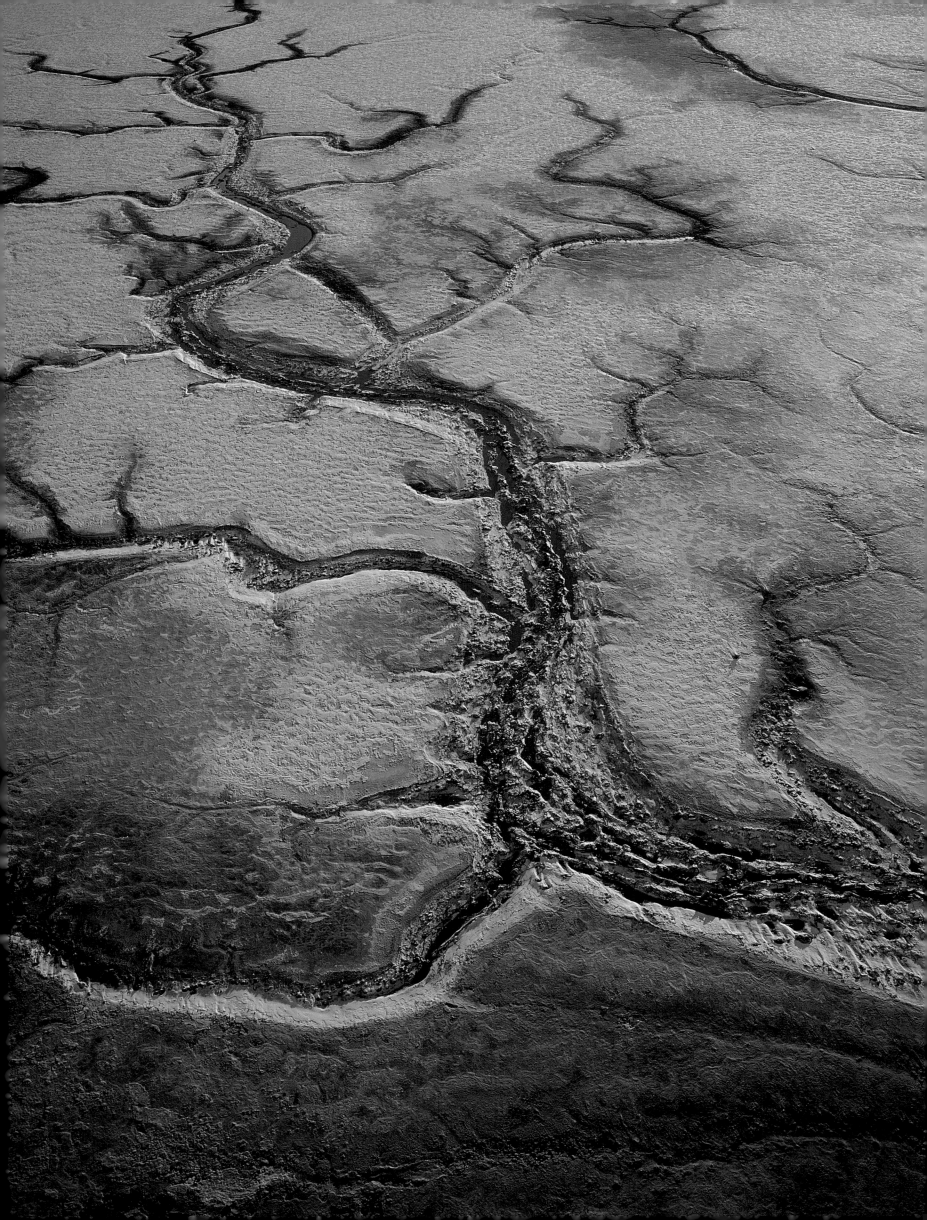

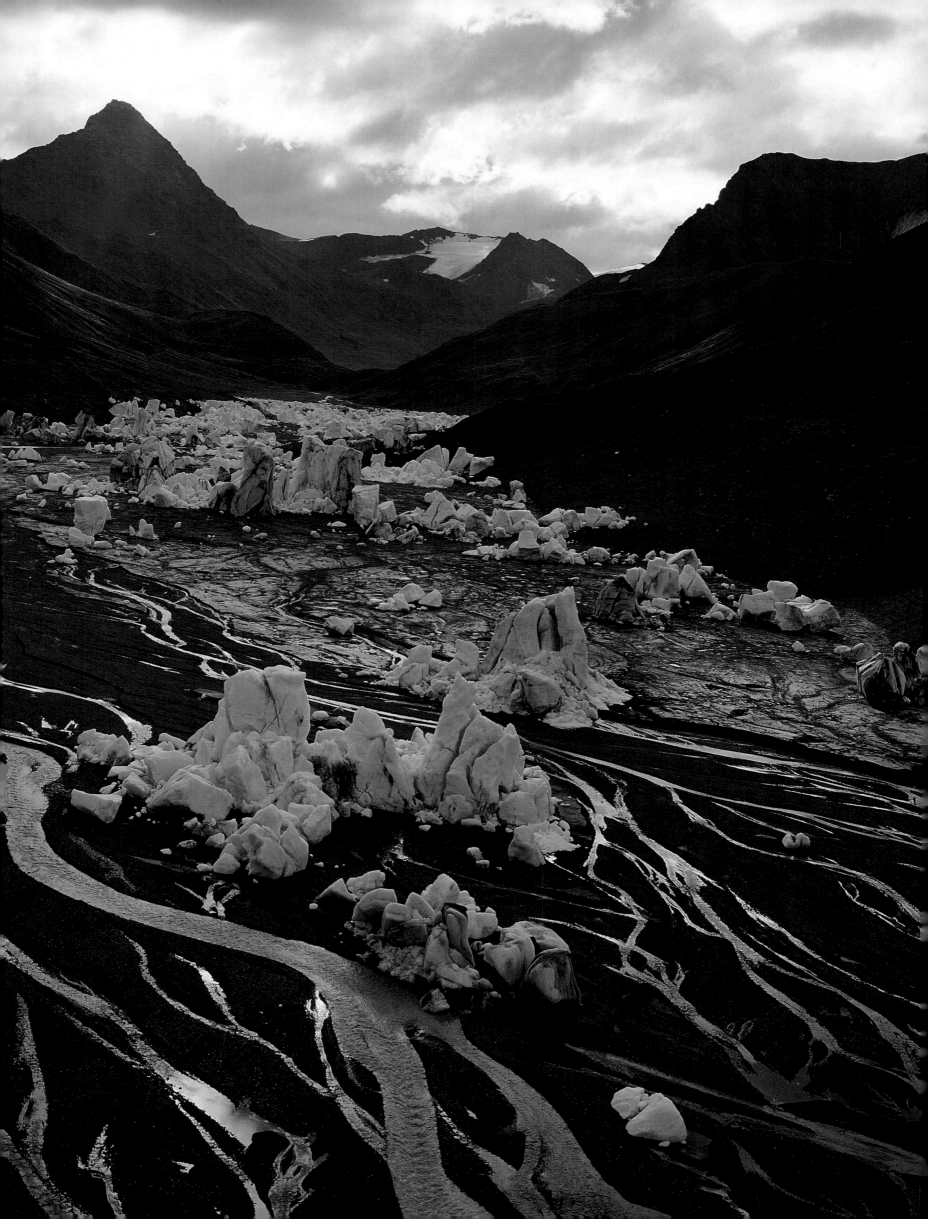

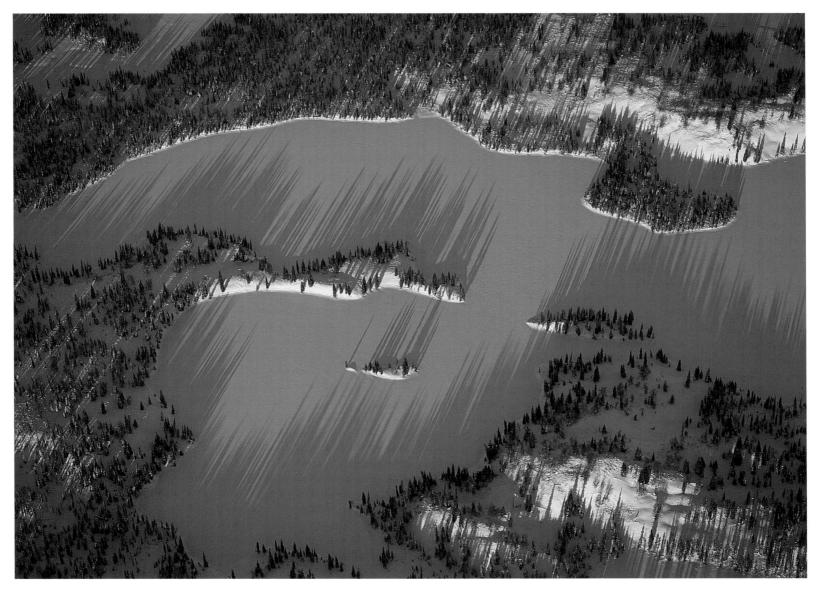

◄ Drainage of an ephemeral lake dammed by the Nelchina Glacier creates an interesting mix of stream channels and stranded icebergs.
▲ The low angle of a winter sun casts shadows from white spruce that is growing along the shore of Felt Lake west of the Beluga River.
► ► In the lee of 13,176-foot Mount Marcus Baker of the Chugach Mountains, Bryn Mawr, Smith, Radcliffe, and Harvard Glaciers flow into the Harvard Arm of College Fiord in Prince William Sound. The 5.6-million-acre Chugach National Forest has superb glacial scenery.

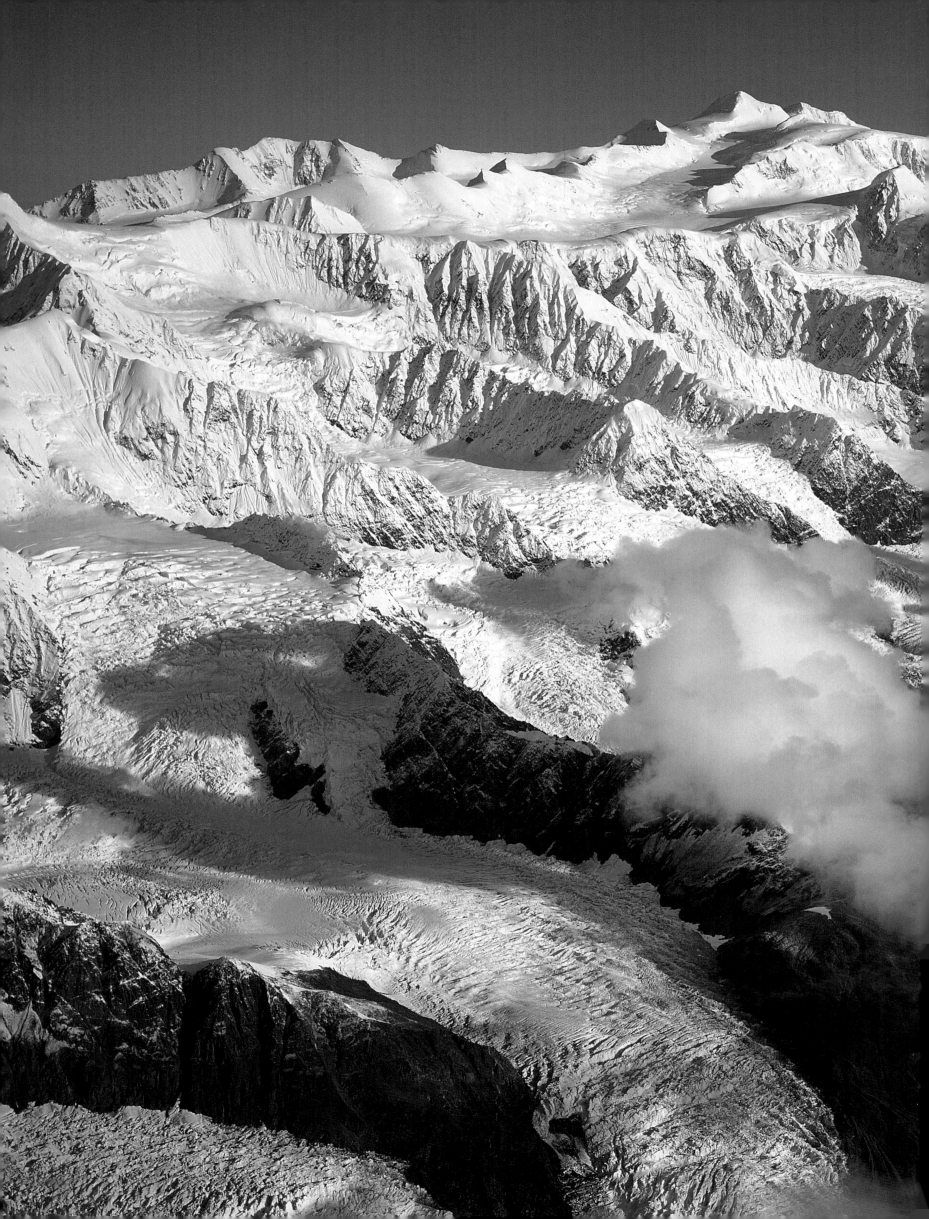

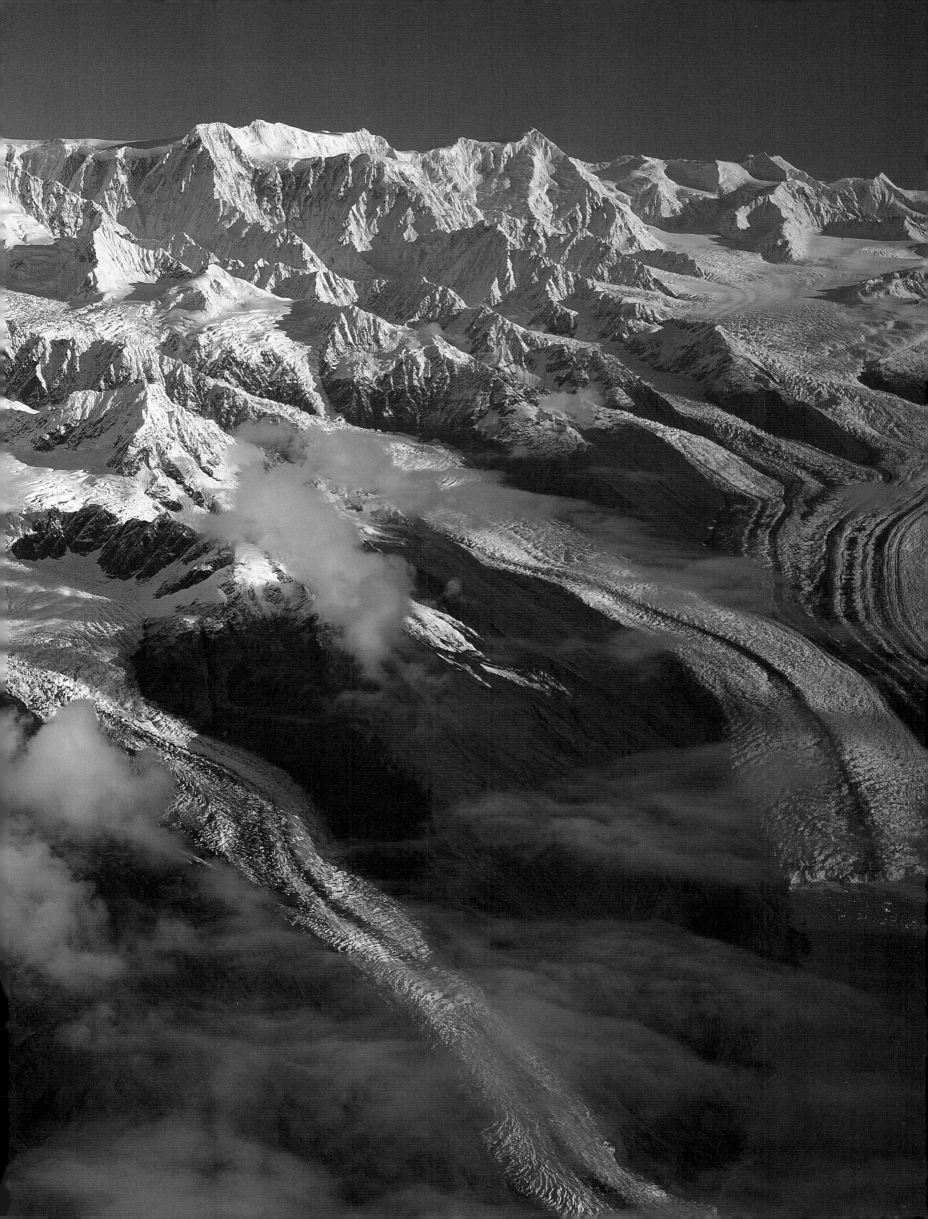

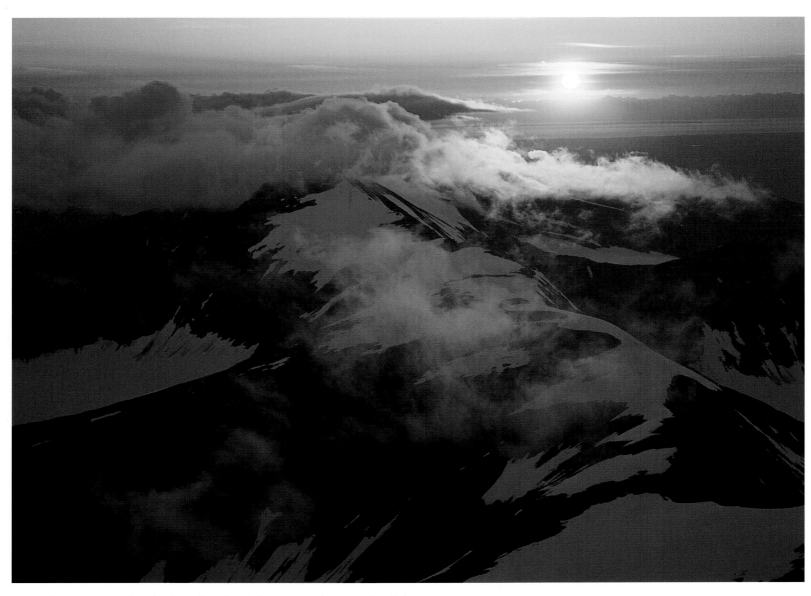

▲ As the sun sets, lenticular clouds embrace a ridge south of the Chernof Glacier in Kenai National Wildlife Refuge. Lenticular clouds above mountains signal high winds and turbulent flying conditions.
▶ Glaucous-winged gulls and black-legged kittiwakes frequent the canneries at Cordova for an easy meal. With such an avian air force overhead, the Coast Guard is challenged to keep their decks clean!

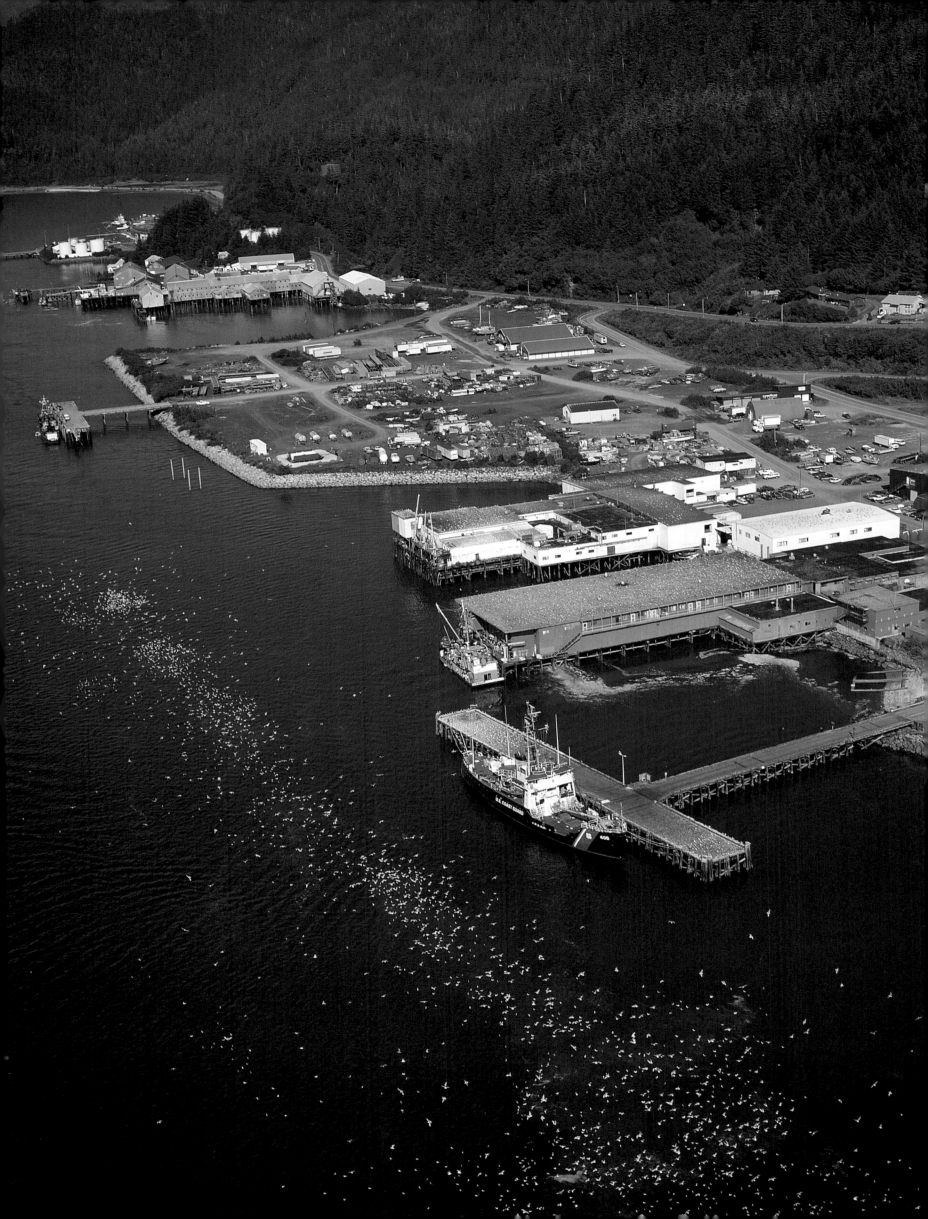

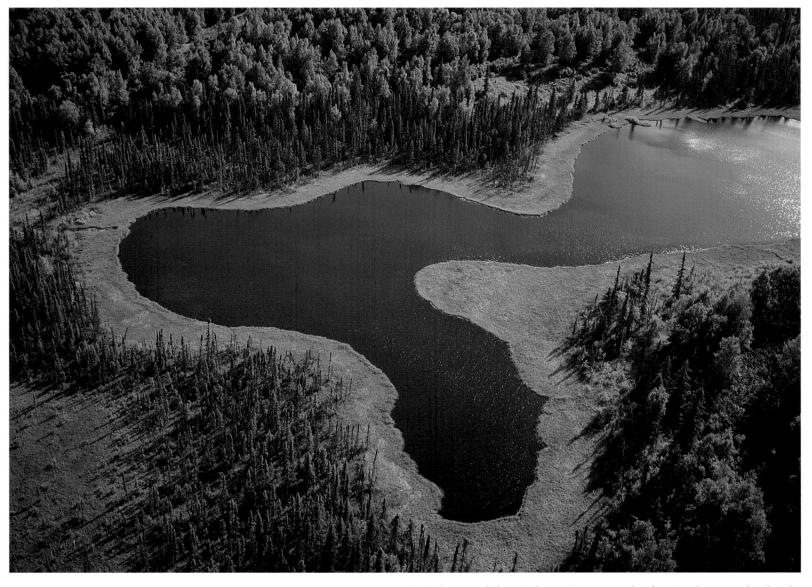

◄ Twin barns of the Gislason Farm speak of agriculture in the fertile Matanuska Valley. Small ranches in this area breed fine horses. Nearby are farms that raise hay and potatoes, and gardens that yield giant vegetables. Long, cool summer days and soils enriched by glacial loess contribute to the valley's superb growing conditions.
▲ Birch and spruce forests surround a pond west of the Yentna River.

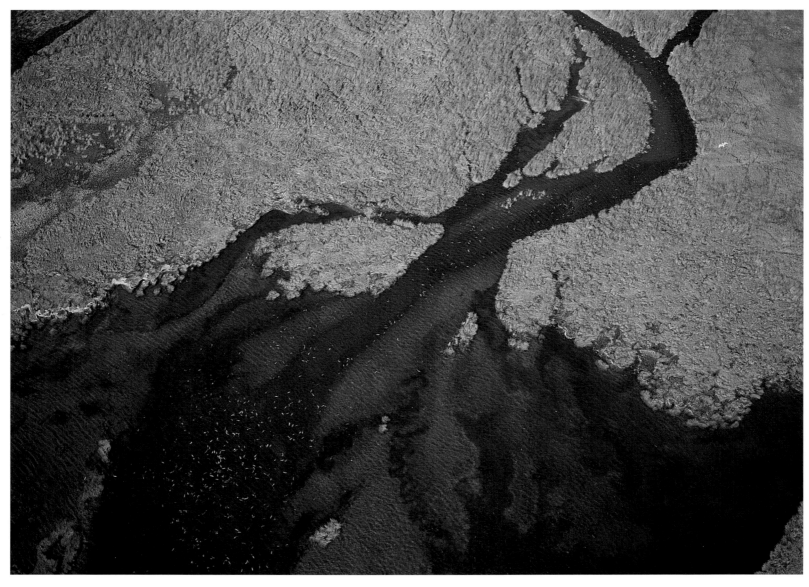

▲ Spawning salmon return to Sahlin Lagoon at the head of Sheep Bay in the Chugach National Forest. Portions of the ecosystem of Prince William Sound have slowly recovered from the *Exxon Valdez* oil spill. This area near Cordova was not coated in oil from the spill.
► The braided Eyak River flows alongside the Heney Range on its way to the Gulf of Alaska. The Copper River Delta State Critical Habitat Area protects approximately seven hundred thousand acres of wetlands east of Cordova. The area is an excellent site for viewing birds.

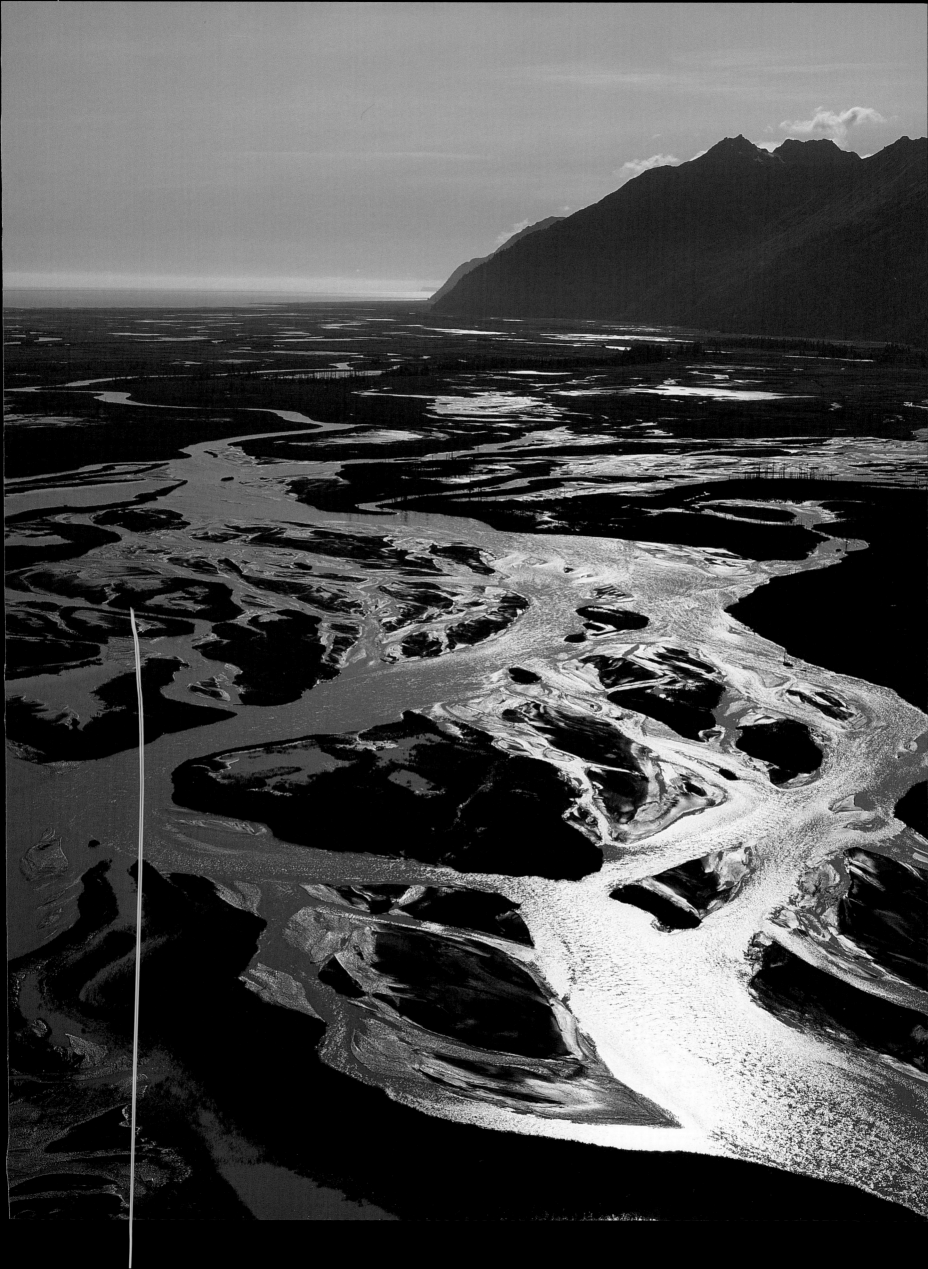

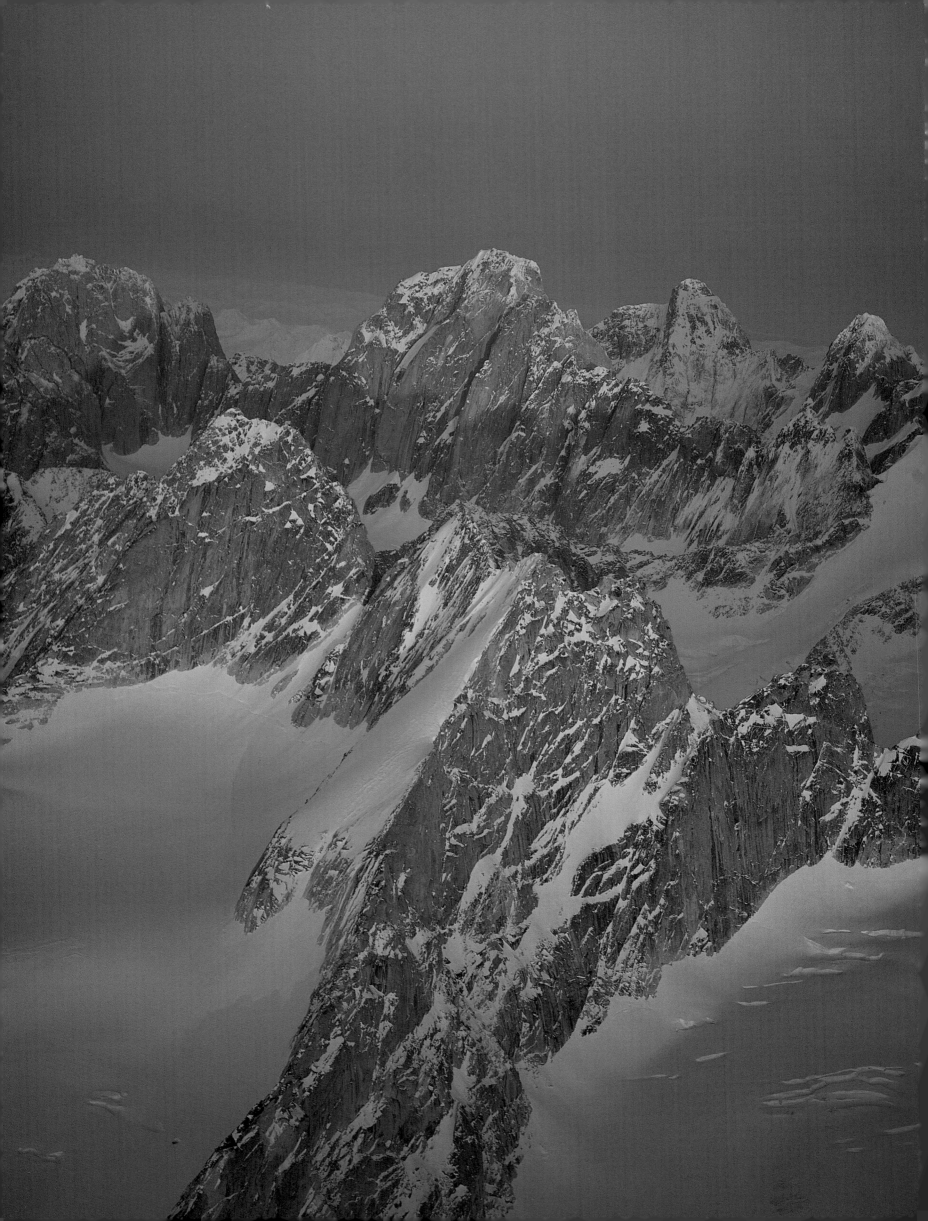

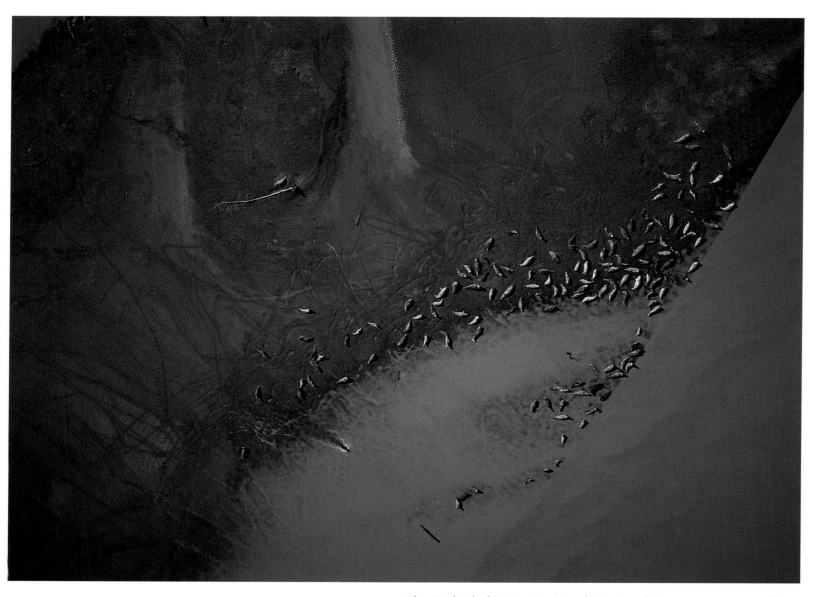

◄ The Cathedral Spires in Denali National Preserve are a small but spectacular portion of the six-hundred-mile-long Alaska Range. As mountain ranges go, the Alaska Range is relatively young at only ten to twenty million years old. Active mountain building continues today, as evidenced by frequent earthquakes along the Denali Fault.
▲ More than 150 harbor seals haul out on a muddy island in the Copper River Delta. Adult harbor seals, which may weigh as much as 180 pounds, often follow the salmon they relish into freshwater.

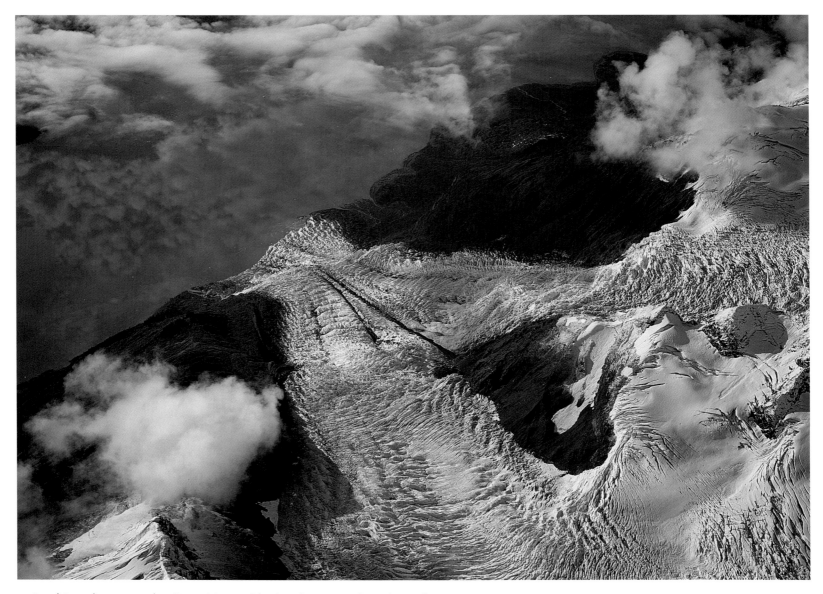

▲ Looking down on the Bryn Mawr Glacier from an elevation of seventy-five hundred feet provides an interesting perspective on a valley glacier that drops nearly a mile in elevation over a distance of approximately four miles. The Chugach Mountains surrounding College Fiord encompass more than a dozen named glaciers.
▶ Moist air originating from Prince William Sound and the Gulf of Alaska dumps massive amounts of snow on the ice-covered ridges that lead toward ten-thousand-foot Mount Gannett in the Chugach Mountains. The thirty-mile-long Knik Glacier collects ice from Mount Gannett as well as nearby Mounts Goode and Marcus Baker.

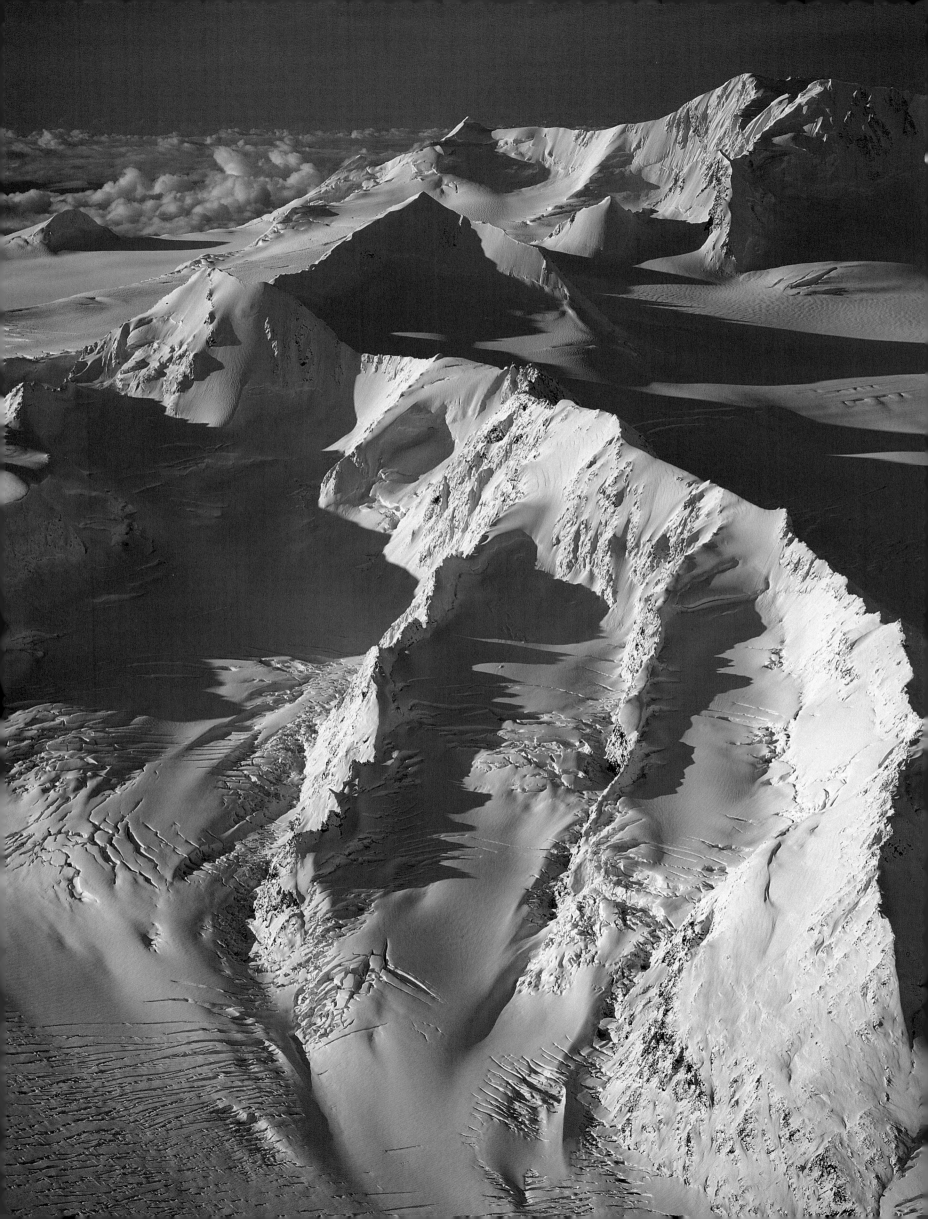

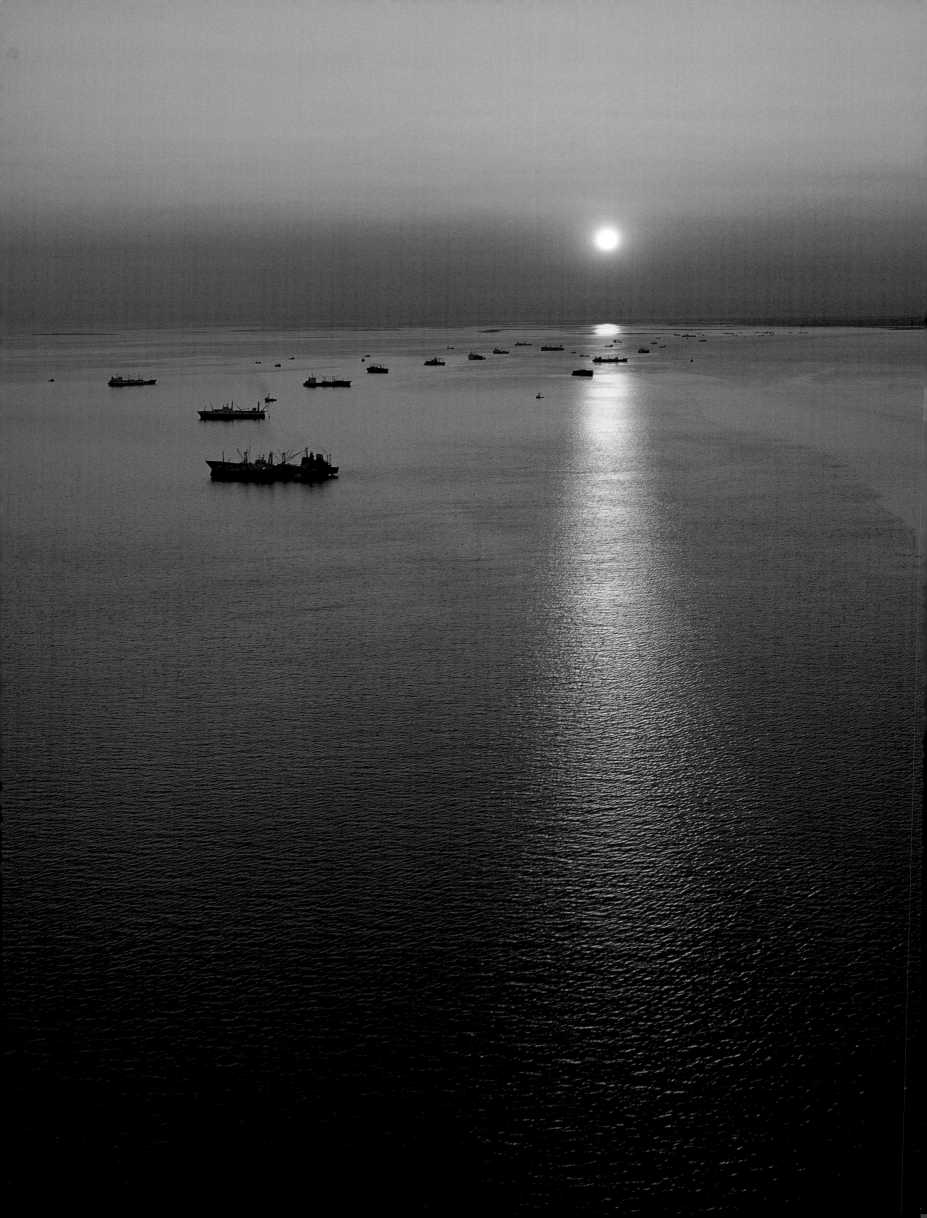

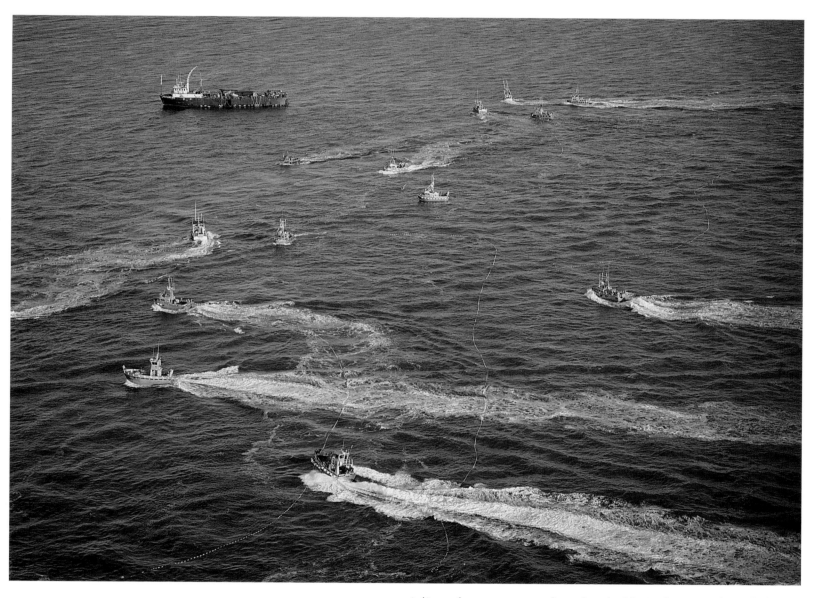

◄ A line of processors and tenders holds in the "Y" of Kvichak Bay between openings of the commercial salmon fishery in Bristol Bay.
▲ Fishing boats erupt in a frenzy of activity as their skippers battle for position to lay driftnets at the start of a sockeye salmon opening off Egegik. Some 85 percent of the sockeyes caught in the rich Bristol Bay fishery will head to the Japanese market, where the fish is prized for its firm, red flesh and high oil content. Salmon fishing is a risky business in which the prices may be as fickle as some years' runs.

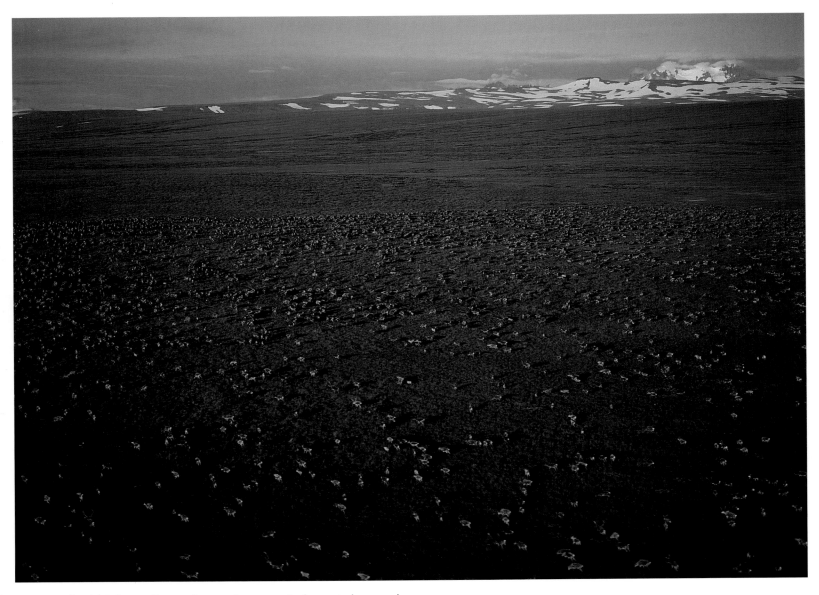

▲ Around mid-July, caribou often gather on windswept slopes where they hope to avoid bothersome insects. This group, part of the Alaska Peninsula Herd, grazes on tundra-covered slopes leading to Mount Martin in Katmai National Park. The numbers of caribou fluctuate from year to year. Currently, more caribou than people live in Alaska.
▶ Sugarloaf Island, part of the Barren Islands, rises from the Gulf of Alaska between the Kenai Peninsula and the Kodiak Archipelago.
▶▶ The state's largest river, the Yukon, flows lazily through Yukon–Charley Rivers National Preserve in the eastern Interior. Fourteen hundred miles of the river's two-thousand-mile length are in Alaska.

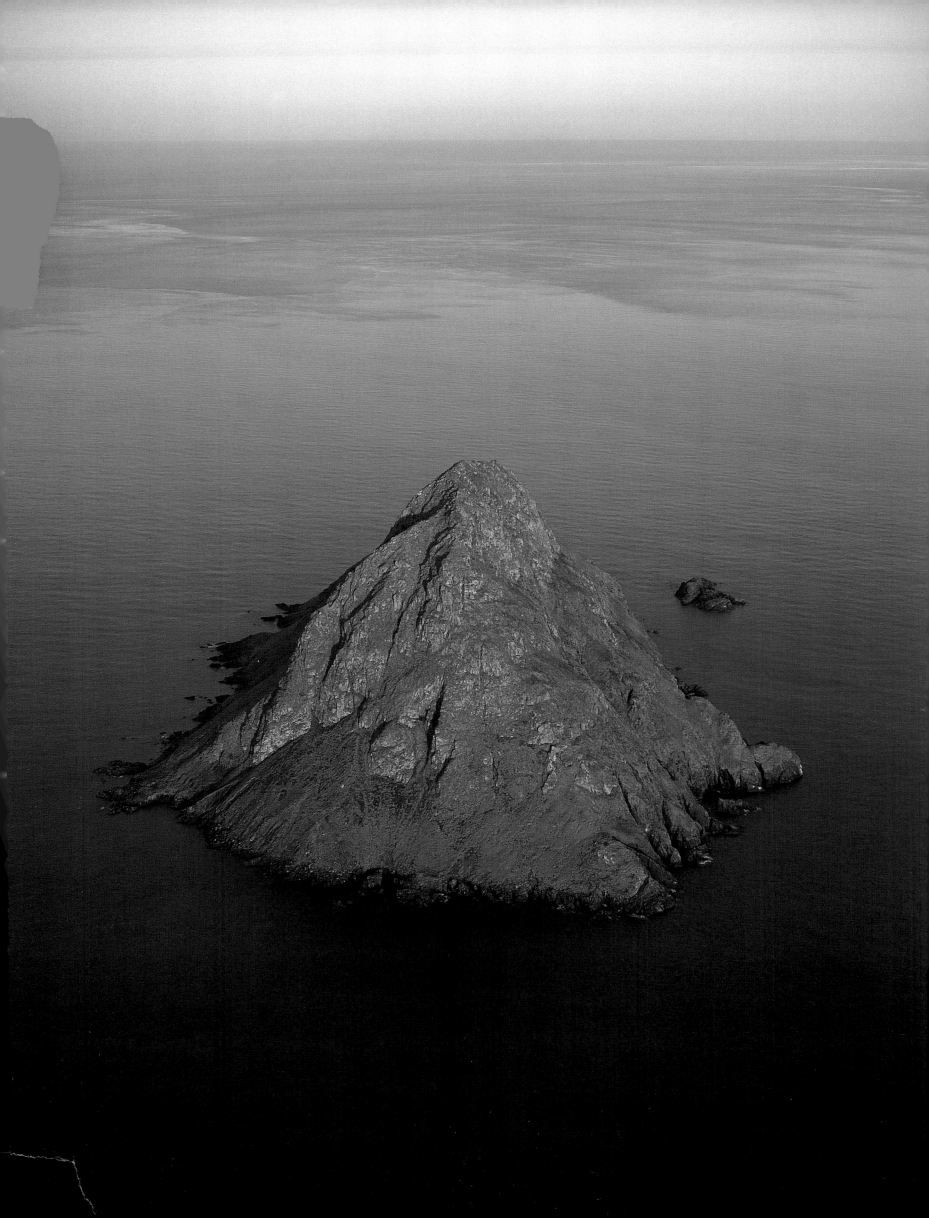

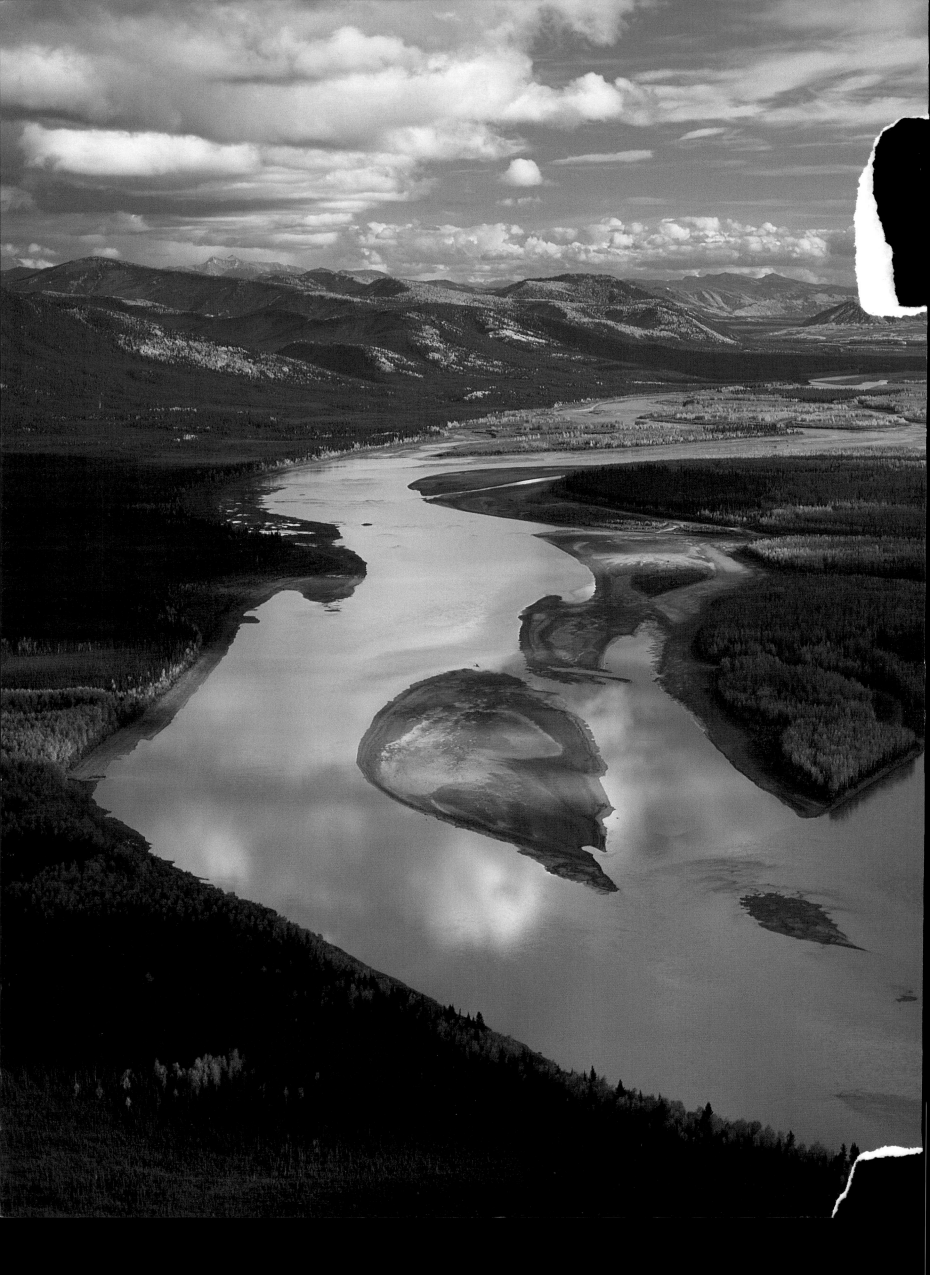

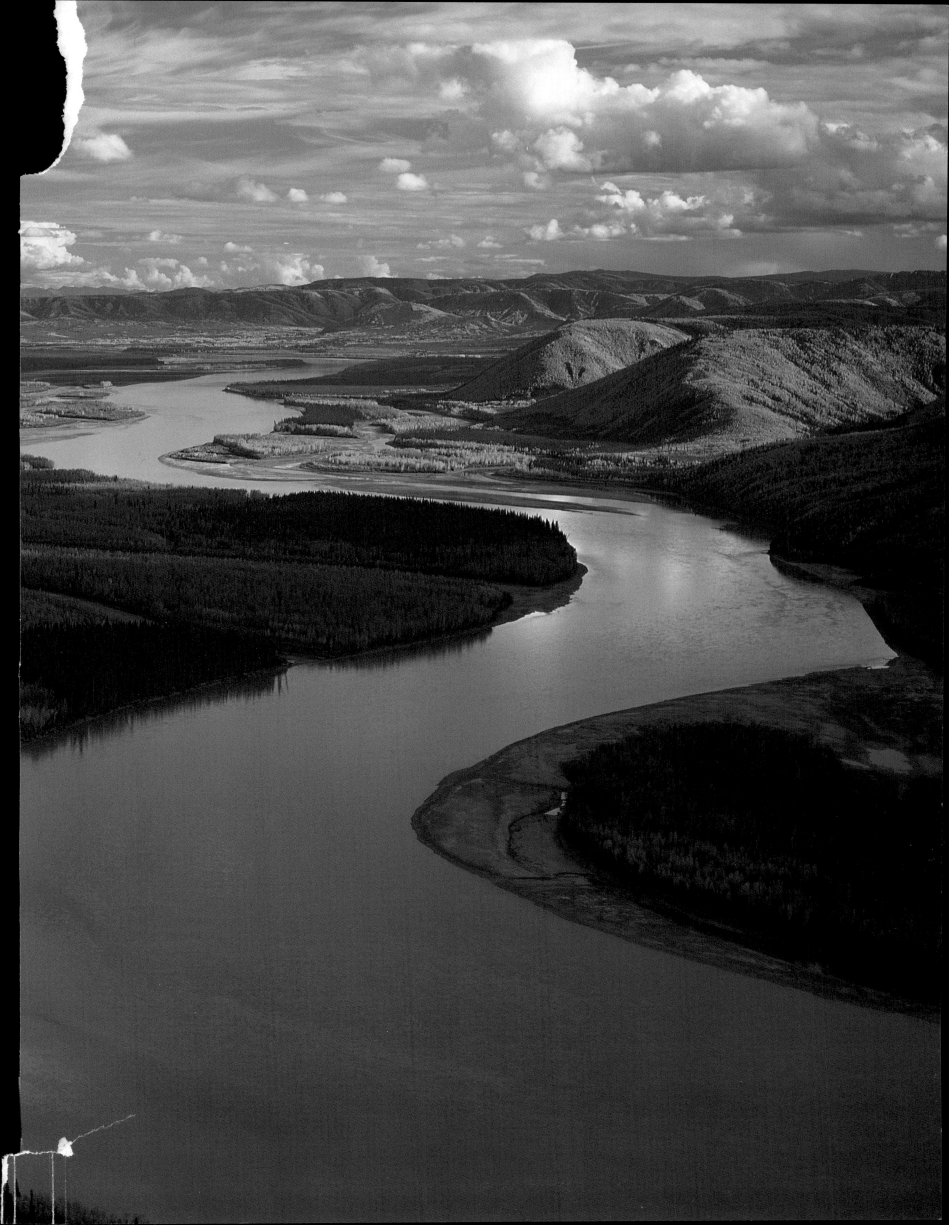

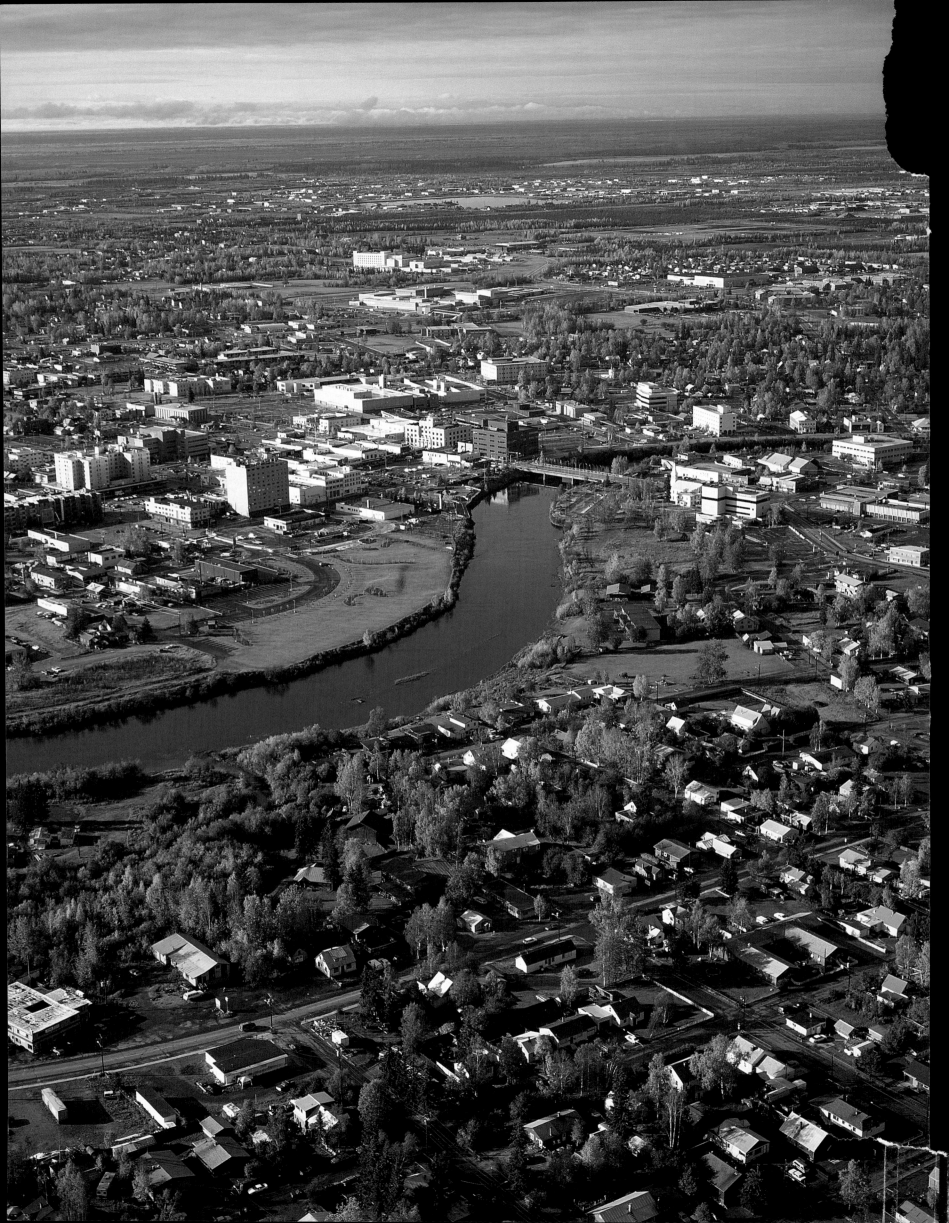

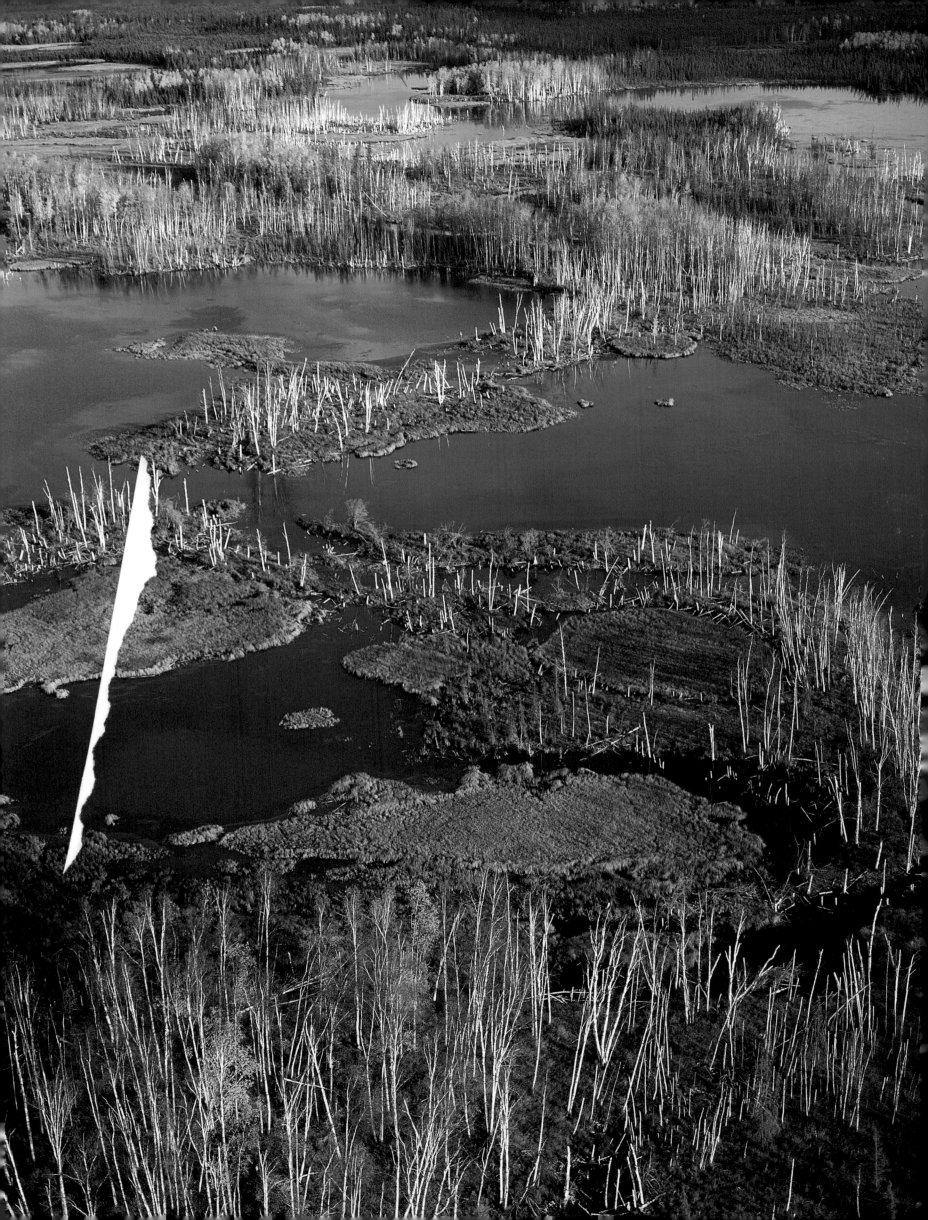

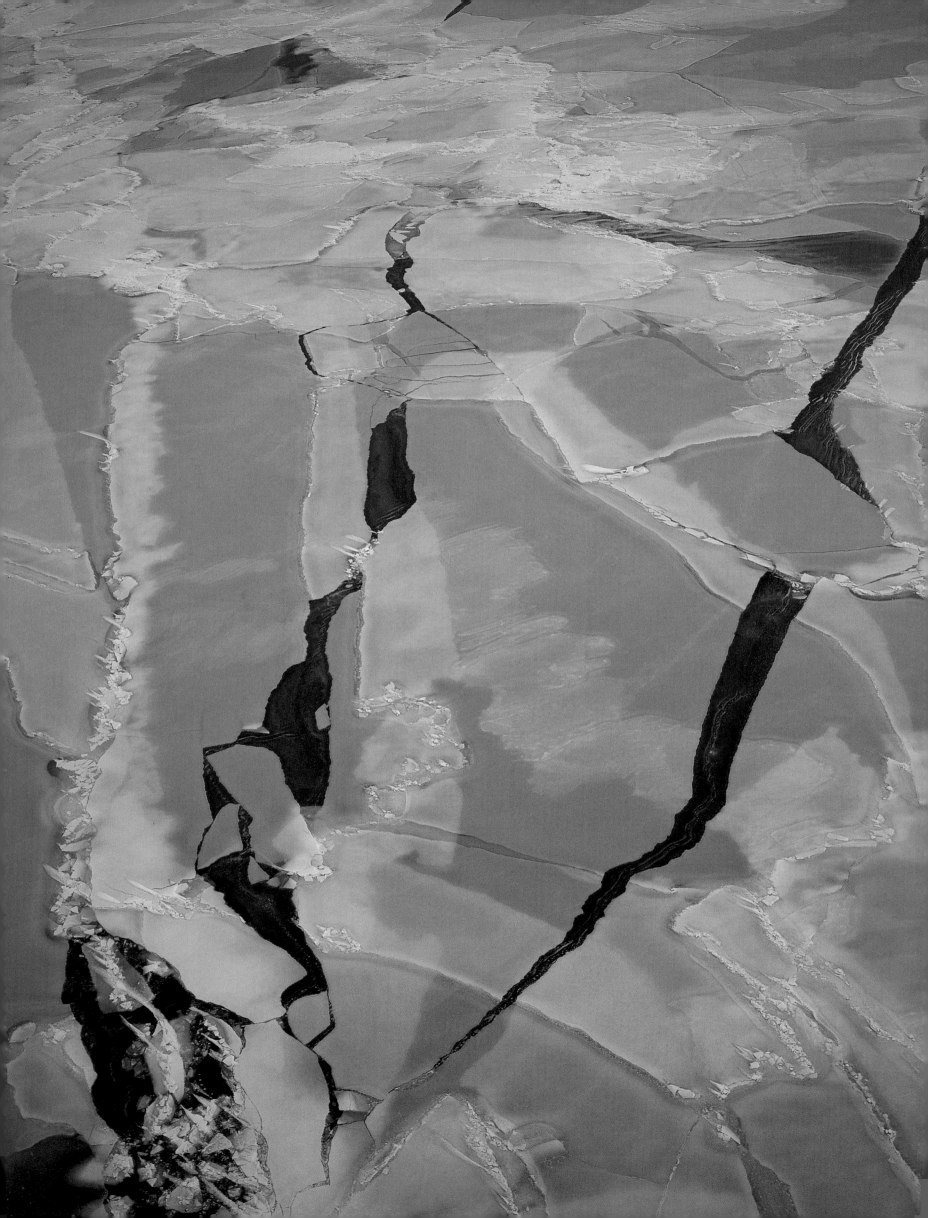

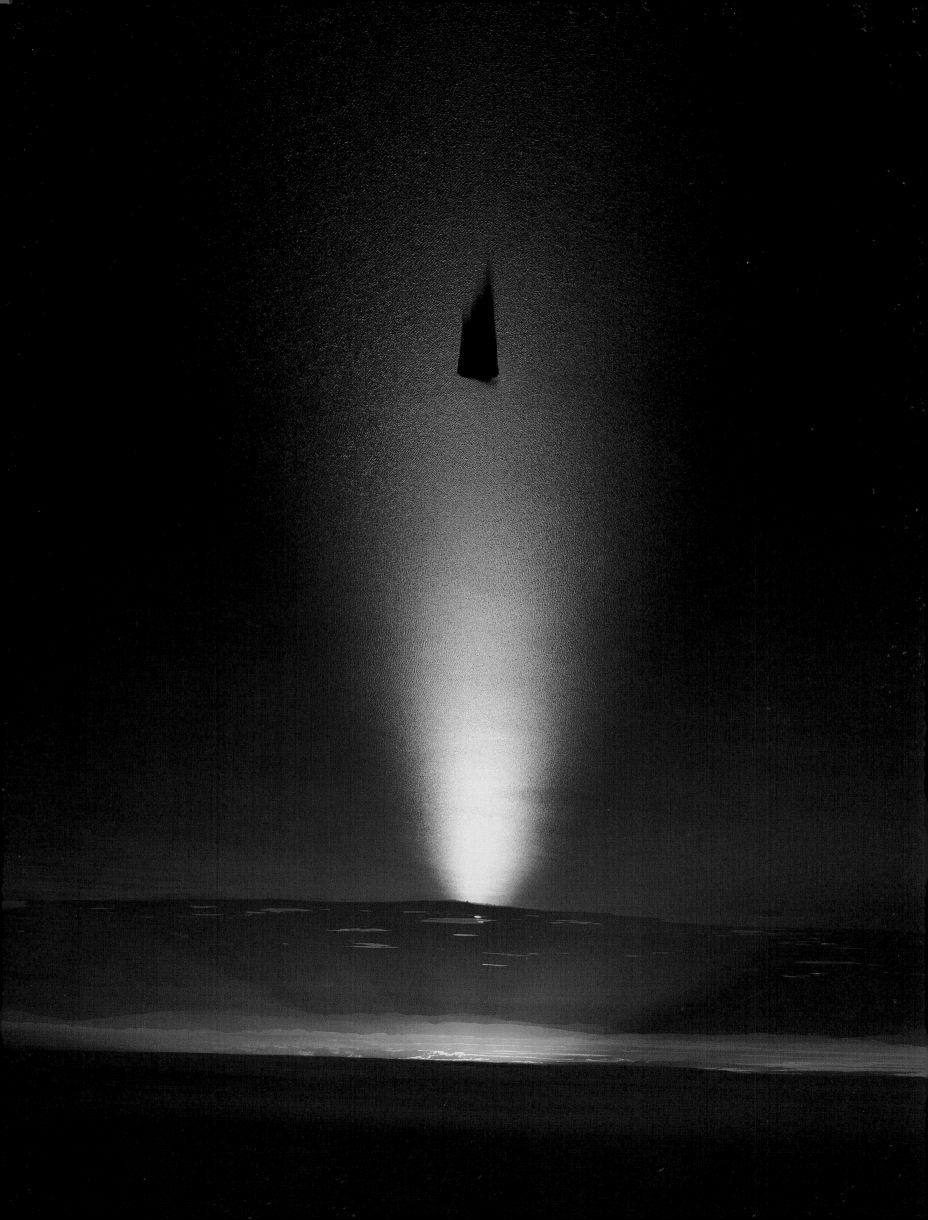

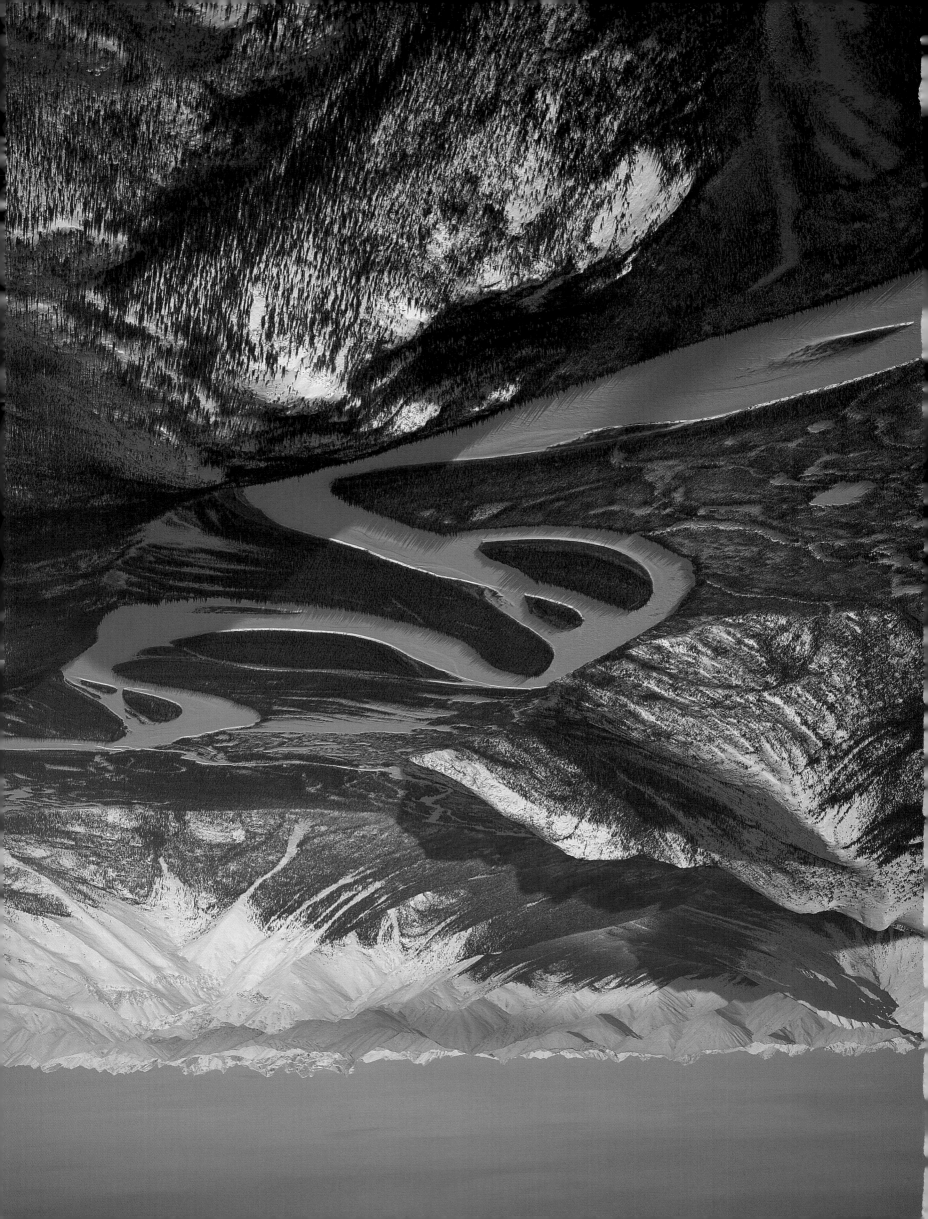

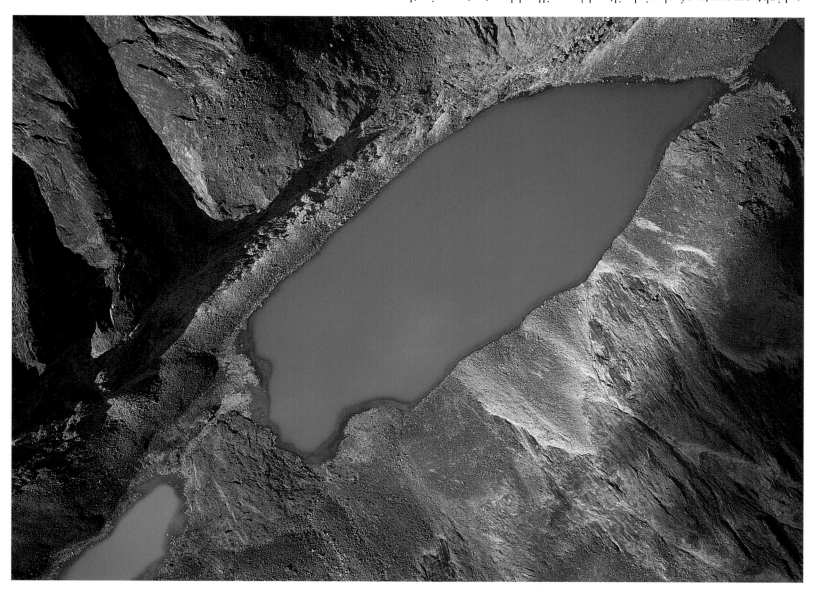

▼ Light amounts of glacial silt add a milky blue to tarns in the Arrigetch Peaks in Gates of the Arctic National Park and Preserve. The second largest national park in the United States, it encompasses some 8,473,000 acres of pristine wilderness in the Brooks Range.

◄ The meandering Alatna River remains frozen during a winter overflight. In summer, occasional wilderness enthusiasts float the Alatna Wild and Scenic River through Gates of the Arctic National Park.

▶ Caused by leads cracking through ice on Norton Sound, wild and interesting patterns are visible from a thousand feet above the water. During the yearly Iditarod Trail Sled Dog Race, mushers who travel along Norton Sound cross Norton Bay only where the ice is thickest.

▼ An Iditarod musher races over the frozen Yukon River downstream from the village of Ruby. The eleven-hundred-mile race from Anchorage to Nome starts each year on the first Saturday in March. From a field of fifty to sixty teams and nearly a thousand dogs, the winner has typically reached Nome in about nine to ten days.

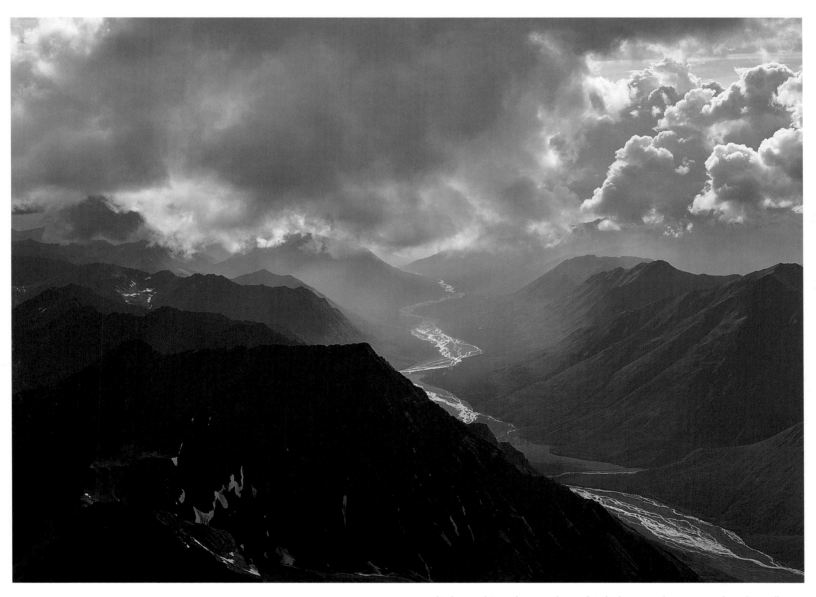

◄ Sunlight poking beneath a thick layer of stratus clouds reflects on the surface of Iliamna Lake, silhouetting a small island. Covering approximately 1,150 square miles, Iliamna is the state's largest lake. Its freshwater supports an inland population of harbor seals.
▲ Smoke (blowing over from forest fires in Western Alaska) and building thunderstorms provide a sense of depth and majesty to the valley of the Tatina River as it cuts through the Alaska Range.

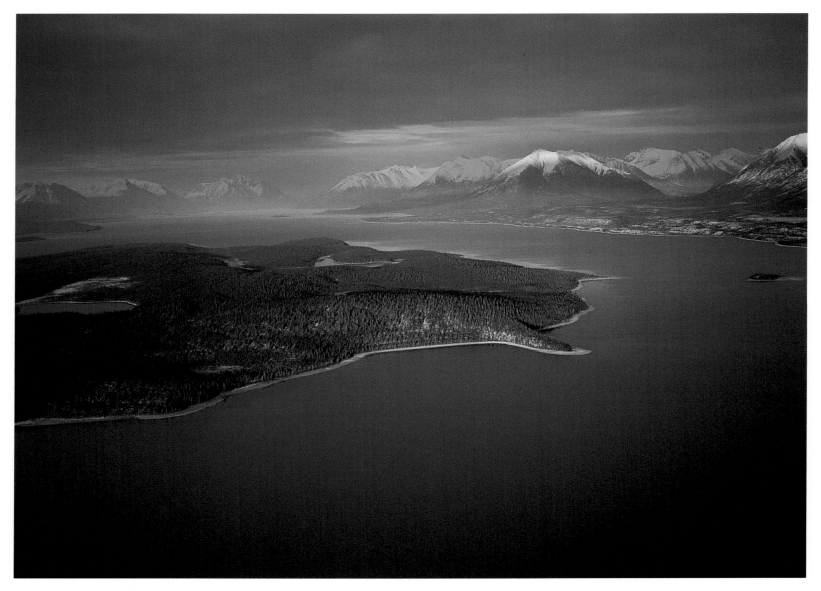

▲ Lake Clark, Alaska's sixth-largest lake, covers 110 square miles. Four-million-acre Lake Clark National Park and Preserve epitomizes the diversity of Alaskan landscapes: beautiful glacial lakes, towering mountains, rugged coastline, boreal forests, and alpine tundra.
► Birch and quaking aspen cover the hills west of Montauk Bluff along the Yukon River. The bright gold of their leaves in autumn evokes thoughts of earlier times when prospectors swarmed over the many tributaries of the Yukon searching for paystreaks of placer gold. Today, more peregrine falcons than prospectors roam the two and a half million acres of Yukon–Charley Rivers National Preserve.

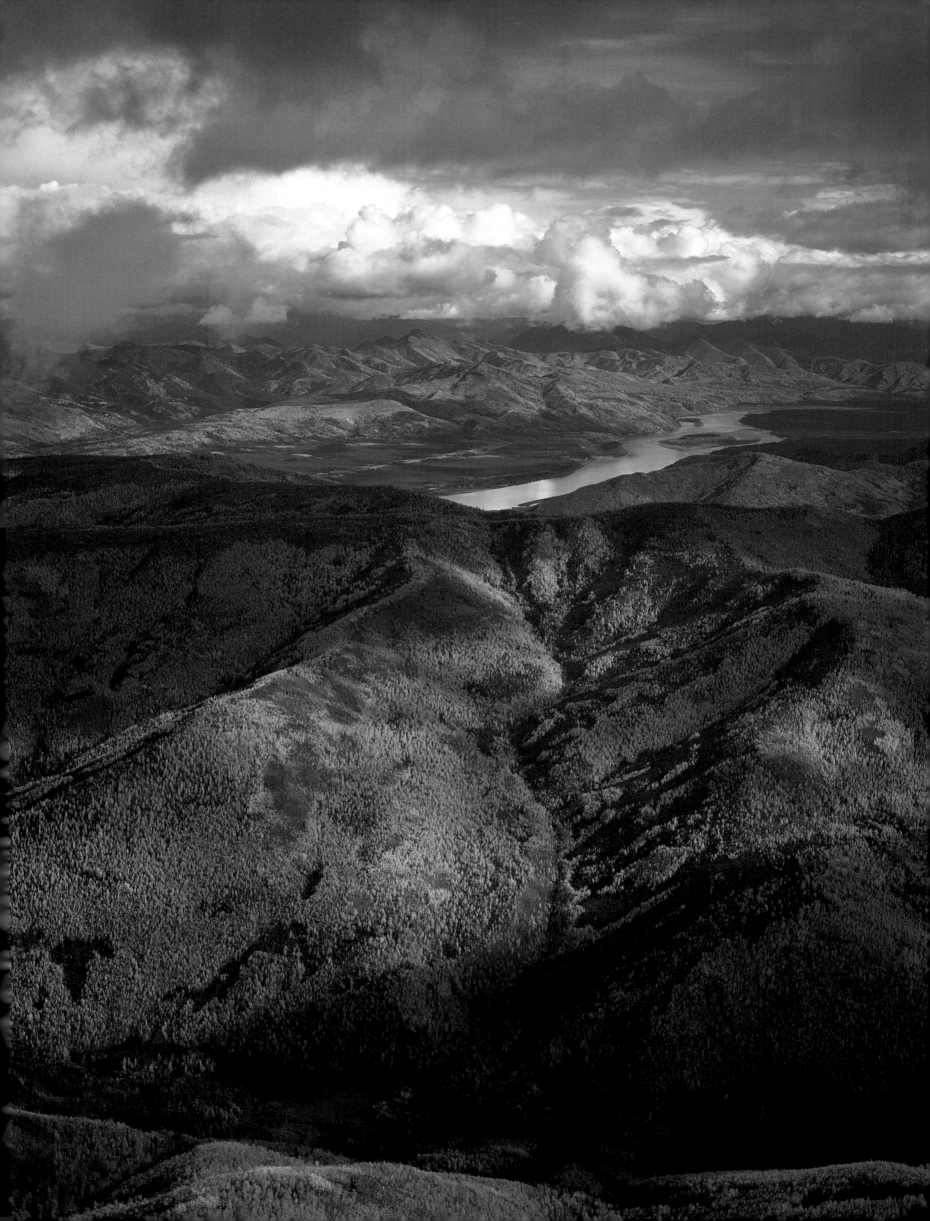

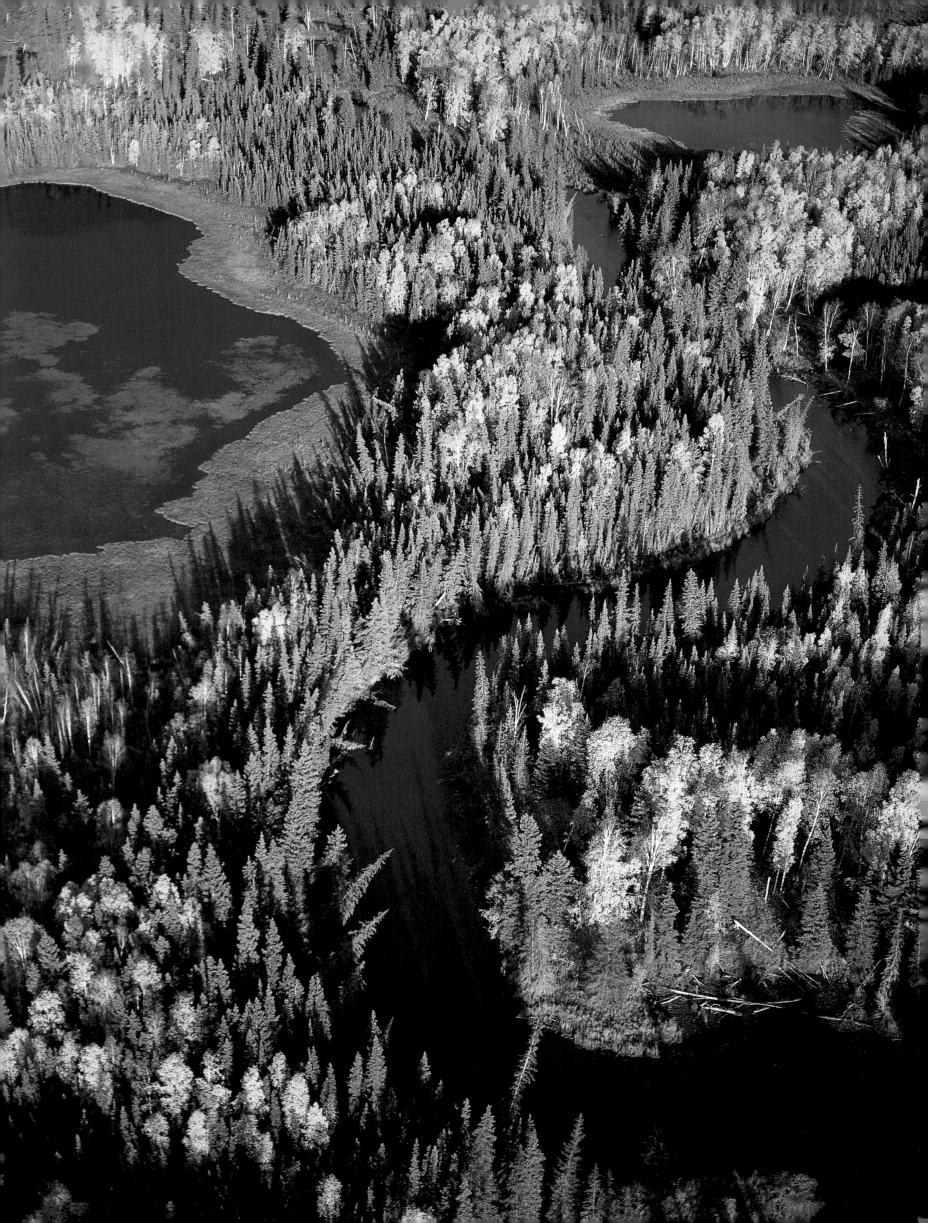

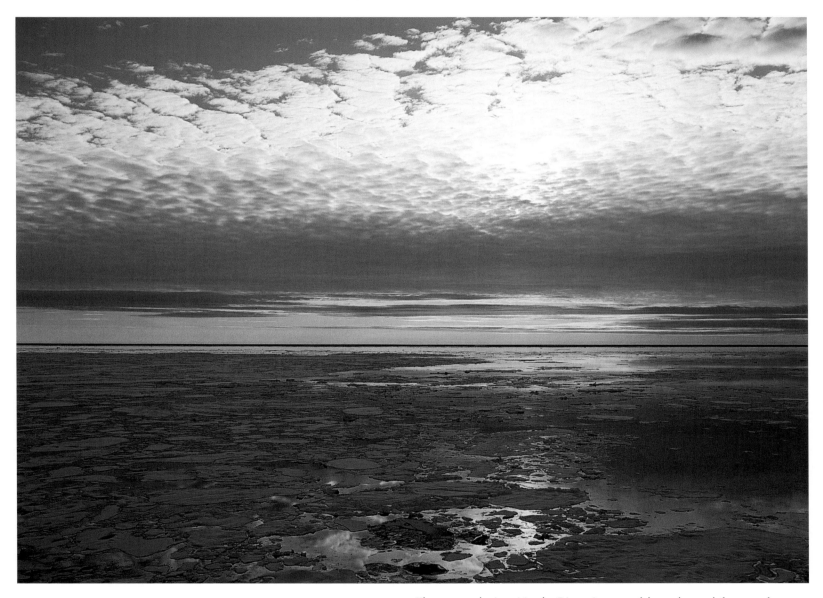

◄ The meandering Healy River is traced by a boreal forest of paper birch and white spruce. The seasons change quickly in Alaska; a fall storm may rip the leaves off trees just as they start to change color.
▲ West of Barrow, breakup of the Arctic Ocean pack ice appears to mimic breakup of the stratocumulus clouds in the Arctic sky.
► ► Sunlight streaming through a breaking storm illuminates Sirr Mountain, located northwest of Wild Lake in the Brooks Range.

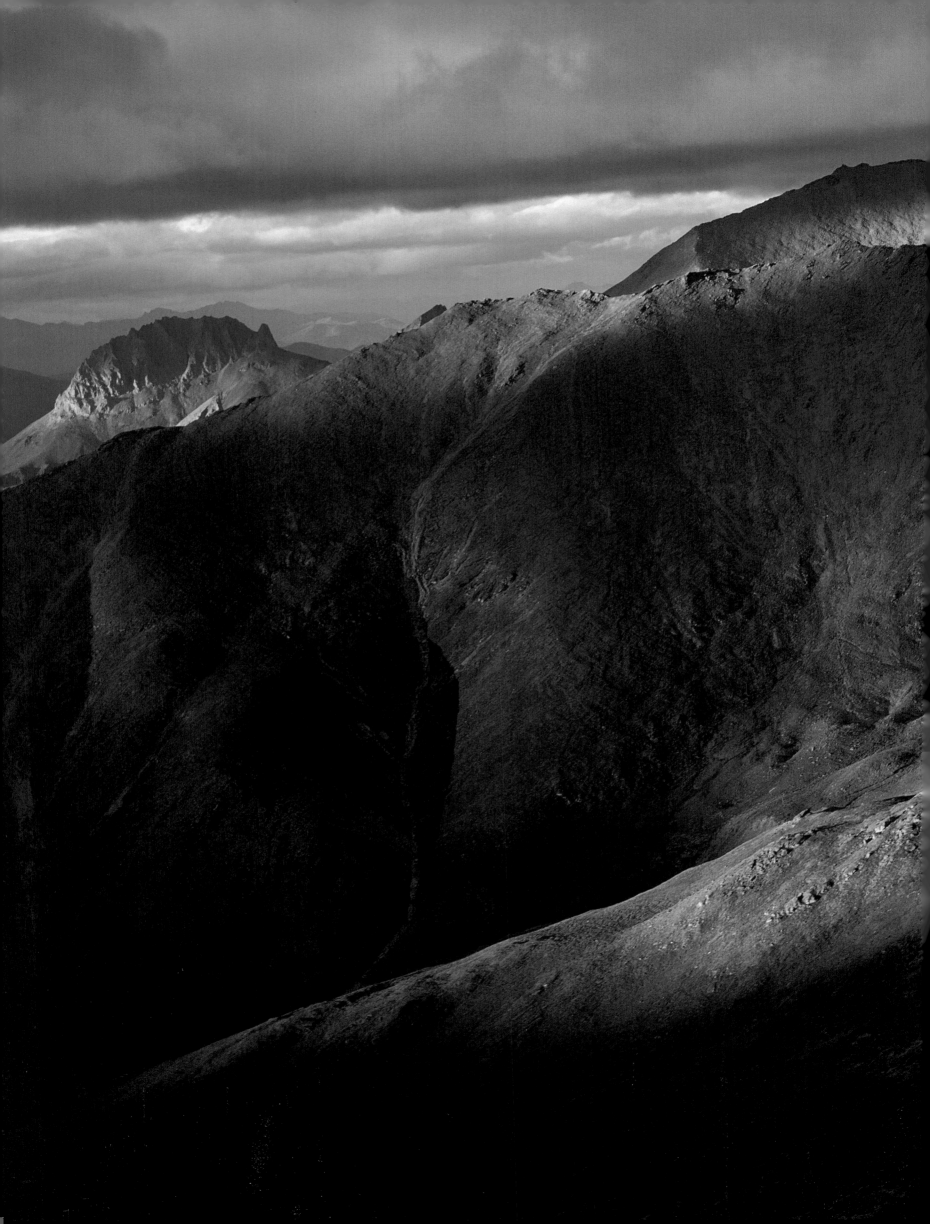